ART BEFORE THE LAW

Art before the Law

RUTH RONEN

UNIVERSITY OF TORONTO PRESS
Toronto Buffalo London

Library and Archives Canada Cataloguing in Publication

Ronen, Ruth, 1958–, author
Art before the law / Ruth Ronen.

Includes bibliographical references and index.
ISBN 978-1-4426-4788-6 (bound)

1. Art and morals. I. Title.

N72.E8R65 2014 701 C2014-900129-0

University of Toronto Press acknowledges the financial assistance to its
publishing program of the Canada Council for the Arts and
the Ontario Arts Council.

University of Toronto Press acknowledges the financial support of the
Government of Canada through the Canada Book Fund for its
publishing activities.

This project on art and ethics was supported by ISF – Israel Science Fund.

Contents

Figures and Illustrations

Acknowledgments

The research, writing, and publication of this book were supported by the ISF (Israel Science Foundation).

ART BEFORE THE LAW

Introduction: By Way of the Law

a. Art before the Law: From Kant to Psychoanalysis

When art is placed "before the law," it is already caught in its contradictory relation with the law. "Before the law" suggests that art is submitted to the law, given to the dictates of the law, but it also suggests that art has precedence over the law; it suggests that art appears before the law as its subject but is also anterior to it, unable to enter it. This dual face of art in its rapport to the law is in fact not a specific concern of art but of every practice. The law, while destined to regulate human actions, also appears basically inhuman, even opaque to human considerations and comprehension.

Immanuel Kant was the first to maintain that while the law is produced and sustained by the higher faculties in the subject, in practice the subject's actions do not directly correspond to the law and cannot be identified as concrete manifestations of the law. Kant describes the moral law as *mere form*, and hence distinct from *maxims* that put the law into action, even if the law is in harmony with them. While maxims as rules of conduct (i.e., subjective principles that accord with the conditions of the subject) are unified under and by force of the moral law, they are opposed to the universally legislative pure form of the law.[1] In other words, Kant identified an intrinsic alienation between the formulation of the law (as *practical* law) and the human action that claims to enact it. For Kant this strange distance between the law and its implementation is intrinsic to morality, its law and its ideals, as these present themselves in human experience. Morality's presence is absolute and imposing, harmonizing and alienating, standing in infinite conflict with human interests and practices.

What Kant has termed the strange thing about the law also has a constitutive role in relation to art and to the particular moment in which an artistic object is created. Like any other human practice, art is created under and before a law, and yet it is typical of art to act as if it neither submits to the law nor is prior to it. Art has presented to the world the ultimate facade of indifference to the law, when not operating as the ultimate transgressor or deceiver. When referring to the law, both in the context of Kant's practical theory and in aesthetic contexts, it should be clarified that the law is always formulated as an imperative from which rules of action are generated. In other words, the law always relates to what it means to act in a suitable or right manner within a certain practice, while the imperative itself assumes an ideal of action that transcends that practice (e.g., how to act as a good citizen? How to produce good art? How to teach? How to govern rightfully?). The law of the ideal action is hence by necessity moral as it assumes positive and negative modes of action in relation to a principle assumed by the presence of the law. In relation to this observation, art can be seen as subject to a moral law as much as any other practice is. To create good art, one should produce an artwork that aspires to resemble the real world, or an artwork that reproduces a spiritual presence, or an artwork that gives expression to sensible perceptions, or an artwork that explores its own nature as art or the logic of its form. Thus, a work of art is an enactment of a rule of action (realist, idealist, impressionist, modernist, or abstract) supposed to satisfy the imperative "Produce good art!" Art is a practice that stands, as any other practice, alienated from its own law, from the imperative commanding to act in the domain of art.

While art is, like any other practice, subjected to the law, the present study suggests that art's intricate position with respect to the law is singular and defines a particular engagement with the imperative to act in an artistic mode. Through a study of art in relation to the law, and of the question of the commitment of art to being true to the law, a broader picture of the link between aesthetics and ethics will suggest itself. This study reveals that art holds intimate, primordial, and singular relations with the law, relations that transcend the variability of moral values that art may be called to represent (good, evil, freedom, the absolute) and the changing repertoire of moral subject matters with which art is engaged. Art touches our moral sensibilities because of its particular engagement with the law. Art occupies a singular position from which it can constantly touch and sharply *expose the immanent alienation* between the law, which aims to regulate practice, and the action that is supposed

to be regulated by the law. This singularity of disclosure is what I propose to see as art's ethical stand.

Kant believed that the moral law is introduced in the subject as a distinct voice that cannot be silenced and yet is indeterminate and irreducible to the legislative form of the maxim or to schemes of action: "But for the law of freedom ... and hence also for the concept of the unconditionally good, there is no intuition and hence no schema that can be laid at its basis for the sake of its application *in concerto*."[2] Although the law is irreducibly present in the subject of reason (that is, the law is not imposed from the outside), there is an uncertainty as to how to apply it to the domain of action, as to what it means to act according to the law. Kant assumes a fundamental incompatibility, an immanent misrecognition between the law in the subject and the subject of the law.

The present study employs psychoanalytic thought in order to explore the relation of art to the law, and as a first move in this direction a similarity should be noted between Kant's antinomy of the law[3] and Sigmund Freud's antinomy between unconscious desire and the subject's practices. Freud maintained that the unconscious imposes itself on what the subject believes he or she knows about his or her well-being, through *unconscious formations*. These formations (like a dream or a symptom) cannot be explained in perceptual or cognitive terms, and they oppose the subject's train of thought/speech. In other words, from a psychoanalytic perspective, unconscious desire (Wunsch) that governs the psyche imposes itself on the subject, interferes with the automatic or wilful modes of action and thought in the subject, and creates an immanent discontinuity' between the ego's orientation in practice and the subject's unconscious desire. For psychoanalysis it is the law of desire before which the subject stands, producing symptoms, dreams, and slips of the tongue. These formations of the unconscious point at a fundamental antinomy between desire and ways in which the subject acts to increase his or her well-being (a nightmare, for instance, can interfere with the subject's well-being while as an unconscious formation it represents an unconscious desire). Both Kant and Freud point at a law (principle of action) that produces moments of alienation within the subject and in relation to the subject's practices because both assume a subject split into multiple agencies. In Kant it is impossible to adjust desire (defined as subjective volition) to the moral law, while in Freud it is impossible to adjust the ego's volition and inclination to the law of desire. We see that the law presents itself in a similar way in both contexts: it is an absolute presence that is alienated from the subject's interests and will.

And yet, for Kant, this alienating nature of the law is explained by the interests of pure practical reason, interests which demand from the subject to decline his or her inclinations, considered alien to this demand. Freud however links his version of the law, the superego, to the core of desire itself. The superego is an imposition of an imperative intimately related to the id (i.e., to repressed satisfactions of the drive).[4] The Freudian idea that the law of the superego (that sets the limits of good action), is itself the law of desire and enjoyment, is, allegedly, contradictory to Kant, who approaches the moral law and desire as radically opposed: to act morally the subject is required to infringe all inclinations, emotions, and sensibilities.[5] Curiously, within psychoanalysis, this apparent contradiction between Kantian moral theory and Freudian psychoanalytic ethics has been turned into an unexpected proximity. This proximity is revealed through the idea that the absolute imperative has to do with the very origin of morality, an origin situated in a state of absolute enjoyment. Hence, as Jacques Lacan has shown, for the subject the Freudian superego and the Kantian moral imperative reside in the very same structural place.[6]

The present study investigates the relation of desire and the law in the domain of art as art is a practice that reveals most clearly and irreducibly the impossible relation between human practice and the absolute imperative. Art, as this study demonstrates, is given to imperatives, to laws of proper action that function as *disharmonizing* elements within artistic practices. While human practice generally aims to camouflage this fundamental discord by isolating a distinct good as the ultimate moral purpose, or by suggesting a human terrain where practice is adjusted to the law, art conducts its practices differently. Art exposes the discord by exhibiting the law in its imposed presence in relation to specific maxims of action. The law of artistic action appears as an irreducible presence that cannot be defined or reconciled, and this real, irreducible presence of the law is what gives art its aesthetic and ethical value. In order to attest to the paradoxality of the law, art not only questions the compatibility between the desire to act and the law regulating actions but primarily shows the absolute, non-contradictory, primordial nature of the law that is prior to, yet intimately related to, human desire. In other words, in this study the idea of the moral law as a *practical* law, and its effects on modes of action, will be explored in the context of art, where the alienating presence of the law turns out to condition creative action. This singular position of art, in relation to the law commanding action,

stems from art's being subjected to *a logic of negation*, to the negation, first suggested by Plato, of its truthful and of its moral being.

While we tend to identify morality with certain good-aspiring acts and good-seeking judgments, such practices, rather than exhibiting the law, dissimulate the presence of the law as immutable demand that cannot be satisfied. Art, with its indeterminate relations with specific moral ideas, constitutes a singular mode of discourse in which the absoluteness of the law and the proximity of its origins to desire are enacted. Art discloses and exhibits the origins of the law rather than camouflaging its absolute presence. The singularity of art, designed to disclose the nature of the law, is discussed throughout the chapters of this book.

The present chapter aims to reconstruct the myth of the birth of the law through art. The birth of the law is recounted through myth because a historical enquiry into the origins of the law is impossible. Every structuring of knowledge requires that the question of origins be abandoned, claimed Lacan,[7] and yet also assumes the primary condition without which knowledge could not be formalized. Art is required in order to recount the moment in which the bare presence of the law in its disquieting intimacy with the possibility of human action and enjoyment is exposed. This is a mythical moment disclosing the particular conditions under which creation can take place. Not all art equally exposes its birth with the bare form of the law – even if art often does exhibit some privileged moments in this respect. From the biblical Second Commandment, through Kantian aesthetics, to psychoanalytic references to art, this study addresses singular contexts in which the relation of art to the law and to its practices can be revealed.

b. Kafka and Derrida – before the Law!

The intricacy of the relation of art to the law was addressed by Jacques Derrida in his commentary on Franz Kafka's short story "Before the Law." Derrida shows how the law, which functions as the absent protagonist of Kafka's story, must remain inaccessible to the individual before it. Art, being one "mode of revelation" of the law, demonstrates that the law "yields by withholding itself, without imparting its provenance and its site. This silence and discontinuity constitute the phenomenon of the law."[8] While Kafka's story is set to reveal the law, the law acquires its categorical power by remaining outside any mode of revelation: outside the narrative, outside history, and outside any known practice. The law

ineluctably imposes and manifests itself through practices in relation to which it remains indemonstrable, inaccessible, as the futile moves of the subject before the law in Kafka's story attest to. This ambivalence between the law as a moment of imposed certainty and its indemonstrable nature – an ambivalence caught in a literary moment – is that which both Derrida and the present study aim to grasp. Kafka's story, even if it is one unique artwork, operates here as a key moment, disclosing the fundamental mode of the being of art before the law.

Yet Derrida does not simply point at the indemonstrability of the law, at the presence of the law as an indeterminate hollow core in relation to the discourse of the law and the subject of the law. Even if Derrida concludes that "Before the Law" "does not tell or describe anything but itself as text,"[9] clearly the implications of his analysis for an understanding of the nature of the law are more far-reaching. The law is more than textual fabrication. The more ambitious implications of Derrida's analysis emerge from his extensive references to Freud, and first to one of Freud's letters to Wilhelm Fliess from 1897. Here Freud divulges a belief that he was close to *discovering the source of morality*, a discovery that he would later associate with the *primary repressed* in the unconscious.[10] But how does the primary repressed illuminate the origin of morality?

To answer this we should remember that Freud's unconscious is not constituted by representations of repressed thought but is rather a representative of what is inaccessible. It is this inaccessible element, identified by Freud as the source of sexual repression, that generates both morality and the affects accompanying it. Repression, claims Freud, is the turning away from a disgusting memory that exudes the stench of an extinct sexuality, thereby eliciting a sense of morality. Derrida even finds implicit traces of moral evolutionism in Freud's reference to repression: by turning away from our sexual organs we actually elevate ourselves to an upright position, which constitutes the origin of moral value. Freud's interest in the source of morality and in the possibility of articulating this source, as expressed in his letter, is exemplified in his use of myth. The myth, shows Derrida, is the mode of discovering the source of morality and of acknowledging this source's irreducible presence in human life.

Freud, in Derrida's presentation of his struggles to discover the source of morality, demonstrates that the only history that can be located at this place of origin is a mythical history. Such is the history recounted in "Totem and Taboo," where the birth of morality is marked by the pointless crime of killing the primordial father. This is a useless crime, says Derrida, a crime that kills nobody, and as such "this event is a sort of

non-event, an event of nothing or a quasi-event which both calls for and annuls a narrative account ... Everything happens *as if*."[11] Through the myth, as a kind of invented history, as a sequence of *as-if* events, Freud articulates what cannot be said, the source of morality, and the practices it entails. Thus, if we follow Freud, we can see that since the origin of the moral law raises a question that cannot be settled directly, it generates a myth, a semifictional story. *Totem and Taboo*, in other words, establishes the inaccessibility of the law as the cause of creating myth. The impossibility of recounting the origins does not result in abandoning this pursuit or in producing an imaginary (religious, moral, or historical) story that covers up this acute lack of account, but in replacing it with the only mode of gaining access to the origin of morality, that is, with myth. Hence, if to gain knowledge about the law we must give up the question regarding its origin, myth, rather than other discourses, is the only mode of posing the question of the origin of morality that may produce knowledge about the law without reducing the law's opaque, inaccessible nature.

Myth is capable of approximating the question of morality because myth has a questionable truth value; it presents historical events as non-events. Put differently, getting nearer the question of the origin of morality forces us to abandon the epistemic distinction between factual and fictional knowledge. Through myth rather than through a history of origins, the difference between the true and the false becomes inconsequential in constituting our knowledge of the moral law. Mythical events are *as-if* events that nonetheless convey knowledge of the law. What we learn from Freud is thus that the truth about the origin of morality lies in myth, a myth that gives presence to the form of the law and to its origins (which is precisely the way in which Freud believes the primary repressed will return in formations of the unconscious).

Kafka's story is a story about the extreme aridity of the human condition when totally subjected to the law. Like Freud's myth of the primordial horde, this story recounts the constitutive relation of humans to the law. The story describes the status of the subject before the law at a moment that cannot be articulated as knowledge held by the subject before the law; there is nothing one may know or understand of the law, and yet its presence is real for the subject. Kafka's is a story in which the agent/subject is not engaged in any substantial practice or action, and the story is not much of a story; nonetheless, what happens to the subject in the story conveys something real about the law. "Before the Law" recounts the relation between man's desire and the law by removing from the

scene any specific inclinations or concrete actions. What emerges from this peculiar staging is that knowledge about the law is indifferent to questions of virtue and vice, right and wrong, and also that recounting the origin of the law necessarily touches the limit of narrativity. Indeed, Kafka teaches us that a narrative dedicated to the constitutive moment in the human condition where the law presents itself is empty of concrete action, of motivation or desire. At the moment the law is established as absolute decree, it annihilates human desire, because the absoluteness of the law can only be related to absolute, and hence inhuman, desire. The law "intervenes as an absolutely emergent order ... as something that does not appear as such in the course of a history";[12] hence telling the story of this absolute emergent order as narrative is both impossible and inevitable. The law demands a form (of story) both to sustain itself and to elude this very mode of recounting. The law is what cannot be narrated or represented in utterances that portray truthful or fictional states of affairs, and any attempt to convey the law through human situations would take epistemically doubtful forms.

In investigating what is involved in being before the law, Derrida demonstrates through Freud that the state of being before the law is outside human practice, which is why the origin of morality lies in an *as-if* event; it is an event that necessarily preceded morality, that is, an event outside any known human practice. Before the law one stands beyond the truth principle, at a moment whose articulation produces truthful events that never were. The articulation of an event or narrative that is neither true nor fictional, and yet whose truth indeterminacy is required for the very assumption of morality, is inherent to the encounter with the law. This quasi-event, claims Derrida, bears the mark of fictive narrativity as it is the *simulacrum of narration* and not simply the narration of an imaginary history. In other words, the story of the birth of the law does not falsely narrate the birth of a spectre but truthfully narrates an event that is impossible to represent. The real power of narration is to bring into existence the very elusive yet real thing that is the law, while the presence of the law is affirmed through the undermining of narrativity itself. Kafka's story about the origin of the moral law fails by exhibiting that the law is of such a nature that it cannot be narrated. Beyond truth (where truth is recounted with an *as-if* event of Freudian myth) and beyond narrativity (where Kafka's narrative recounts the impossibility of recounting) is where we touch a kernel of truth regarding the moral law.

For Derrida, Kafka's story embodies the inaccessibility of the law, demonstrating that there is "no itinerary, no method, no path to accede to the law, to what would happen there, to the *topos* of its occurrence."[13] By

defying the impossible access to the domain of the law, the literary text suggests a region that lies beyond its frontiers. The story of the law does not include the law as represented content, and yet constructs the law's all-determining form as no less real: while the law cannot be accessed, nothing lies outside the domain of the law. Therefore, for Derrida, discursivity, the very presence of the text, by incessantly deferring access to the indeterminate silent law, turns it into an entity or an individual.[14] It is by such means that literature creates its literariness, that art creates its artistry.

Derrida's reference to Freud's dream of discovering the origin of morality carries his analysis of Kafka's story beyond the mere deconstruction of the notion of the law. Freud's mythology reveals that the law is not the imaginary *latent content* to be unearthed but is in the *manifest content* of the story itself. Derrida, by way of Freud, oversteps the idea that the source of the law is sourceless; that the law has no history or genesis and cannot be traced back to its cause. He oversteps the idea that the law creates a reality of obedience to the law through discursive form and not through substance. Derrida's "Before the Law" suggests something beyond the negation of origin and the disclosure of the law as mere textuality: it *affirms* the origin of the law and its irreducible presence. Derrida's sources suggest that the lack of origin at the heart of legal thought is a form of affirmation rather than of denial. The myth that stages an original event as non-event conveys the truth about the presence of the law. Freud's idea of the superego, similarly to Kant's categorical imperative, posits an idea devoid of actual substance, as the absolute irreducible core that constitutes the real presence of the moral law, an idea that Kafka's story portrays.

Like Kafka, Freud tells the story of the law and of standing before the law, which in Freud is configured through the murder of the primordial father. The murder of the primordial father, whose unlimited access to all the women of the horde goes together with an absolute prohibition on such free access for his sons, is a murder whose historical truth value is suspended if not actually negated.[15] Here, as in Kafka, a discursive mechanism that constitutes the law as lying beyond the textual frontiers gives rise to an affirmative indication regarding the presence of the law: "the earliest moral precepts and restrictions in primitive society have been explained by us as reactions to a deed which gave those who performed it the concept of 'crime.'"[16]

Derrida's reading of Kafka's narrative, as already suggested, implies striving towards something beyond the limits of experience, something not ineffable or transcendent, but which rather serves as the absolute

condition of experience: to experience the law, one remains before the closed gate to its domain. This is made even more explicit in Freud's story of the ancient horde, which renders an event (the sons murdering their father) at the limit of social experience. While this event presents an unreal experience, it institutes the social binding between fathers and sons. The law is hence made affirmatively present where the limit of its applicability is staged.

The murder of the primordial father, an event of doubtful historical factuality, constitutes "this creative sense of guilt"[17] that still persists in neurotics, in whom guilt results from psychic rather than factual realities. Through the introduction of an event that has an affirmative value for one's sense of morality, a more determinate sense of the law is gained. This is the difference between Kafka's story, which portrays the law as a powerful void, and Freud's myth, which makes the absoluteness of the law thinkable through an articulated event whose epistemic status is doubtful. For this reason the myth about the primordial horde is not simply a story that fills in the gaps of ignorance regarding the origin of the law, and in this sense it converges with Kafka's "before the law." The myth only carries the form of story, the form of narrative development, which, while collapsing as narrative, displays something truthful about the law. A law, accompanied by the notions of crime and guilt, points at a cause outside its domain. Whether dead or alive, the "father of the law," is registered through its effects in the domain created before the law.

In his study of Kant's *Critique of Judgment*,[18] Henry Allison presents his understanding of Kant's idea that beauty is a moral category. Allison claims that the aesthetic faculty is connected with morality because the demand to develop taste is fundamentally moral. In what sense can beauty contribute to our moral sense, unless morality is viewed as a metaphor for the general notion of a human good sense? The morality of the aesthetic is tied to the fact that beauty, both in nature and in art, gives rise, through a sensible object, to freedom as the ultimate purpose of reason, freedom that by definition eludes sensible experience. The beauty ascribed to an object thus suggests the presence of order in nature but also the amenability of ideas of reason to our thought through sensible forms even if the latter cannot actually represent ideas of reason. The Kantian assignment of moral feeling to the experience of beauty, to which the second chapter of this study is dedicated, suggests that in standing before the law in Kafka's narrative, we do not simply stand before a textual form that suggests moral reflection about the law. Rather, a sensible object – the narrative, which in itself is devoid of moral ideas – turns out

to be concordant with the idea of the law, and thus sensibility affirms the purpose and attributes of an entirely different object, the law. The narrative of the law, while saying nothing of the specific purpose the law is destined to serve, corresponds to the idea of reason with regard to the purpose of the law and its real presence in human life as absolute and unavoidable, which is what the story had strived to exhibit. The idea of the law, as an idea of reason that cannot be articulated or demonstrated through sensibility, is thus disclosed through a narrative form that conveys the law as impossible to convey. It is to this role assigned to art, as giving sensible yet deficient form to the moral idea of the law, that we should turn. While works of art, being sensible objects, seem to counteract any moral task, art does elicit moral feelings.

Kafka's "Before the Law" portrays the law as eternally inaccessible, while Derrida's "Before the Law" suggests ways in which the form of a story can make accessible the law as an impossibility. The origin of morality lies in a fictional non-event, in a simulacrum that takes the form of a narration of the origin of morality, thereby blocking rather than disclosing the nature of the thing born as law. The origin of the moral law lies in the myth of its establishment and thus necessitates the advent of fiction, of an *as if* to propagate the law's cause. The present study demonstrates that art is the ultimate arena in which the absolute presence of the moral law can be disclosed, as art provides the ideal practice for exhibiting the paradoxical birth of morality. Art does not differentiate between the true and the fictional, a fact that has nourished claims that art is immoral. Art not only presents itself as uninhibited by a commitment to truth but also appears as the ultimate transgressor of the law. However, in claiming that art has a constitutive place regarding the moral law, that art constitutes the site where the form of the law in its entire force of imposition on the subject is disclosed, we assign to art an essential truthfulness and lawfulness. To disclose the presence of the law as the absolute condition for every practice, art is hence bound to develop practices of ultimate transgression, thereby revealing that no act can transgress the law, that no art can be there prior to the law, and that no art can implement the law's decree.

Art's intricate and playful position towards the truth enables it to disclose, beyond the truth principle and beyond positivist assessments, that it is a symbol of morality. Derrida has claimed that unlike texts of philosophy, science, or history, which would never abandon themselves to a state of not knowing, literature begins where we do not know what the law is.[19] For this reason the literary becomes a parable never to be

explained "with the help of semantic contents originating in philosophy and psychoanalysis, or drawing on some other source of knowledge."[20] Art is the site where the state of not knowing creates a fundamentally productive move towards disclosing the truth about the nature of morality. Through art the law in its particularity, in its destiny for one subject (as neither manifold nor universal), can be tackled and exhibited. It is in such a context that Kafka's story becomes a parable and a singular manifestation of the moral idea of "lawfulness," a literary text that defies the communicability of the law as truthful content to be adhered to, while conveying the truth about the law.

~⌾~

But creative writers are valuable allies and their evidence is to be prized highly, for they are apt to know a whole host of things between heaven and earth of which our philosophy has not yet let us dream.[21]

The present study is not a study in ethics, and it does not present a moral theory about art. Its overall aim is to formulate a possibility for *an ethics of art from within aesthetics* by passing through a number of relevant contexts. This study thus considers the relevance of ethics to creative art in relation to aesthetic rather than meta-ethical considerations. Art appears to relate to ethics or morality in a peculiar manner; furthermore, its ethical dimension reveals the presence of the moral law without attempting to solve or disguise the acute paradoxality inherent in this presence. The hypothesis investigated in this study is that the absolute presence of the moral law in its impossible, insoluble relation to human desire and to human action and practices is disclosed in the most radical way within the domain of art. This is the singularity of art as an ethical act, and it reveals the immanence of the ethical question to the very being of the artistic object. Given this hypothesis regarding art's relation to the law, this study touches the question of the moral law in connection with a number of logical, epistemological, psychoanalytic, and aesthetic discussions.

A note on terminology regarding the distinction between *morality* and *ethics* as used in this study: while traditionally the distinction either is not very sharp or is constituted by the difference between universality and non-universal considerations, it has been mostly used since the mid-twentieth century to refer to normative conceptions of the good as opposed to theoretical ones (from a meta-ethical or a priori perspective). The present

study, when it does not follow specific philosophical resources and their terminology, adheres to the Lacanian fundamental distinction between the two. Lacan's idea of ethics refers to the subject's particular standing vis-à-vis desire, which means that the subject's ethical position relates to how the subject's practice either conforms or gives way to the kernel of the subject's being – desire. *Morality*, on the other hand, refers to conformity to civilized values that dictate the subject's social feelings of satisfaction or guilt.[22] The present investigation addresses the question of ethics with regard to the artistic act in so far as ethics transcends social values, shared knowledge, and moral directives. The ethics of art should be revealed at the moment prior to the distinction of good from bad, right from wrong, where art reveals its prior commitment to the creative drive, to what I call an aesthetic imperative, which cannot be translated into positive values or reduced to civilized notions of acting well. It is there, where the ethics of art distinguishes itself from the moral values of the good, that art's being before the law will reveal its significance.

Further, this study examines the ethics of the artistic act by constantly moving between the disparaging Platonic *doxa* that art is *neither true nor moral* (i.e., a binding of art's truthfulness with its morality) and the psychoanalytic position that art constitutes a privileged ethical moment *because*, among other things, truth is immanently fictional in structure. An attempt is made to reconcile these two apparently contradictory positions by showing that both originate from art's singularity as an ethical moment.

One fundamental tenet of the present study relates to the Platonic association of truth and morality (or rather of falsity and immorality) in the case of art, as constitutive of art's particular ethical stand. Plato's image of the ideal state emerging precisely at the point where the poetic is expelled has not just determined many things in the history of aesthetics but also the way the chapters of the present book evolve. The chapters circle around the idea that the ethical place of art is affirmed through the very act of negating the moral foundations and moral commitment of artistic creation.

Chapter 1, "By Way of Negation," develops the foundations of a logic that grounds the ethical position of art in a negative structure. This chapter traces the affirmative value that the Platonic negating act attains with regard to art, its truth, and its morality by following the psychoanalytic notion of *negation*.

Chapter 2, "By Way of Beauty," mainly concentrates on how Kantian aesthetics (and some later developments in aesthetics) makes the case

for the necessary presence of the moral in the aesthetic domain. *In beauty more than beauty itself*: Kant associates natural beauty with freedom and the moral law, showing how a judgment of beauty (and the sublime) is based on an overcoming of sensibility, on a leap from the sensible form of nature to supersensible ideas and to a moral interest free from empirical laws, while maintaining the enduring presence of the sensible mode of exhibition. Kant also suggests an analogy between judgments of beauty and moral judgments that transform beauty into a symbol of morality, thus tightening the link between morality and beauty. This chapter examines the initiation of a moral disposition in aesthetic judgments, tied to the very essence of beauty as grasped by Kant.

Chapter 3, "By Way of Truth," concerns art's resistance to identifying truth with epistemic knowledge. Born in a moment of negation, art has to come to terms with a primordial event, uncommitted to the distinction between the true and the false. This chapter presents the ontological implications of Plato's view on the corrupting force of art in terms of a truth singular in the sense that it is always only half-said. The chapter examines various possibilities for relating the loss of truth in the fabricated object of art to a gain of truth elsewhere. The practice of art always subtracts from the possibility of saying the truth, thereby affirming that the truth about art is not the truth of what is said or known. Art is committed to mythical and fictional forms of expression, to telling what cannot be measured by a truth identified with epistemic knowledge.

Chapter 4, "By Way of Deception," takes the artistic example of trompe l'oeil as a radical case in which an artwork that at first appears to be identified with the thing itself turns out to be something else. This chapter concentrates on the implications of this refusal to assessment, as trompe l'oeil first denies its status as art (it looks like the thing itself) and later denies its status as a thing (it is only a picture). This chapter shows in what sense the deceptive gesture of trompe l'oeil is fundamentally ethical. The deceptive move, eliciting doubt in the observer regarding the status of reality, leads to certainty in the subject regarding another truth affirmed in aesthetic creation and judgment.

Chapter 5, "By Way of Prohibition," examines the relations of art and the law through the prism of the biblical Second Commandment. The commandment prohibits the imaging of god in pictures or sculptures, thus indicating that images are both intimidating (they can show something one is not allowed to visualize) and incapacitated (incapable of conveying the real thing, except through inferior substitutes). In assuming the position of immanent transgressor, art affirms the paradoxical

place of the law in relation to any human practice. Art denudes the absolute law of all mediating practices, revealing its real impossibility with regard to attempts to fulfil the law's dictates. Art's ethical involvement, in this respect, lies in revealing the place of the imperative as fundamental to human desire, thus demystifying the frustrating relations of the individual to the law.

1

By Way of Negation

a. The Birth of Art in Negation

The birth of art lies in a moment of two negations. When Plato, for whom the idea of the good necessarily resides with truth, wishes to expel art from the ideal city, he names art's deceptive character (non-truth) as the cause for its lack of moral value:

> When any one of these pantomimic gentlemen, who are so clever that they can imitate anything, comes to us, and makes a proposal to exhibit himself and his poetry, we will fall down and worship him as a sweet and holy and wonderful being; but we must also inform him that in our State such as he are not permitted to exist; the law will not allow them. And so when we have anointed him with myrrh, and set a garland of wool upon his head, we shall send him away to another city.[1]

Plato claims that the law of the state cannot allow the existence of what is beautiful or pleasant for its own sake. The law finds the light pleasantness of the mirage created by poets unbearable, thus calling for the poets' expulsion. As is elaborated further in the fourth chapter, Plato does not expel art because of its frivolous function but rather assigns it a more menacing position. Still, his qualification of art in terms of a doubly negative structure results in its exclusion from the domain of the republic. Art is non-true (imitative, simulating, feigning) and hence non-moral. Thus, according to the law, it should not be allowed to exist in the ideal city, and so the city should do without it. Note that the law of the state is established by Plato as an ideal that leaves the art of imitation outside its domain. The law imposes an external standard of good that

art cannot reach. However, as will be shown below, the doubly negative structure turns the external law of the state into an absolute, affirmative presence, inherent to the practices of art.

In his fourteenth Seminar, Jacques Lacan claims that in accordance with the cardinal place given to negation in psychoanalytic thought, what we know about the drive in the human psyche cannot be traced except through the "reversals of partial and chosen negations."[2] Following Lacan, this chapter attempts to articulate in general terms the logic of negation, as developed in the psychoanalysis of Sigmund Freud and Lacan in order to assess the effects of Plato's negative move on art. Thus negation is assigned the role of a paradigmatic framework for understanding the creative drive and for instituting the affirmative role of the Platonic act of negation for art's relations with truth and morality. It is through this link with psychoanalytic negation and its affirmative function that the philosophical position that marks art as non-existent within the domain of the law (because it trifles with the seriousness of truth) can be reversed or developed further.

Although Plato's position is unique in the history of philosophy, his move constitutes a founding act that resonates throughout the history of aesthetic and non-aesthetic philosophical approaches to this problem. Suffice it to mention Immanuel Kant (discussed at length in the following chapter), who denies any moral interest in art only to later reverse this claim by predicating beauty as a symbol of morality. Or Hegel, who declares the death of art, a negative gesture that has nourished both artistic creation and aesthetic discourse (for instance, in the contemporary thought of Jean-Luc Nancy, Alain Badiou, Jacques Rancière, and others). The negative gesture takes many forms in the history of aesthetics, and, as claimed here, it corresponds to a fundamental structure through which art's moral value and truthfulness are affirmed.

The proposed logic of negation does not present itself as an alternative solution to the ethical problem of art. Rather, the logic of negation provides the access road to art because negation plays a predominant role in philosophical approaches to art. This is attested to by Plato's image of the ideal republic as one from which the poets have been expelled, as if saying "this [art] is what I am not." It is in response to this philosophical gesture of negation that we should regard not only the mainstream aesthetic positions but even a position such as that of Martin Heidegger, who wishes to overturn both the Platonic and Kantian pictures, showing that art both discloses and is most akin to truth. Heidegger attempts to rescue art both from the Platonic grasp and from the clasps of aesthetics,

where the association of art with truth has been consistently overlooked. Assessing the truth of art is a way of affirming what has been denied by many aesthetic positions. Indeed, the main question to which the logic of negation should provide an answer relates to how the Platonic exclusion of art, as non-existent in the domain of the law, enables us to assign to art in affirmative terms that which is lost to the domain of the law when art is expelled from it. In other words, the exclusion of art from the domain of the law restitutes art in the place of the part lost/excluded from it. It is because of this founding act of art as excluded that the law turns out to be an internal absolute presence to which art is submitted. Whether we say with Plato that "art is not good" or we say with the critic shocked by Duchamp's readymade "*The Fountain* is not art," by negating the place of art within the domain of a relevant law, its place is affirmed in this very domain as the practice internally excluded from it. At the same time negation affirms art as a lawful practice, the law as the law of art or of this art is thereby affirmed (e.g., "this is not art" is the first stage in the process of aesthetic affirmation of the readymade as art).[3] Following the logic of negation and pursuing the productivity of negation are not oriented towards affirming the negated as new positive content. Hence, the thing that art is not cannot be identified with what philosophy and science claim about art; the thing we call art cannot be identified with its disparagement as lacking aspiration to the true or moral validity. Nor can we identify the element affirmed by negation with the poetic licence to transgress the common morality and to fictitiously construct worlds, a licence vehemently defended over the centuries by artists and art lovers. Art's being in relation to the law cannot be given the role of the "other" of the law, of the graceful or even obnoxious outlaw. In other words, the present study does not attempt to restitute the éthical status of art in order to enable philosophy to reconsider it as an alternative to mainstream ethics. Rather, the artistic act of creation, the object of the present discussion, is itself born in negation, in the declaration "I am not it," a declaration taking place in close proximity with the moment of founding a law.

The function of negation in establishing being is a much-discussed issue in the psychoanalytic context. From Freud's essay on negation[4] to Lacan's many references to and frequent usage of the logic of negation, this psychoanalytic interest discloses the problematic nature of truth and knowledge as understood within the psychoanalytic framework. The psychoanalytic interest in negation stems from the assumption that the subject's being cannot be identified with what the subject consciously thinks

or says but rather with what the subject denies, refuses, or represses. That is, the key to the psychoanalytic emphasis on negation lies in the fact that the ego is not the sole instance determining subjectivity, and negation is the operation that discloses this fact. "The principle of speaking true is negation," says Lacan[5] towards the end of his teaching, thus summarizing the insistent use of negation in clarifying the place of the unconscious and the nature of subjectivity within psychoanalytic thought.

While psychoanalysis refers to many forms of negativity, such as repression, foreclosure, and denial, this study refers to negation only in the sense of "presenting one's being in the mode of not being it … [when] the person speaking says 'this is what I am not.'"[6] Lacan's reference to negation as the paradigmatic mode of stating the truth clearly exceeds in its implications the specificity of art. Still, the psychoanalytic use of negation to indicate a crucial logical and ontological aporia in every discourse will be examined to reveal the particular mode by which negation discloses a moment of split in every artistic creation.

This chapter is composed of three sections corresponding to three phases that gradually reveal and elaborate the logic of negation. The first phase in this logic concerns the principal gesture of negation: the emptying of a set as a way to attain certainty; the second phase in this logic concerns the mode of affirmation of what is refused by the ego; the third phase concerns the logico-structural relations between two negations as sustained in a truthful structure of implication.

b. Negation – an Act of Exclusion

This section examines the way negation functions by excluding from a domain. Lacan refers to negation as the prime principle of speaking true, thus endorsing the place allocated to negation in terms similar to those used by Freud in his innovative work on the subject in psychoanalysis[7]: the truth lies in analysis. In elaborating on this formulation, Freud commences with the patient who, when asked about the identity of the figure who appeared in his dream, replied that *this was not his mother.*[8] Freud's analysis of this example and of the mechanism of negation may appear to be simply an assessment of the logical proof that a false statement can yield a true implication. There is, however, a radical difference between negation in formal logic and its status in psychoanalytic thought.[9] Freud's analysis has implications that are more far reaching than those suggested by a logical analysis. While in logic such possible implications refer to a formal procedure, Freud assigns ontological value

to negation and examines the ontological implications of a true implica-
tion drawn from falsity.[10]

Yet psychoanalysis does not treat negation in a more mitigated form
than does logic but rather in an inverse manner. Negation for Freud
and Lacan is absolute, non-negotiable, and in terms of such absoluteness
the subject's being is disclosed through the structure of negation. The
absoluteness of negation does not lie in the discursive rejection itself,
which is why psychoanalytic negation is not a total emptying out. Lacan
examines these aspects of negation, exposing the underlying fundamen-
tal logic, best exemplified in terms of *sets*. Every act of negation creates
a set that empties itself by refusing something in its domain. Lacan's
method demonstrates, through sets and the relations between sets, in
what sense negation cannot be exhausted in terms of a refusal to what is
being negated since the being of what is refused is actually affirmed. Psy-
choanalysis shows us that there is more to negation than refusal precisely
because what is negated is that which absolutely cannot become con-
scious, that which can never be incorporated back into the set as integral
to it; it is what the I must be without. That is, negation discloses that what
is negated has an intimate relation with the subject's being *as negated*.
The logic that is thereby activated determines that what is actually pres-
ent and affirmed is partially open to what is rejected and refused.

When the patient says regarding the figure in his dream, "This is not
my mother," a two-faced judgment is enacted. First, the subject judges
that the possible relevance of his mother to his dream is undesirable, as
such an association would be painful to his ego. The subject thus judges
"the possession by a thing of a particular attribute,"[11] in this case the
attribute of being unpleasant or disagreeable to the ego, as determinant.
The other side of the judgment concerns the dispute regarding the exis-
tence of the presentation[12] expressed in the claim that the mother does
not exist in the dream. The image that serves as the object of negation is
hence unpleasant and non-existent.

Freud insists that according to the negative formulation, the libidinal
question that ties the presentation to the pleasure principle precedes
the existential question. Judging something as painful or pleasant deter-
mines whether its existence should be denied. What is disagreeable to
the dreamer's ego is judged as belonging to the outside, as being exter-
nal to the ego and non-existent with regard to what the subject wants
to know about: "This was not what I was thinking about," the dreamer
implies in his negation. Things are denied existence on the basis of libid-
inal charge. What is refused is regarded as a "bad thought," and what is

taken to be bad by the ego "is often not at all what is injurious or danger-ous to the ego; on the contrary, it may be something which is desirable and enjoyable to the ego."[13] This correlation of the libidinally charged thought with an external threat to the ego is explained by Freud in terms of the early threat of loss of love from an external protector. Hence, the ego's rejection of a thought or image is caused by the libidinal *charge* of what is essential for the subject's being. This addition explains why something essential to being is rejected as undesirable by the ego, which says "no."

The refusal of being takes two sides: the side of things expelled to the domain where the ego is not, and the side of the ego left empty of con-tent: these are *Bedeutung* (sense) and reference. The I remains an empty referent and yet is qualified by the things it rejects, by what it is not. This logic of negation, as articulated by Freud in terms of the emptying of the ego domain, is later developed by Lacan through an analogy to the Car-tesian cogito and its implications. René Descartes's cogito also works as a mechanism of emptying the domain of the ego. The cogito is a truthful implication drawn from doubtful or even false suppositions. The Carte-sian subject can draw a true implication, even if everything that he thinks is false – the mere fact that the subject is thinking is already true. The I of the cogito emerges from the subject's false or ungrounded beliefs, from the negation of all knowledge: "My being is not *what* I think," Descartes would say. The operation of negation renounces all paths of knowledge in order to reach the point of avowal: here, at least, it must be that I am. Descartes taught us to establish an emptiness of ego, an "I = am not," since this emptiness is a prerequisite for the point of avowal to be reached. Freud uses this Cartesian manoeuvre to reach, through a vacuous ego, the place of the "I am." The domain of the "am not" thus has the power to restore the I, affirming the ego's being on new grounds that take desire into account.

Freud's negation and Descartes's cogito both depict the ego as aim-ing to approximate *maximal vacuousness*. Descartes reaches a maximally empty ego, where thought stocks no necessary content, appearing as a sheer formality sufficient to assure the existence of thought. Similarly, Freud shows that the ego is an immanently negating function that affirms itself through rejection. This emptying function becomes evident when the ego rejects things according to the pleasure principle: "the original pleasure-ego wants to introject into itself everything that is good and to eject from itself everything that is bad. What is bad, what is alien to the ego and what is external are, to begin with, identical."[14] As the function

of judgment is given to the ego, the ego expels whatever it judges to be displeasurable.

The fact that the ego has a fundamentally renouncing function already touches on the particular nature of negation. In expelling the displeasurable and thus functioning as a negating agency, the ego acknowledges the substantiality not just of the repressed but of repression itself. The negative formula creates a split between expelling something from consciousness as non-existent and affirming the expulsion as such. Freud sees this as driven by the pleasure principle, as, for him, the affirmation of the repression is in fact an affirmation of the psychic reality of the primary repressed. As Lacan has claimed, "I only am on condition that the question of being is eluded, I give up being, I … am not, except there where – necessarily – I am, by being able to say it."[15]

Freud has described negation as "a way of taking cognizance of what is repressed; indeed it is already a lifting of the repression, though not, of course, an acceptance of what is repressed."[16] The negation does not make the negated present to the ego, yet it enables the subject in the analytic situation to display something about the real presence of the repressed as marking the domain of the not-I. This domain is libidinally charged and hence displeasurable to the ego, and thus it is marked as non-being, as the place where I am not.

The act of exclusion is the intellectual side of negation,[17] the product of reasoning for both Descartes and Freud. It denies a certain thought yet suspends repression, suggesting that what is negated is the I as thinking a given thought and not the thought itself.[18] In this manner, the ego constitutes its domain. Similarly, the thinking Cartesian ego is not identified with a positively present thought but rather is the result of emptying the place of the I of all doubtful thoughts. Their suspension outside the ego marks the place where the I cannot be thinking. When Descartes designated the I as the only place of being, a being that for him is but a place empty of the evacuated thoughts, he left us no choice, claims Lacan, but to go towards the *I am not thinking*.[19] The Cartesian cogito is imbued with the logic of negation, as the place of the thinking I is determined by that which the I cannot think. The logic of negation thus has two consequences: that what is negated does not disappear even if it retains its status as non-existent, and that the denying agency, the ego, sustains itself by declaring "not-I." Inside the domain of the ego, there is only negation; there is no domain where the I identifies with a thought. Rather, the ego negatively recognizes itself in what lies outside and is displeasing. Inside and outside are in fact simply two forms that separate

the ego from unwanted thoughts, while the ego itself is reduced to emptiness. This emptiness is sustained by what is refused by the ego as what cannot be thought.

c. "This Is Not-I" – "This Is Where I Am Not": Affirmation of the Excluded

The idea that negation is an *Aufhebung* of repression that conserves the repressed lends Freud's paper its "philosophical density," claims Jean Hyppolite.[20] The "philosophical density" involved in Freud's negation emerges from the way it opens up a different path in considering the logical import of negation. Freud's negation is tied with Descartes's cogito because both present the individual's being in the mode of not being. According to Lacan's analysis of negation, Freud follows Descartes's footsteps yet reveals that the logical implications of negation are more far-reaching. For Freud the negative operation empties the domain of the I, where one encounters the refusal of being, but negation also works as an affirmation (*Bejahung*) of the bounds of the domain beyond which the being of man is *verworfen* (discarded). Negation thus first affirms the bounds of the discourse of the ego as transgressable and then affirms the non-complementary domain of the not-I that lies beyond the bounds of discourse. Negation hence does not affirm being but is rather an affirmation of the place of the not-I, of what is constituted by negation as being of a different register than the domain of the I that has been voided of being. Even if this place is a fictitious, phantasmatic one (as is the place of the god of Descartes that lies beyond the subject's domain), negation excludes the possibility of its imaginary interpretation. Negation identifies the ego in what pleases it, and it is precisely by pointing at the limit of pleasure that the domain of the ego is isolated. This affirmation of the limit of the domain of the I, and of what belongs to another register of the pleasure ego, reveals one of the crucial differences between the operation/function of negation in philosophical logic and in psychoanalysis, a difference that illuminates the philosophical import of Freud's negation. In philosophical logic, negation does not transgress the universe of discourse, and hence the way negation is written does not affect the structure of truth. In contrast, in psychoanalysis, the way negation is inscribed affects the structure of truth as it may affirm another register to which negation applies: "We have only to observe what happens when we say: 'it is true that it is false' [as opposed to 'it is false'].

It does not budge, namely, quite simply the false regains some luster, framework."[21] Thus, the function of negation is seen as rejecting "from any order of discourse, in so far as the discourse articulates it, what it is speaking about," which implies no grasp of one universe of discourse for the I and the not-I.

The differences between the two paradigms in understanding the logic of negation can support our claim that the psychoanalytic analysis, articulated by Freud and Lacan, enables the subject's being to be disclosed through the structure of negation. Negation is absolute because it is not a form of restriction or of exclusion per se. Beyond the negative gesture of emptying or totally reducing the structure of subjectivity to the ego alone, negation also draws from a discourse that counteracts the presumed absence of subjective cause for its establishment. Hence negation can affirm the being of the not-I at the limit of the register of the I as not-being.

The ego is emptied of what is dissatisfying and hence recognized as alien to it.[22] Having seen the operation of emptying out the domain of the ego, we will now turn to the affirmation of "being as not being it" that is thereby enacted. How can the negated thing be affirmed without being turned into positive content; how is the repressed acknowledged when repression by definition cannot turn into cognition?

In his seminar on the logic of phantasy, Lacan uses the example of "I do not desire"[23] to illustrate that the implications of negation do not concern the sustenance of what is being denied. The most immediate response to this negation would concern the object of non-desire: "what is it I do not desire?" But the refusal to desire does not solely concern the transitive dimension of desire – that which the subject does not desire. It also demonstrates that in relation to desire the subject says, "not-I desire," negating the I rather than desire itself. The I denounces its being by negating desire, thus indicating the implications of this picture of renunciation as constitutive of the ego. Denying desire amounts to the refusal of the ego to being-in-desire but also constitutes another instance or another subjective agency, unto which desire is assigned. Hence desire does not vanish; it is the I-as-desiring that is effaced. Understanding desire as what returns after the negation indicates that the repression of desire has changed the status of the operation we call "desire." What has changed through negation is that desiring has moved from the denial of the thing desired to the denial of the I-as-desiring. Following Lacan's often-quoted formulation, *the rejection of being from the symbolic,*

reappears in the real, we can say that the movement has taken us from the symbolic object of desire to the cause of desire; we have moved from symbolic articulation to real disturbance.

What has been denied of being, deemed inarticulable in the domain of the ego, returns. Lacan, as we will see shortly, indicates two ways in which the refused being returns, without this return being identified as a symbolic articulation of the repressed. Lacan stresses that the ego, having established itself through the refusal of being, cannot incorporate a return of being. What returns must be an un-being or non-being, which is the effect of placing being in the place where the ego is not. So how does the rejection of being by the ego reappear in the real? The first return can be shown through the case of phantasy, where the I thinks/ speaks while being excluded from the realm where the phantasy is enacted: "A surprising number of people who have come in search of analytic treatment on account of an hysteria or of an obsessional neurosis *admit* that they have experienced the phantasy: 'A child is being beaten.'"[24] This is how Freud's discussion of phantasy begins, indicating that in the structure of phantasy the speaking function is assigned to an I, yet the I is denied the being-in-phantasy (which is why the subject in phantasy is split between speaking and being). In phantasy the "not-I" appears in the phantasy as what reappears from the domain of the id. This latter domain is not posited as the result of speculation concerning what lies beyond discourse but rather is imposed through a simple grammatical fact. When a subject recounts a phantasy, he or she does not appear in it in the first person; he or she will not assign the phantasy to himself or herself. Thus, in Freud's famous analysis of phantasy, it is recounted under a formulation that does not concern the I: "*a* child is being beaten" rather than "*I* am being beaten by my father."[25] This grammatical montage, as Lacan terms this discursive phenomenon, the not-I who enacts the phantasy, divulges the presence of the id in the domain of the ego. The grammatical structure affirms the presence of an additional agency, the not-I or the "it," which speaks in/for the phantasy. "Not-I" refers to the remainder of the grammatical structure, uncovered by the speaking I, thereby restituting the subject, who never avows his place in the phantasy, although through its interpretation he necessarily ought to be present. The id is hence the effect of negation per se; it is what reappears as a result of repression. Id is the domain of the not-I, marking the phantasy as the place from which the I, as the subject of the phantasy, has been excluded.

The return of being in the domain of the ego also takes another mode according to Lacan, a mode that can be illustrated through the case of the *Witz*. This is exemplified by the *Witz* of a patient of Freud's, referring to the patient's relationship with Rothschild as *famillionnaire*. Here the I does appear grammatically, even if the discourse of the I is controlled by the witty signifier. In the witticism the speaking subject "finds himself, in this very non-existence, reduced to a sort of being for whom there is nowhere a place."[26] Following Lacan's reasoning, the signifier *'famillionnairely'* does not represent what the subject thinks but rather how the subject is split between his speaking being (i.e., the agent saying the *Witz*) and the way, as the subject, he is thought about from the position of the Other (as a millionaire). *Famillionnairely* locates the subject's being outside the domain of the speaking subject, in the place where the subject is not, in the domain of millionaires. The subject appears only as the "I am not"; that is, the subject who appears as the I speaker refuses his "I am." When the "I am" is refused because it is replaced by the Other's representation of the subject (as one of Rothschild's entourage of millionaires), this refusal functions as affirmation of the unconscious, that is, of the subject's desire in relation to the desire of the Other. In the witticism the unconscious comes in to replace the non-being of the I. Elsewhere Lacan marks the appearance of the subject as the subject of the unconscious, as a moment of alienation when the subject renounces his being in order to appear in the field of the Other.[27] Being a *famillionnaire*, the subject's singular being is displaced, and he becomes non-being in the field of the Other. In other words, the I is reduced to mere speaking by the appellation of the Other.

The refusal expressed through negation thus affirms the not-I of the id (as that which speaks instead of the subject) and the non-being of the unconscious (as what *is* where the I who speaks *is not*), as the two terms designating that the being and thinking of the subject cannot be reunited. What reappears by the power of repression is hence not a presentification of being but rather the affirmation of non-being: where the I is not, and from where the I cannot think. Lacan contrasts this non-being with Descartes's attempt to substantiate the place of "it thinks" (identifying the "it" with god). Descartes posited an "*I* think" empty of thoughts, while attributing knowledge to an Other, a godly authority acknowledged as the reference supporting every instance of the "I think." The certainty of the Cartesian cogito is conditioned by a place of being (of god), as a place substantiating the empty place left

in the domain of the cogito. In contrast, Freud acknowledges the full implications of the emergence of the ego as the effect of repression that cannot be overcome.

Let us linger over the meaning of the emptying of the domain of the ego by the force of negation and its implications for constituting this "other place," by examining the example of "I do not desire." The question this sentence raises is whether being can manifest itself where desire is refused. The negative formula opens two paths along which the being is restituted. First, "I do not desire" may mean that it is not the *I* that desires (negating the pronoun *I*) but rather something else that desires. That thing (*ça*) desires through me, while I, the ego, am disposed to its desire without desiring. In this reading the I is split from the domain of desire. Second, "I do not desire" also means that the I is not concerned with desire as the predicate is negated. In such a case desiring can emerge only where the I *is* not. Desire hence concerns the unconscious, where the unconscious desires. "I do not desire" therefore seizes on the double rejection and affirmation of the negative cogito: "I am not thinking; therefore, I am not."

d. The Disjunction of Two Negations – a Shortcut or an Imperative?

Implication in philosophical logic means that in the liaison uniting the *protasis* (true or false subordinated condition) with the *apodosis* (the true or false consequent), both are constitutive of the same universe of discourse. The relation between these elements is of the order of *complementarity*. Complementarity can be illustrated through Descartes's interpretation of the implication uniting the two sides of the cogito as part of one universe of discourse. Descartes achieves the certainty of cogito through what Lacan has termed the "instauration of the being of the *I*," thus sustaining the relation of thinking to being.[28] In renouncing every knowledge through which the I of thought could have accumulated substance, the being of the Cartesian ego as an empty set is restored as merely thinking: being and thinking become the same thing in Descartes: *cogito ergo sum.*

No such relation of complementarity exists in psychoanalysis, and the futility of assuming such a relation is revealed through Lacan's analysis of the cogito. Within the structure of the Cartesian cogito, the implication between thinking and being becomes evident through the status of *ergo* (in *cogito ergo sum*). *Ergo* represents a necessity, holding together the entire structure of the cogito: if "I think" is true, the whole implication,

that is, the "*cogito ergo sum,*" is true. According to Lacan, Descartes's *ergo* exhibits the power of negation because it positively ascribes being to the *I* under which no element exists; we have only the being of the I as thinking. *Ergo* thus overcomes the refusal of everything that could have been included in the domain of the "I think," demonstrating that the total negation of knowledge and thought brings back the I as being (and not only as thinking). Under these conditions, the *ergo* reveals Descartes's refusal of the hard path from thinking to being (were being not implicated in the formality of thinking), which had preoccupied philosophy from Aristotle to Descartes. Instead, Descartes takes "the shortcut of being the one who thinks ... because already the question of its own existence is, for its part, assured."[29] The cogito is a being (*étant*) that has no need to question where its being is derived from. The question of being is evaded by Descartes, because the "I am" is constituted by the fact that it contains no element of being beyond the fact of thinking.

According to Lacan, Descartes's avidity for certainty made him empty both the set of thinking and that of being. Descartes presents an intersecting set between the two sides of the cogito marked by necessity, because the "I think" had already evacuated every element of being that could have disturbed the truth of the implication. Negation is first revealed in the emptying of the set, creating a zero distance between the two elements of the implication. This explains Descartes's need of god in order to assess the certainty of the cogito in terms of a meaningful cause prior to the later acts of negation. In this manner Descartes achieves the semblance of a conflict-free attainment of certainty, which is implemented by voiding the cogito from any ontological weight, to be filled later by knowledge ascertained by the presence of god.

This is precisely where Descartes and Freud part ways. Freud acknowledges two opposing sides of the judgment: the one is an affirmation, which – "as a substitute for uniting – belongs to Eros," while the other is negation, which – as "the successor to expulsion – belongs to the instinct of destruction."[30] In other words, while Freud's negation marks the ego's recognition of the unconscious, it is preceded by affirmation, touching on Eros's primordial determination. Freud shows that the ego's choice of action, the decision to expel, is preceded by the affirmation of the primary repressed, of a kernel of enjoyment. The negative formula is required because without it enjoyment will not be affirmed; negation conditions the possibility of *Bejahung* (i.e., positive affirmation). Without negation, we would know nothing of the primordial cause of our judgment, the cause for our certainty that certain things are judged as bad

and hence expelled, while other things are judged as good. In Descartes, however, there is nothing prior to the moment of judgment: I think therefore I am. Here the cause lies at the very moment of conjoining thinking with being.

A number of conclusions can be drawn from Freud's analysis of negation. First, expulsion is conditioned by the affirmation of a prior moment of enjoyment of which we would have known nothing were it not for negation. Second, morality, the ability to judge bad from good, evil from virtuous, is born at the very moment of negation. Judgment is the consequence of affirming a primordial pleasure, a pleasure negatively marked through the inadmissibility of the bad thing into the domain of the ego. A moral judgment is, in fact, the establishment of a necessary distance from a preliminary moment of enjoyment, a moment that is thereby affirmed. Finally, the power of moral judgment is enabled by the immanently split structure of negation, sustained between thinking and being, negation and affirmation, as the two, necessarily distinct sides, of the negative structure.

As previously mentioned, Lacan represents the relations between negation and affirmation in terms of the conjunction and disjunction of two sets.[31] The significance of representing the logic of negation through the conjunction and disjunction of two sets can be made evident with the Cartesian cogito. Here the moment of doubt (the negation of the content of all thought) leads to an affirmation identified with the intersecting set. Putting 'ergo' in this set means that the cogito affirms the zero distance between the thinking and the existing of the I.

Figure 1.1. Ergo as intersecting set.

Figure 1.2. Ergo as disjunctive set.

But what happens when we take into consideration the logic of negation as implied in Descartes's formula *cogito ergo sum*? How can the implication represent the effect of what has been rejected? How can the implication represent negation both as an expulsion and as an affirmation of a kernel of being prior to negation itself? How can it represent what is involved in the decisive act of negation and the prior event that is thereby enacted and affirmed? Through the implication Descartes rejects the id from the domain of the "I think," and the unconscious from the domain of the "I am." Differently put, "I am not thinking" is correlated with the id, while "I am not" is correlated with the unconscious. Negation, claims Lacan, defies any possibility of overlap or intersection between the id and unconscious. To illustrate their non-rapport, he suggests the structure of an imperative in the spirit of Freud's famous dictum "Wo Es war soll Ich werden," that is, the ego should come to the place of the id, which is, like any pure imperative, impossible to satisfy. ("It is to the place of the 'I am not' that the id is going to come, of course, positivising it in an 'I am that' – which is only a pure imperative for the I to come to the place of the unconscious."[32]) Freud's formulation is as impracticable as any of Kant's imperatives since the I is not and cannot be where the id is. The subject of negation remains split between his "I do not think" and his "I am not."

Negation cannot be transcended, nor do two negations cancel each other out (i.e., they do not overlap). The I is called to acknowledge the distance between the absolute thing rejected by negation and the

judgment of things as good or bad, and to affirm what has been rejected from its domain as what enables this judgment. The split structure whose two sides do not coincide, suggests, as indicated by Lacan, the structure of an imperative that splits the subject between an absolute demand and the practical impossibility of satisfying it. The nature of this split becomes evident in Kant's rejection of the pathological side in the subject as a way of setting the limits of the moral domain. A moral judgment sustains its alienation from the subject's desires and inclinations by negating this pathological side, thus affirming the rejected thing as the prior cause of moral judgment.

The moral act or utterance, just like negation, conceals the disharmonic element in every moral judgment, by distancing the moral act from its cause. The ethics of psychoanalysis is the demand to return to the primordial cause, to acknowledge the ontological impact of this very distance between cause and negation, a distance immanent to morality.

This perception of negation and its logic, as unfolded here, is not unique to psychoanalysis. This delimitation and differentiation of negation from that which brings negation about but cannot itself be negated resonates in Heidegger's differentiation of negation from the nothing. "The nothing itself does not attract; it is essentially repelling. But this repulsion is itself as such a parting gesture toward beings that are submerging as a whole. This wholly repelling gesture ... is the essence of the nothing: nihilation. It is neither an annihilation of beings nor does it spring from a negation."[33] For Heidegger the nothing is prior to the negation of beings, and thus the negation of beings cannot attain the nothing. This is similar to the psychoanalytic distinction between morality and ethics. While morality is the implementation of the judgment of actual beings as good or bad, ethics refers to the acknowledgment of the primordial kernel of enjoyment, which constitutes the real cause of subsequent moral judgments.

The implications drawn from psychoanalytic negation indicate ways by which an ethics of art can be derived from the logic of negation.

1. *Creative art emerges from nothingness.* "The potter ... creates the vase with his hand around this emptiness, creates it, just like the mythical creator, *ex nihilo*, starting with a hole."[34] In his seminar on the ethics of psychoanalysis, Lacan claims that the act of creation arises ex nihilo, from nothingness. The idea of creating from the nothing finds its opposition even within psychoanalysis in a conception such as Melanie Klein's, who places the mother's body as a stand-in at the empty place from which art emerges,[35] similar to the function god fulfils in Descartes's philosophy.

Lacan traces the idea of creation out of nothingness to Heidegger's figure of the vase "as an object made to represent the existence of the emptiness at the center of the real that is called the Thing, this emptiness as represented in the representation presents itself as a *nihil*, as nothing."[36] The fabricated object, like the vase or the work of art, is created to represent the place of the Thing, and this place is a place of emptiness that could not have been without the fabricated object constituting its limits. Thus, the fabricated object is necessary to constitute the place of the Thing as real, even if the fabricated object can only indicate this place without symbolizing it. The Thing is of a different order than ordinary objects and cannot be symbolized because it touches the origin of being and of knowledge, hence a place that is not given to signification. The Thing is born in nothingness, and hence the notion of creation must emerge ex nihilo to indicate the creation of objects around that *nihil*. The fabricated object "is coextensive with the exact situation of the Thing as such."[37]

The fact that art is created from the very place of the Thing, the place of nothingness representing the kernel of the real, situates "the balance of the moral problem"[38] relative to the creative act. At the completion of the creative act ex nihilo, the balance of the moral problem is necessarily positive: for the potter just as for god, who created the world in six days, creation must be good and right. Creation is "always *fine* from the side of the work."[39] It is only later, through questions of benefit, religious consciousness, and human merit, when things are put in the vase or emerge from it, that the act of creation is subjected to morality.[40] At this stage the moral is secondary to the cause of creation, as the moral orders and articulates the world in terms of good or bad. But initially, around the moment of creation, morality, for Lacan, is a way of weighing the pleasure or displeasure instigated by approaching or distancing oneself from the Thing, through forms that constitute the productive void.

If the nothing marks a moment of origin from which creation emerges, art can be said to exhibit a gesture of emptying out; art is created ex nihilo, and it configures with its forms the place of nothingness. Art discovers the place of the real while inventing it. The gesture of emptying out can lead to the certainty of the cogito, and it can also lead to the suffering of the melancholic[41] or to the fabrication of an artistic object. Art is hence ethical because it enacts the logic of negation, and its total disposition to this logic, and to the *nihilo* created through negation, was already present in the Platonic discourse. Approaching art through the analysis of negation suggests that the act of creation moves from the

emptying gesture that refuses the symbolic articulation of a cause to a restoration of the place of the cause with this same creative gesture. For Lacan, the cause restored to the place of origin is called *das Ding*, the ultimate Thing occupying the core of the real. Art, in other words, takes this double route of negation, thus uncovering the distance between the vacuous certainty of the emptying gesture (in creating from nothing) and the psychoanalytic idea of the real that restores being to the place of non-being in the place of a cause.

The potter/artist has his hand around this emptiness, creating it with his vase. Art's modes, shapes, and images can hence be seen as modes of configuring the Thing, which explains why the history of art is laden with insistent calls for attention to the materiality of the image or letter, and to the particular modes in which art fabricates its objects. With the material object of art we come close to the impossible place of the cause of creation. Through the creative fabrication of an object, art reproduces in form the lost cause (Thing) as repressed. Hence art does not regain the place from which it had been evacuated but exhibits the implications of leaving the place empty: the effect of emptying is that an artwork can emerge from this moment of emptiness. Art is not moral but ethical; art discovers the place from which creation is possible, a place prior to the consolidation of moral objects, positions, or values. It is at the place from which creation emerges that one can do fine rather than good.

2. *Creative art emerges as truthful from the place of un-truth.* The act of creation is not obligated to truth, and it does not convey knowledge. In this sense Plato was right; we cannot trust the artist to convey the truth about the essence of anything. Anecdotes throughout history have portrayed artists who were accused of being untruthful, corrupting, and detrimental to the pursuit of truth, attesting to this alleged laxity of art in contrast to other practices' commitment to being truthful.[42] Fictional worlds, realism, fantasy, naturalism, and even the abstract are all pervasive modes of creation attesting to the dubious, playful relations between art and truth. By negating art's commitment to truth, by claiming that art speaks from the place of un-truth, what is affirmed is the place from which un-truth speaks. Thus we suggest that art, in denying the relevance of epistemic knowledge to its position towards truth, creates a path by which truth imposes itself in non-epistemic ways. Art is hence committed, not to the truth associated with representation and cognition of reality in its broadest sense, to which it has been denied access, but rather to the effects of truth that emerge once epistemic truth is negated. That (*ça*) which thinks or speaks when truth cannot be articulated is art. Through

art truth speaks from where it is usually not – from the place where truth is denied.

If art's relation to truth is denied, how can art still speak the truth? The primordial moment in which art emerges, emptied of epistemic knowledge, is a moment that can only be half-said, half-thought, half-spoken. It is a moment that can only be recounted mythically, and thus creative art does not differentiate truth from falsity and is not committed to the dictates of a truth identified with epistemic knowledge. It is the ethical position of art to strive to disclose the truth that cannot be said. Yet from what place can art speak or convey a truth to its readers and spectators?

In his "Art and Philosophy" Badiou claims that the truth of art is singular, that is, a truth that is unique to art and cannot be articulated in any other discourse.[43] Consequently, the only possibility of referring to the truth of art is from the place where art is not (from the place of philosophy or science, of art theory or cultural studies). The truth *about* art is hence external to it, mediated by an Other; it is a truth that can be known from where art is not, the place of the Other and its ideals about art. To make a philosophical statement about the advent of truth in art, claims Badiou, we must first identify artistic procedures, or events, each creating a differential point with regard to artistic truth. Artistic events are not punctual or discrete; they rather constitute a dialectic configuration that sets no determinate limits, creating a shift in the way the truth of art is disclosed. Thus we cannot articulate in a conclusive, exhaustive manner how the "romantic" configuration shifts the eventuality of art, yet we grasp that this configuration differentially (i.e., in relation to other configurations) changes art's disclosure of truth.

Truth is not conveyed by specific works of art but is configured in an event that is subsequently exemplified in these works. Configurations create the truth of art, yet truth can be identified neither with a work nor with an author. An artistic configuration cannot be thought or encapsulated philosophically, since philosophical discourse is immanently detached from it. "The existence of truths [outside philosophy] points to a co-responsibility of art, which produces truths, and philosophy, which, under the condition that there are truths, is duty-bound to make them manifest (a very difficult task indeed)."[44] Badiou suggests that art, through the singularity of its truth associated with indeterminate configurations, creates an imperative or a demand set before philosophy to define art's relation to truth. This binds philosophy to an eternal engagement with the truth of art, a truth that remains unattainable in philosophical terms.

The inability of philosophy to formulate the truth of art, and the inability of art to represent philosophical truth, does not mean that art sustains its own truth domain. Rather, art's position is that of positing through its forms and modes of expression a constant demand of philosophy to disclose the truth of art. Art, a non-being in the domain of philosophy, is reduced to un-truth by its philosophical Other. In relation to philosophy art has no place but the place assigned to it by this Other. It is from this place of non-being in the domain of philosophical truth that art poses a constant challenge before philosophy, of what is truthful in art but cannot be articulated in philosophical terms. It is in this place of what cannot be known that art will come to be (*wo Es war, soll Ich werden*).

3. *Creative art discloses the origin of the law.* Because morality is denied to art, art allegedly appears as uncommitted to the law and its categorical decree. However, the logic of negation can reveal that art is committed to representing the non-rapport between the absolute imperative and human practice. That is, the ethics of the artistic act has to do with the fact that artistic practice is committed to the impossibility of acting according to the law. Art reveals the absoluteness of the moral imperative, although it often strives, like all human practices, to conceal the presence of the law behind specific moral values and concepts, and to perform as if its operations can comply with or contradict the law itself. While human practices strive to appear as regulated by a practical law (distinguishing acting right from acting wrong), the place of the law remains unattainable and indeterminate, as the law cannot be directly articulated or exhibited. Thus, in its strife to arrive at the purpose set by the law, art is both attracted and repelled by the place of the law. Art is immanently committed to transgressing the law, as attested by the critical traditions that describe art as a practice almost addicted to the breaching of conventions. Art discloses in this way the immanent failure of the attempt to occupy the place of the law. Art acts as a being before or beyond the law, and yet it is given to the law and committed to reveal its force. It is through the logic of negation, associated with art's denial of any obligation to moral values, that the impossible relations between the categorical imposition of any imperative and the practice it generates can become evident.

2

By Way of Beauty

But the determinability of the subject ... who can sense within himself ... obstacles in sensibility, but at the same time his superiority to sensibility in overcoming these obstacles, which determinability is moral feeling – is nevertheless akin to the aesthetic power of judgment and its formal conditions.[1]

Looking at Andrea Mantegna's ceiling fresco from the mid-fifteenth century, we see more than what is actually being shown. On the ceiling of one of the rooms in the Ducal Palace in Mantua, Mantegna drew a sample of using perspective "in a fully illusionistic manner to dissolve the plane of a vaulted ceiling" to achieve "the extraordinary effective architectural illusion of an open oculus."[2] And yet, as technically accomplished as Mantegna's work might be (as most clearly manifested in the drastically foreshortened figures drawn through a unique combination of masterful technique and subtle intuition), the overwhelming effect of the picture transcends the illusion. The appeal to heaven, achieved through the skilful use of perspective, seems to elicit not only an image of the celestial but an *idea* beyond the earthly existence of the spectator. This idea is exhibited through the beautiful illusion, without in fact being represented by it. In a way, Mantegna stretches the rules of perspective to their ultimate limit, to where the rule of painting in itself cannot work unless something else interferes, thus allowing its aesthetic effect to take place. Mantegna's extraordinary image exhibits an idea (of moral relevance) rather than suggests it (the ideational domain is not of the order of the ineffable in this picture). The beautiful illusion, achieved through the ultimately skilful employment of technique, brings in another object that cannot actually be shown yet is presented to us by

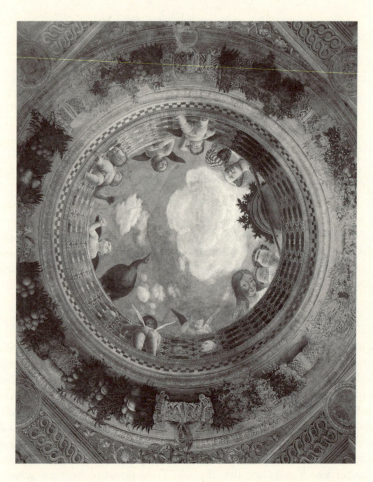

1 Andrea Mantegna (1431–1506), the oculus with cherubs and girls, detail
from the vault, 1465–74. Fresco, San Giorgio Castle, Wedding Chamber
or Camera Picta, Mantua. © getty images

way of beauty. Beauty, or the aesthetic mode of creation, is the domain where ideas are exhibited rather than suggested.

This chapter aims to investigate what qualifies the aesthetic for this exhibition of morality, what makes the beautiful image apt for representing moral ideas, regardless of the specific moral values to which an artwork can optionally commit itself. Mantegna's success in producing a moral idea through a beautiful image may bring us closer to understanding how a meticulous application of the technique of perspective is inseparable from the way the artwork exhibits an idea or Thing. The idea enters the domain of art by way of beauty, touching that which lies beyond the materialization of an illusion and is nonetheless conditioned and exhibited by it.

Beauty comes close to morality because beauty exhibits the essential place of morality in relation to human practices, rather than functioning as a vehicle for conveying moral ideas. This recapitulates Immanuel Kant's argument that beauty can raise a moral interest, and in what follows this argument and its possible implications for the relation between the abstract place of morality and the sensible object will be analysed.

Kant rarely uses the term *'moral ideas'* in his third critique, although their presence is marked in numerous ways. As will be argued shortly, for Kant moral ideas are not ideas committed to specific moral values but ideas of reason that orient the aesthetic creation and appreciation.

In the second critique, Kant refers to moral ideas as a postulate regulating moral behaviour. As such, even if moral ideas might be seen as a subclass of ideas of reason (which are "notions" that transcend the possibility of experience), they refer differently to a law of reason (i.e., the law posited as the cause for action).[3] For nothing can convey an idea of reason in experience, whereas moral ideas, "as archetypes of practical perfection, serve as [the] indispensable guideline of moral conduct."[4] A moral idea is associated with the experiential domain of action; the moral idea of freedom, for instance, even if it has no reality outside the guidance of the moral law, uses nature to posit its "experiential consequences."[5]

If moral ideas mediate between the moral law and moral practice (even if they are concepts of reason), the aesthetic context makes yet a further demand on the possible relation of artistic action with a moral idea. If in non-aesthetic contexts moral ideas such as "holiness," "freedom," and "divinity" have binding experiential consequences, in relation to aesthetic considerations the experiential consequences should not be binding. Moral ideas should in some way regulate representations (*Vorstellungen*) yet without being transformed into binding modes

of implementation. Thus, we would not wish to infer from Mantegna's achievement that for an image to represent the idea of divine infinity, a strict use should be made of extreme perspectival foreshortening. The oculus is a way of exhibiting[6] an idea but does not thereby turn into an obligatory image of the idea; it is a mode of experiencing an idea and yet does not suggest that the artistic image is generated by the moral idea. An indeterminate link between artistic practice and moral ideas is a necessary part of any explanation of the relation between art and morality.

The question of how *an idea can relate to a sensible work of art* is probably the central question posed throughout the history of aesthetics, from Kant through Arthur Schopenhauer and Georg Wilhelm Friedrich Hegel to Jean-Luc Nancy, taking on diverse formulations. Schopenhauer addressed this in his investigation of art as the question regarding the representation of the Platonic Idea, the thing-in-itself independent of mental representation. Schopenhauer claimed that art, as the work of genius, repeats through its specific materials (colour in painting, stone in sculptures, words in poetry, and sounds in music) the eternal Ideas that are essential to the world. Ideas constitute the true content of the world's phenomena, and they reveal the world as pure will, subject to no change, and therefore known with equal truth at all times. Art is the true and pure knowledge of "the *Ideas* that are the immediate and adequate objectivity of the thing-in-itself."[7] How is knowledge of the Idea communicated by the work of art? Schopenhauer believes it has to do with the fact that art, in order to reveal Ideas, introduces forms that objectify the will. Architecture, the lowest grade of the will's objectivity, does not allow us to apprehend the Idea but only its subjective correlative. Poetry, which takes on a higher form of the will's objectivity, already gives us the *true in the universal*,[8] as it does not reduce the unity of the Idea to the plurality of particular forms in space and time. Music, the ultimate form of art, is a direct representation of the will's objectivity, the will being that which "knows no necessity; in other words, is *free*."[9]

In what sense can art be said to objectify or exhibit an idea? In contemporary philosophy of art we will find a version of this question in the idea of the "limit" or "threshold" (Jacques Derrida, Jean-Luc Nancy, Jean-Luc Marion) of the visible; it is at the limit of the painted world that one can encounter what cannot be visualized or made visible. The limit of the visible functions as the idea that can settle the distance between the sensible image and what exceeds the limits of sensibility.[10]

In the context of contemporary philosophy of art one should also note that the immediate, direct interest in the ideational domain created in one's encounter with art does not pertain solely to the beautiful forms

produced by the art of the past that was officially committed to depicting the supersensible (*übersinnlich*), divine, or spiritual domain. The same structure that views the image as exhibiting the moral *Thing* should be equally applicable to modernist or postmodernist artworks, even if these appear to counter any involvement with the moral register.[11] This can be illustrated by the work titled *Erased de Kooning* by Robert Rauschenberg (1953), an image in which the viewer sees almost nothing. Rauschenberg, an American artist who was fascinated by the art of Willem de Kooning,[12] asked the artist to give him one of his drawings to be erased, as an act of art. The result is an erased drawing showing the blurred, indeterminate traces of a former drawing. And yet the image is a performance of an act of erasure through which a moral *Thing* or idea about the constitution and values of art is exhibited. It is the result of the material erasure of one artist's traces of ink charcoal and crayon (significantly, de Kooning did not choose an erasable pencil drawing but a dense multimedia image that turned out to be very difficult to erase), undertaken by another artist, which renders the idea of art present. The idea is made present, exhibited yet unexhibitable in sensible form notwithstanding: erasing de Kooning is a work of art, yet we cannot define what in this erased image constitutes the exhibition. Moreover, erasing de Kooning clearly touches the question of ethics in art, yet the ethical impact of the work remains indeterminable, as there is little sense in trying to express the meaning of this performative act.[13] In other words, the significance of *Erased de Kooning* does not lie in what we see or in any attempt to articulate the meaning of the act of erasure. De Kooning's art and Rauschenberg's mediation of this art by erasing it exhibit a *Thing* about art that transcends both the sensible image and the articulation of its significance.

This chapter examines the leap, which turns out not to be a leap at all, between the beautiful image and the moral idea in Kant. Throughout his third critique, Kant maintains a critical presence of the supersensible (that which cannot be demonstrated in sensible form) in the domain of beauty, attesting to the necessary transition between the realm of nature and the realm of freedom enacted in the domain of taste. Kantian beauty leads us from nature's rules and regularities to where the beholder is free from all necessity. Beauty enables man and woman to feel a freedom from necessity even if such a freedom is never actually enacted in human experience. Kant thus marks a vein of research within the aesthetic domain that, as mentioned above, would be formulated by Schopenhauer in similar terms. Art represents the ultimate place of freedom, where the subject of knowledge becomes disengaged from individual phenomena and from the dictates of (sufficient) reason that

aim to master these phenomena. Art, in other words, takes us to where pure contemplation, which is not accessible to knowledge, is present, as closest to what man really is, to the place where one is absolutely free. But what is this freedom that is experienced in relation to beauty and transforms the latter into a moral notion?

Freedom of the will is inscrutable and impenetrable, claims Schopenhauer, which entails that man, as a phenomenon of the will, is never free, even if he is the phenomenon of a free will.[14] Aspiring to the place of freedom is aspiring to where the full weight of the moral law can be experienced, where one is free to act morally and not according to inclination or desire. Freedom is where one is not part of the phenomenal world, where one is not subject to maxims, regulations, or definite moral principles of action (the latter indicating where freedom has already turned into necessity). It is hence the freedom experienced in the aesthetic state that signals our standing at the gate of the law.

The freedom associated with the absolute necessity of the universal law will be discussed in the final chapter of this book, which addresses the moral law and its (impossible) transgression. At present, we shall concentrate on the question of how freedom attests to the presence of morality in the domain of beauty. The idea that freedom is attainable in the context of aesthetics poses an intricate challenge as the leap thereby suggested is neither obvious nor natural. Numerous impediments stand in the way of articulating the Kantian exhibition of morality through beauty because, for Kant, setting the bounds of the aesthetic is a primary concern. In line with the Kantian interest, tying the beautiful to the moral appears to be inadequate to the aesthetic pursuit because thinking of beauty in terms of morality would occlude whatever is distinctive about aesthetic experience and judgment.[15] That in beauty which is more than beauty and is prior to the judging of the beautiful per se reveals the place of morality in art. How can finding this place not be counterproductive to the main purpose of the aesthetic pursuit? As the following pages will unfold, Kant indeed consistently makes room for what supersedes the sensibility of the beautiful image, thus delineating the coordinates of a morality *distinctive* of the aesthetic domain.

By tracing Kant's insistence that moral interest does not compromise the distinctness of the aesthetic, the present pursuit of morality within Kantian aesthetics indirectly also offers a way of reconsidering some Heideggerian and post-Heideggerian diagnoses of aesthetics. Jacques Rancière, for instance, diagnoses the aesthetic regime, as it emerges from Kant, Friedrich Schiller, and Friedrich Wilhelm Schelling, as promoting a type of knowledge foreign to itself so that "the aesthetic state is a

pure instance of suspension, a moment when form is experienced for itself."[16] This diagnosis of the aesthetic stresses that the aesthetic regime has implanted itself as a mode of thought about art by implying that the singularity of art within the aesthetic regime depends on defying any way of knowing this singularity. The aesthetic regime withholds any claim to truth by relying on the self-referentiality of its forms. The present reading of Kant would suggest, however, a dimension of knowing the singularity of art within the aesthetic regime through the relation of *non-rapport* established by Kant between the aesthetic image and the moral idea. The aesthetic position, as analyzed by Kant, indicates that while the aesthetic suspends cognition-through-concepts and particular moral interests, it touches the origin of morality and the cause of knowledge.

It is not only in light of the overall aesthetic project that the claim for the morality of aesthetic beauty appears problematic. Two other, more specific elements, immanent to Kant's own aesthetic theory, appear to contradict this association of beauty with morality. One relates to the fact that being engaged with the moral law requires interest, whereas beauty is a priori conditioned by the absence of interest in the observer. The second constraint relates to Kant's disqualifying of *art* from arousing a moral interest: "the *beautiful in art* ... provides no proof whatever that [someone's] way of thinking is attached to the morally good or even inclined toward it."[17] To demonstrate that our experience with art involves a moral interest, it will be necessary to reconsider the terms of this involvement of morality in beauty. The overall move will reveal that in the context of aesthetic judgment, the negation of interest (in the existence of the object of judgment) affirms the presence of a disinterest that involves freedom rather than indifference.

Kant argues for the aesthetic subject's freedom from the kind of commitments that also regularly divert him/her from moral considerations. The aesthetic subject faces through his/her experience of beauty the moral kernel in his/her very being, unmitigated and unmediated by experience, knowledge (concepts of understanding), or specific moral values. Aesthetic disinterest (presented by Kant as disengagement from inclination and from the desire to obtain the object) touches on this dimension of freedom in a specifically aesthetic mode, tantamount to moral attunement. From these introductory remarks to the problem of beauty and morality that occupies the present chapter, it is already apparent that the concept of interest is central to its solution. Jean-Francois Lyotard, in his reading of Kant, makes a claim that can provide a clue to the analysis that follows. Lyotard shows that the interest of practical reason does not contradict the disinterest of the aesthetic judgment. This

is so because practical reason's interests are not invested in an object but only in the practical prescription *to act* (to actualize the law). "The interest of the practical rational faculty is such that it must actualize itself without arousing any empirical interest in this faculty."[18] In this paradoxical sense (i.e., an interest without interest) practical interest is prior to any action (whether one that practises interest or disinterest) and conditions it. As part of this reconsideration of moral interest, art, which may appear to be the domain most remote from the experience of freedom,[19] will turn out to offer a privileged moment in relation to this aesthetic-moral state.

To ground this argument for beauty's engagement with morality, this chapter first outlines what might appear to be a self-evident disparity between beauty and morality in the third critique. This introductory part establishes the terms of the initial distance between the beautiful and the good in Kant's theory of beauty, prior to any attempt to negotiate between them. In establishing a prior and necessary disparity between beauty and morality, we establish a ground that will later be regained as particularly aesthetic. This notion of regaining the ground between beauty and morality reverberates in later aesthetic theories. Schiller, for instance, argues for the precedence of beauty over freedom,[20] yet beauty and morality can be reconciled or come across one another only subsequent to an initial disharmony; they never emerge from a primary harmony or coalescence. It will be argued in this chapter that the radical difference between the beautiful and the good is never superseded by Kant even if the moral idea turns out to be immanent to aesthetic judgment.

Once the distance between beauty and morality is established, Kant's shift to the idea that when someone is directly interested in beauty (the beauty of nature) "we have cause to suppose that he has at least a predisposition to a good moral attitude"[21] will be outlined. Three steps will be taken in the remaining parts of this chapter, in order to grasp Kant's reconciliation of natural or artistic beauty with morality.

1 The experience of beauty will be shown to be regulated by a supersensible dimension and to be characterized by an attunement favourable to moral feelings.
2 While ideas of reason cannot be intuited through a sensible object, Kant refers to aesthetic ideas that intervene between reason and beautiful forms.

3 The intervention of morality in the domain of beauty is immanent to the a priori conditions for experiencing beauty. Beauty is moral not only because it requires a superseding of the sensible object but because in the case of beauty superseding the sensible demands an abandonment both of given concepts of understanding (i.e., those that regularly lead to the object's cognition and meaningfulness) and of moral determination (the attachment of the object of taste to specific moral values).

a. The Immanent Distance between Beauty and Morality

In the first moment of the analytic of the beautiful, Kant asserts that "*taste* is the ability to judge an object ... by means of a liking or disliking *devoid of all interest*."[22] This a priori condition later gives way to what seems to be its opposite: "the mind cannot meditate about the beauty of *nature* without at the same time finding its interest aroused."[23] While the initial diagnosis of the aesthetic judgment as disinterested positions it at the negative pole with respect to a moral judgment, which must give rise to interest, Kant later bridges this distance when a necessary connection between the aesthetic and the moral is established. In this section I examine the negative notion of *disinterest*. I question what in fact it negates, in order to have a better grasp of the relations between the aesthetic and moral interest.

Kant's notion of interest is derived from his moral theory. Interest refers to a mental state that represents, through reason, an object or state of affairs as attainable. Interest is hence connected with pleasure in the existence of a willed object or state of affairs, willed in order to attain some desired end.[24] Our moral interest is oriented by the desire to realize our moral ideas, which is why interest, in the domain of practical reason, drives the agent to act.

While interests are immanent to the moral state, disinterest is actualized in the judgment of the beautiful. Disinterest assumes that the existence of the object judged beautiful is not involved in the act of judgment; aesthetic judgment posits a liking that is contemplative and distanced from the object of experience. Disinterest hence negates both the relevance of the object's mode of being (which moral interest must represent as existent)[25] and the subject's drive to act with regard to the object (a drive that the moral interest brings about because the object is considered the right incentive for action).

Kant's approach to beauty through negativity is manifested in the notion of disinterestedness, which primarily applies to the involvement of beauty with material existence. However, disinterest goes further: while delight in the morally good object or action presupposes a concept (given in the moral conception or in the practical law), aesthetic judgment is uncommitted to epistemic truth. Aesthetic judgment gains its distinctness vis-à-vis moral judgment not only by a lack of interest in objects' existence (as the aesthetic posits no desire and hence requires but a distant underpinning in the reality of objects) but also by the absence of epistemic aspiration to attain knowledge of the object.

The denial of definite conceptuality is again assessed against moral judgments, regarded by Kant as dependent on conceptuality. A moral judgment "makes us feel a liking ... as proper for mankind generally," and this liking is attained "from concepts." The peculiar absence of conceptual knowledge characteristic of objects of our aesthetic judgment again denies art (and beautiful nature) any moral standing. Since beauty does not convey knowledge about its presentations, an object judged beautiful cannot turn into an object of cognition, even if it does awaken our cognitive faculties in a particular manner. Beauty, claims Kant, is a presentation to the imagination that animates the mind, prompting much thought "but to which no determinate thought whatsoever, i.e., no [determinate] concept, can be adequate."[26]

The disinterest predicating the aesthetic state thus might seem to imply a permanent dissociation of judgments of beauty from morality. Many have indeed claimed that Kant's notion of *disinterestedness* rendered aesthetics detached from moral concerns. Kant has been said to have perpetuated a conception of art as being aloof or detached from questions of morality. The idea that judging something as beautiful indicates indifference or lack of care for the thing's existence also nourishes the view of aesthetic experience as irrelevant to the quest for truth (there is no point in assessing the truth of an aesthetic judgment if no interest in the existence of the beautiful object is assumed). In the spirit of Kant, claims Karsten Harries, we have been instructed to believe that "aesthetic experience leaves the world alone ... [It] asks nothing of reality and lets it be."[27] Furthermore, according to Harries, modernism, reflecting the long-standing effects of Kant's formalism, has come to accentuate visibility and form at the expense of love and desire towards the object of art. Art, in its disinterested detachment, is taken to be indifferent to whatever human life involves, hence defying any ethical commitment to the world's being. For Harries disinterestedness implies aesthetic

indifference, which he proposes to replace with an alternative conception of art that stresses the involvement of the beholder.[28]

This line of interpreting the consequences of disinterestedness may represent a possible derivation from Kantianism, and yet in the following sections disinterestedness will turn out to have another role for Kant, functioning as the universal condition for raising a moral feeling and for reflecting the subject's *involvement* in judgment, rather than the forestalment of the subject's desire.

Harries's position corresponds in some respects with Martin Heidegger, for whom the question regarding the origin of the work of art is opposed to the aesthetic interest in art, which he sees as excluding the problem of truth from considerations about art. Heidegger has indeed formulated his indictment of aesthetics in such terms: "until now art presumably has had to do with the beautiful and beauty, and not with truth."[29] The aesthetic interest in beauty (and the disinterest it elicits in other things) imposes a conception of art as irrelevant to questions of truth, a situation that demands to be remedied, according to Heidegger. At the end of his treatise that diverts from everything previously associated with aesthetics (beauty, pleasure etc.) Heidegger claims to have restituted the place of art as a place where "the truth of being is setting itself to work," where "the beautiful belongs to the advent of truth, truth's taking of its place."[30] Art, in other words, is where truth is disclosed.

Heidegger, while negating the possibility of disclosing the relation of art to truth through aesthetics, affirms such a disclosure through the opening of a world in the *work* of art. Although Heidegger does not address the question of art's ethical position, it is clear that he disparages the aesthetic occupation with art through beauty (rather than by way of truth). It is by restituting art's relation to truth that it will regain its importance. The truth with regard to which the place of art should be restituted is not an epistemic or transcendent truth; it is not a truth that can be articulated in assertoric terms (i.e., by asserting that something is the case). The truth to which art is committed is a *truth equivalent to its mode of revelation*, and hence a truth that can be articulated neither with concepts nor with absolute ideas: "the unconcealedness of beings – this is never a merely existent state, but a happening."[31] Art is a particular mode of disclosure of the truth of Being (as connected to work and to instruments), and it is by committing itself to this mode of disclosure that a philosophy of art becomes feasible and of value. So the singularity of art, its distinct achievement, has to do with the mode of truth disclosure that art enacts rather than with what art conveys.

The Heideggerian notion of non-epistemic truth with regard to which art's place should be recovered can be related to Kantian disinterest. Disinterest disengages beauty from truth in its metaphysical sense and from any epistemic value, as disinterest annuls the subject's interest in the conceptualization of the object in order either to determine the object's existence or to fix its meaning.[32]

In Guyer's summary of Kant, we see that interest indeed represents epistemic value: it demands knowledge of the desired object (or state of affairs) whose existence is at stake: "the reason for action toward the realization of an object is always a pleasure promised or predicted by the classification of the object under a determinate concept, as a consequence of its existence."[33] The conceptual support, that is, the definite knowledge of the desired state of affairs, is hence the other side of interest, as described in Allison's commentary on Kant: "the role of reason common to all interests involves the conceptual representation of a possible state of affairs to be actualized through volition."[34] Conversely, in denying interest, the aesthetic judgment of beauty not only denies the object's existence as an object to be consumed or enjoyed but also our ability to articulate in what way the object can ascertain the attainment of an end. While interest is restricted to objects of determinate concepts, disinterest is what attaches us to objects of indeterminate concepts.[35] In this sense, disinterest in the object implies a contemplative attitude, indifferent to the object's existence as much as it is disconnected from conceptual knowledge of the object.

On this score there is a partial compatibility between aesthetic experience and the moral demand. In aesthetic judgment we comply with the moral demand not to be engaged with an empirical object of our direct inclination. However, aesthetic judgment remains outside of the usual coordinates of the moral domain in that there is no conceptually determinate object that is adequate to our judgment. Aesthetic judgment lacks the conceptual support provided in regular moral assessments.

Disinterest in the object's existence, which entails more than actual distance from the object's material presence, has given rise to various considerations of the meaning of disinterest. The questions that loom behind these discussions concern what is being denied when interest in the aesthetic object is negated, and why by negating interest the particularly aesthetic is affirmed. Paul Guyer has examined the various meanings of interest in the object's existence in order to explicate how the peculiar status of the aesthetic object is determined. An interest can be directed to the object's material existence, to the concept with which the

object complies, or it can be directed to the regularity or law to which the object conforms. This multiplicity of ways for understanding interest entails that what is negated in disinterest is left unclear. Guyer does not see any of these layers as irrevocably determinant of the object's aesthetic status, as he views the determinant aspect in the manner in which the beautiful object is *experienced*. According to Guyer, while Kantian disinterest implies both lack of concepts and indifference to the object's material existence, these carry only a restricted sense for Kant and cannot be incorrigibly determined a priori (but only through hypothesis and conjecture in the actual experiencing of objects). I mention Guyer's reading because he also stresses that the implications of disinterest lie in what it affirms no less than in what it denies to aesthetic judgments.

To resume Kant's case for the presence of a moral interest at the place where knowledge of the object and a sensuous investment in its presence are lacking, a considerable effort to reconcile the allegedly contradictory demands of the moral and the aesthetic is required. The notion of disinterestedness is indeed a key to arguing with Kant, and with contemporary Kantian commentators, that the moral is a necessary dimension of aesthetic judgments.

b. Disinterestedness in the Beautiful Object and the Emergence of a Moral Interest

"That a judgment of taste by which we declare something to be beautiful must not have an interest *as its determining basis* has been established sufficiently ... But it does not follow from this that, after the judgment has been made as a pure aesthetic one, an interest cannot be connected with it."[36] This structure that has no interest at its basis but gives rise to an interest is shared by both aesthetic and moral judgments.[37] The interest necessarily raised in moral agents has to do with morality's purely practical essence; that is, a moral interest directs us into giving a moral answer to the question "what ought I to do?" The moral interest that arises from aesthetic judgments denotes a different dimension of our moral orientation in the world. Aesthetic judgment turns out to endorse the subject of judgment's moral ideas since a judgment of taste, as conceived by Kant is based on an idea of purposiveness in nature, an idea that regulates reflective judgments in general.[38] The appreciation of beauty thus raises a moral interest, although this interest does not lead the subject to search for a course of action in the moral sense. Rather, moral interest in the context of beauty points at the ability to find in the appearances of

nature acknowledgement of the determinant presence of supersensible ideas in our aesthetic experiences. But in what sense is the regulative principle that assigns purposiveness, albeit indeterminable, to nature a moral principle?

The feeling of pleasure or displeasure indicates the subject's involvement in a judgment of beauty but also the subject's moral involvement in the aesthetic object. The pleasure felt in the aesthetic domain not only attests to a harmony attained between cognitive faculties; pleasure also pertains to a harmony attained between a sensuous presentation and a principle of reason. In other words, there is a working of the intellectual faculty in ways specific to the aesthetic context. Such an aesthetic transformation of the moral ascertains a necessary link between them that yet hinders their simple collapse into one another in a judgment of beauty.

So in analysing the involvement of beauty with moral interest, it will be shown that moral interest is not mitigated or compromised but is a direct outcome of the negation of interest in the appreciation of beauty. In interpreting disinterestedness as the negation of interest both in the object's existence and in its being an object of epistemic knowledge, a different understanding of the notion of moral interest suggests itself. The previously denied interest is now affirmed as a moral-aesthetic one, which does not contradict the standard moral interest or the disinterestedness of a judgment of taste.

How can the apparently paradoxical tying of the moral and the aesthetic be solved? If moral interest cannot be simply directed to the sensible object of beauty, then what promotes the mind's receptivity to moral feeling in the aesthetic judgment is an interest emerging from the higher power of desire, desire for what cannot be identified with the sensible object per se. To identify that which the moral interest in the aesthetic subject is directed to, Kant first suggests that aesthetic disinterest does not contradict a possible interest it can give rise to. He claims that there is something additional to the direct object of appreciation and that "this something else may be something empirical ... or something intellectual ... Both of these involve liking for the existence of an object and hence can lay the foundation for an interest in something that we have already come to like on its own account and without regard to any interest whatsoever."[39] Hence the interest raised does not contradict the initial disinterest as it concerns "the will's property of being determinable a priori by reason."[40] Guyer suggests that we should not take this indirect interest raised through aesthetic judgment as merely indirect pleasure in the existence of the object (that would already take

us away from aesthetic considerations) but "that the way in which such an interest will work is by means of a basis for interest in the possession of taste."[41] So while aesthetic judgment is disinterested, enacting it gives rise to pleasure in possessing this faculty of taste. In other words, while for Kant the negative gesture enacted through the notion of disinterest in the object's existence is necessary, an interest of some kind is also necessary to affirm the ex-istence[42] of another object whose existence cannot be directly presented to intuition and is yet constitutive of aesthetic disinterest. This "something else" in Kant that raises indirect interest is a supersensible object that conditions aesthetic practice in the first place.

The poet, claims Kant, gives sensible expression to things such as death, envy, and so on in a way that goes beyond the limits of experience.[43] In section 59 he concludes that beauty works as a symbol in the sense that it brings about a "transfer of our reflection on an object of intuition to an entirely different concept, to which perhaps no intuition can ever directly correspond."[44] That is, if intuition for Kant refers to the a priori forms through which things are immediately apprehended as singular, beauty bridges the gap between the object intuited and the purely intelligible thing that is not given to intuition. In its "mediating" function, beauty makes sensible forms in nature appear as morally purposive, thus causing ideas of reason (which constitute the realm where morality is enacted) to appear to us as a little less indeterminable, less unexhibitable to intuition.

The relation of beauty to morality is hence deeper than mere analogy as suggested by the fact that interest and disinterest are not mutually exclusive. *Disinterest turns out to function as a mode of disclosure for moral interest.* While beauty resists both the power of desire, which would appraise the object's existence as a source of sensuous pleasure, and the relevance of conceptual knowledge to unifying the object of judgment, it affirms a prior idea that makes appreciation of beauty possible. Following Kant's argument, a disinterest in the object's existence does not exclude all possible interest but is rather the complementary side of an immediate interest in the object, unimpeded by external considerations and interests. Disinterest is part of the self-imposed struggle of the will against temptations, therefore stipulating and giving room to the assessment of morality by way of a judgment of beauty.[45] For Kant, aesthetic disinterest converges with moral interest, a convergence attested to by pleasure itself, which turns out, in the aesthetic domain, to be a genuine moral feeling emerging from a fundamental moral standing on the part of the aesthetic subject. In the next section we will see why, despite this

picture of convergence, aesthetic appreciation is not taken by Kant as instrumental for moral action.

c. Aesthetic Attunement to Moral Feelings

In the "General Comment on the Exposition of Aesthetic Reflective Judgments,"[46] Kant introduces moral interest into aesthetic considerations. There he claims that while moral judgments are determining ones (dependent on the idea of reason of the good), their determinateness requires the subject to sense "obstacles in sensibility, but at the same time his superiority to sensibility in overcoming these obstacles."[47] For Kant, moral feeling refers to the subject's determinability regarding a moral concept accompanied by a sense of incompatibility between the concept and its legislation in experience. Kant finds this uneasy relation of ideas of reason to sensibility akin "to the aesthetic power of judgment and its formal conditions inasmuch as it allows us to present the lawfulness of an act done from duty as aesthetic also, i.e., as sublime or for that matter beautiful, without any loss in the feeling's purity."[48] How does Kant understand the presence of lawfulness within aesthetic judgment?

Rodolphe Gasché claims that the analogy between aesthetic judgment and the moral feeling is precarious and cannot suffice to ground the moral within the aesthetic judgment. The analogy indicates only that a moral feeling has an indirect, oblique aesthetic function. The moral feeling can become aesthetically relevant because of another dimension of the analogy holding between the formal structure of a moral interest and the formal structure of the aesthetic judgment of the beautiful and of the sublime – as both are associated with overcoming the hindrances of sensibility.[49] This aspect of the analogy resides in the form of the moral act on the one hand and in that of the object of aesthetic judgment on the other hand (rather than in any abiding content or idea). The moral feeling pertains to beauty, as beauty disengages the play of reason from determinate experiential content and concrete moral themes. Beauty in this sense discloses something essential about the presence of the moral disposition in man and woman.

This interpretation given by Gasché leans on his idea of form, central to his commentary on Kant. Gasché stresses that when examining how the imagination operates in conjunction with reason in the judgment of the sublime, it becomes clear that the sublime feeling is not actually moral but *only acquires a formal resemblance to moral judgment*. The

imagination and its power in the judgment of the sublime demonstrate the mind's ability to discover totality in the absolutely formless, which is similar to creating in the subject receptiveness for moral ideas. Since in judging the sublime the sensible faculty of the imagination fails to attain unity in the object of judgment, the sublime needs reason (the cognitive faculty independent of everything sensible) for its appreciation. While moral feeling resides in the domain of the sublime because the totality of form cannot be supported by sensibility, moral feeling resides in the domain of the beautiful because disinterest maximally reduces the sensible dimension in the presentation. In the beautiful, "the sensible is 'reduced' to the mere form that is beneficial for the powers of cognition ... the sensible is stripped here of all appeal to the senses."[50] Gasché argues that the sublime's resistance to sensibility and beauty's stripping of sensibility open a space in both for a relation to moral feeling. Thus, for Gasché, only an entirely disinterested judgment of taste allows the post hoc addition of moral interest that does not compromise the purity of the aesthetic judgment. Hence "disinterestedness on the level of the sense – a possibility realized solely in the case of entirely pure judgments of taste – is the provision under which alone a relation between the beautiful and ethics is conceivable."[51]

Gasché demonstrates not only that an aesthetic inclination supplements every moral disengaging from the sensible but that the moral feeling resides at the heart of aesthetic judgment and is not merely analogous to aesthetic disinterest. This goes well with Kant's further demand on the moral interest in the beautiful that it cannot be an indirect add-on to aesthetic disinterest but that moral ideas should have an immediate presence in the beautiful form. Had the relation between the judgment of the beautiful and morality not gone beyond formal analogy, Kant would not have insisted that the possibility of an immediate interest in beauty is limited to the natural rather than the artistic domain. This limitation indicates the presence of a more intimate link of the moral to natural beauty, and this difference between natural and artistic beauty cannot be substantiated by a formal analogy alone. The knowledge that beauty was produced by nature is a condition for binding moral interest with the judgment of taste. The priority of nature's forms in this context stems from nature's ability to produce a disinterested pleasure through forms that imply the pliability of nature to reason.[52] Nature's beautiful forms present themselves to us as expressions of nature's suitability to reason, as ways in which nature's forms exist as a proof and realization of reason's ideas and exigencies.

For Kant, then, only the beauty of nature can transcend the formal analogy between the aesthetic disposition and the moral feeling. Natural beauty is produced free of interest, which settles its suitability for eliciting a direct interest in ideas of reason.

Kant maintains that natural beauty manifests a lawful harmony, which the morally trained mind associates with a moral attitude. Kant locates the arousal of moral interest in the fact that the beauty of nature arouses in us "an interest that nature should at least show a trace or give a hint that it contains some basis or other for us to assume in its products a lawful harmony with that liking of ours which is independent of all interest."[53] The beauty of nature (or of art that deceives us into believing it is nature) raises a moral interest when its forms exhibit a purposeful movement reflective of nature's purposiveness. Purposiveness is revealed as the hidden kernel that nourishes the interest we have in beauty because it touches on, albeit indeterminably, *the idea of the cause of beauty.* Reflective judgment of natural beauty hence enables us to think about nature as morally purposive, thus establishing one dimension of the bridge between Kantian aesthetics and ethics.

The kinship found by Kant between aesthetic judgments and moral feeling has to do with the *unspecificity* of the cause of interest in the harmony (or purposiveness) manifested by nature (unspecificity is hence what distinguishes aesthetic from teleological judgments). Not knowing what causes beauty, and for what purpose, enables us to directly sense the finality exhibited in beauty's sensible appearance. The beauty of nature gives rise to an idea of reason because we, entertaining a moral feeling or a moral disposition, can link the indeterminate purpose of the object before our eyes with the lawful order we believe nature sustains.[54] The indeterminable idea, to which beauty attests, reinforces our sense that nature is on our side and that "our moral efforts will not be in vain."[55]

If moral interest pertained to the realm of beauty only in the sense of revealing that nature is purposive, the rejection of art as a deceptive attempt to look like nature would have sufficed in establishing art as immoral. And yet morality resides also with the beauty of art, and to establish the role of artistic beauty in furthering moral feelings, Kant suggests a more singular sense in which beauty, whether natural or artistic, symbolizes morality.

In the following passage Kant suggests that it is not the difference between art and nature that is at issue:

For either art imitates nature to the point of deception, in which case it achieves its effect by being regarded as natural beauty. Or it is an art in

which we can see that it intentionally aimed at our liking; but in that case, though our liking for the product would arise directly through taste, it would arouse only an indirect interest in the underlying cause ... This is also the case if an object of nature interests us by its beauty only insofar as we link it to an accompanying moral idea. However, it is not this link that interests us directly, but rather the beauty's own characteristic of qualifying for such a link, which therefore belongs to it intrinsically.[56]

This is an illuminating passage that asserts that art aimed solely at our taste will raise no moral interest, yet to the same extent natural beauty, bound to a moral idea, will raise a moral interest dissociated from beauty itself. In other words, only art that aims to look like nature, or nature whose beauty immediately suggests a link with an indeterminate moral idea, meets the requirements of the association between beauty and morality. Art, equally to nature, is committed to the interests of morality through its immanent structure, by pointing directly at the way reason is directed at our sensible experience yet misfires.

Henry Allison proposes a solution to the way artistic beauty can be assigned a privileged place from a moral point of view. He grounds his solution on the notion of *aesthetic ideas*, a notion that gains significant explanatory value in the context of Kant's references to art. Aesthetic ideas are sensible intuitions that strive towards what lies beyond the bounds of experience; aesthetic ideas are the closest one can get to exhibiting rational concepts as they have transcendent pretensions, a feature they share with ideas of reason. Transcendent pretensions are the result of the attempt to depict something explicitly supersensible, such as the poetic depiction of heaven or eternity, or the attempt to emulate ideas of reason. The latter case is demonstrated in the striving for completeness or the maximum in the representation of something sensible, as in Kant's ideal of beauty or in the sublime.[57] Allison shows how aesthetic ideas enable beauty to mediate between nature and freedom in the domain of art. Aesthetic ideas expand ideas of reason by symbolizing what is absolutely indeterminable with regard to an idea of reason. Through an artistic image, aesthetic ideas *exhibit* what belongs to the sphere of morality, as these ideas are primarily presentations of the imagination. And yet the aesthetic idea, similarly to an idea of reason, is not entirely identified with the image, and its ideational value surpasses the sensible form.

Allison presents a convincing argument for accommodating Kant's section 59, in which beauty is claimed to be a symbol of morality beyond mere analogy. Allison's discussion provides a key to understanding why

the deceptive appearance of art does not entail negative moral conse-
quences for the subject. Aesthetic ideas are exhibited in an image and
are nonetheless on the verge of indemonstrability; they are rationalized
and yet almost unexpoundable as they cannot be analysed in conceptual
terms. The fact that aesthetic ideas span the gap between the sensible
and the supersensible (while keeping both ends distinct) is what enables
artistic beauty to function as a symbol of morality despite Kant's initial
stipulation that only natural beauty is apt for the moral task. The aes-
thetic idea, reduced to a sensible object/image, can exhibit an idea of
reason only indeterminately, while resisting any possibility of identifying
the sensible with the ideational as such. Yet the relation established by
the aesthetic idea between the supersensible, to which the aesthetic idea
aspires, and the sensible image, in which the supersensible is indetermi-
nately exhibited, is a relation that "can be beheld only in the sphere of
morality."[58] Art can thus be shown to be committed to the domain of the
moral.

d. Art – between Deception and Morality

Aesthetic ideas settle the problem of making artistic images relevant to
the moral sphere by mediating the sensible object with the unexhib-
itable idea of reason. Yet the question of whether art qualifies for the
moral task only when it successfully deceives is disconcerting, as we can-
not overlook Kant's insistence that "in order for us to be able to take
a direct *interest* in the beautiful as such, it must be nature, or we must
consider it so."[59] In the context of his discussion of the moral interest in
beauty, Kant chooses to restrict the possible relation of artistic beauty to
morality with the following examples: "Suppose we had secretly played a
trick on this lover of the beautiful, sticking in the ground artificial flow-
ers (which can be manufactured to look very much like natural ones)
or perching artfully carved birds on the branches of trees, and suppose
he then discovered the deceit. The direct interest he previously took in
these things would promptly vanish."[60] While beauty can be produced
by imitation, encountering its deceptive nature will make the interest
in beauty itself vanish. The loss of interest in the beautiful yet artificial
flowers, claims Kant, is due to the fact that our pleasure in the beauti-
ful has been raised in the first place by our belief that nature, rather
than human contrivance, produced the object of our appreciation. Only
natural beauty raises an immediate interest, and is hence susceptible to
the morally good, while the beautiful produced by the arts and aiming

to look like nature may agree with one's utmost refinement but cannot cultivate moral feelings. Kant, in section 42, illustrates the impediment to direct interest introduced by artistic beauty by reference to the fact that beauty in art is founded on simulation, on the manipulation of our senses, thus raising the puzzling question of how art's deceptive motivation in producing beauty can be reconciled with the supersensible aims of aesthetic ideas.

In line with the illustrations given above, Kant in the same section elaborates on the primordial sin of art with the example of the jovial innkeeper who, unable to find a nightingale to entertain his guests with beautiful singing, hides a gifted youngster in a bush who is able to reproduce the song of the nightingale "in a way very similar to nature's."[61] Exposure of the deception will lead the whole scene astray as the melody that sounded so charming before would no longer be endured by the listeners keen on beauty. It is the manipulative, deceptive nature of art that now excludes it from any moral consideration. What has been lost of the moral space opened up by beauty, when beauty turns out to be unnatural?

Commentators routinely use these examples of the deceptiveness of art to illustrate Kant's recurrent theme of the relative inferiority of art to nature.[62] It is the beauty of nature, rather than that of art, that exhibits the fundamental qualities of a reflective judgment. And yet I would like to suggest a further implication of Kant's examples regarding the deceptive appearance of art as nature. This implication not only explains the insertion of these examples in the context of a discussion on morality but furthermore touches on a possible correlation between moral interest and the question of truth at the moment of creation. With these examples it is implied that an immediate interest in beauty is elicited at a moment in which the true is not distinguished from the false in epistemic terms (is it a "bird" or a "human" singing?). It is, in other words, a moment prior to the distinction between the true (to nature) and the deceptive, in relation to which the aesthetic moment that assigns moral value to art can be located.

What is it at this prior moment that assigns moral value to art? It is the moment that reveals the origin of what can be termed the aesthetic-ethical law, the moment in which the form of the law establishes its link with beauty. While a moment later the mere appearance of truth will give way to deception, prior to the exposure of the "imposter" singer, when the listeners are still exposed to the beauty of singing per se, lawfulness can be related to beauty. At this prior moment what the law demands is

indeterminate, and the question of commitment to nature is assumed beyond truth and falsity. Kant's example touches where attunement to the law encounters the idea of beauty, and this moment is the moment of the birth of beauty, where beauty is real but yet unknown. The origin of beauty is with the aesthetic law that demands a disinterested interest in the production and appreciation of beauty. The story exposes this moment of origin and thereby also the reason for Kant's dictum that it is sufficient for art to look like nature to be qualified for an aesthetic judgment. When beauty meets the absolute necessity of the law before the law is transformed into maxims, values, or courses of action, beauty transcends the question of interest on the one hand and of truth on the other hand. This is when beauty's truthfulness to the law is possible because singing appears, unadulterated by specific concepts, subjected only to the aesthetic-ethical interest of producing beauty (when the singing turns out to be an imitation produced by the sheer interest to entertain, it will become impossible to assign beauty to the melody). Here, singing beautifully approximates the primary imperative that rules the aesthetic domain according to Kant: "aspire to create beauty!" and we can come across the imperative only prior to the transformation of the imperative into a (right or wrong) mode of action. Beauty is moral because "beauty" constitutes the law that would appear as a command to produce, aspire to, and appreciate beauty. In view of such a command, can we say human singing is less authentic or less beautiful than natural singing? That it is not regulated to the same extent by the universal law that assigns moral value to the creation, free of interest, of beauty?

If beauty exhibits the form of the law, it is because the modes of exhibiting the law are indeterminate. We cannot say what rule of action should be followed to implement the command to produce beauty or when beauty will actually be produced. It is because beauty cannot be determined in an object of intuition, because we cannot intuit the privileged conditions for producing beauty, that beauty can reveal the place of the supersensible, of the idea of reason. The moment at which moral feeling is raised in the face of beauty is hence a moment when both the specific moral concept and epistemic truth are suspended. Thus, upon hearing beautiful singing, we can rely neither on the law from which "singing beautifully" derives nor on the concept of beauty that dictates what constitutes a correct use of "singing." This moment is prior to the distinction between art and nature. It is through reference to a moment of listening to beautiful singing prior to knowing who is producing the singing (bird or human) that attuning oneself to beauty reveals its affinity with a moral disposition.

When Kant claims in section §59 that beauty is a symbol of morality, such a claim must rely on a prior reconciliation of the universal validity of the judgment of beauty, attainable without concepts, with moral judgments whose universality is associated with concepts (like the good, happiness, will, etc.). Section 59 offers the conclusive argument regarding the question of aesthetics and morality, which has, in a way, already been solved. Kant had already demonstrated in previous sections that art and the beautiful forms it presents succeed in stimulating thought, in activating ideas of reason, ideas that constitute the domain in which morality is enacted. The faculty of taste, in other words, is singular in enabling us "to make the transition from sensible charm to a habitual moral interest without making too violent a leap."[63] Kant's fundamental claim is that morality can be assigned to beauty because the moral interest that pertains to beauty circumvents all commitment to determinate moral concepts. The bridging of the distance between the sensible and the moral is conditioned by the circumventing of moral determination (since determinate moral concepts compromise the distinctness of aesthetic judgments). The morality of art is also sustained by the fact that beauty does not create an object of knowledge. This lack of epistemic determination enables beauty to enact the free cognitive play that gives rise to moral feelings. Thus, the fact that beauty is neither the result of a determinate rule of action nor the object of cognition comprises its particular moral task. It is the absence of determination, both theoretical and practical, that constitutes the place where the origin of the moral law is disclosed, unoccluded by determinations of any kind.

If we now consider the whole moral *dispositif* described by Kant in relation to art, the paradoxical[64] place Kant assigns to deception will be part of the picture. Kant never addresses the question of truthfulness as a relevant issue for aesthetic experience (truth generally has a minor place in his epistemology). Moreover, Kant deliberately detaches the experiencing of beauty from all that is based in testable reality or in given epistemic knowledge.[65] And yet in section 42, in relation to the moral interest in the beautiful, Kant brings in the problem of deception and simulation of truth. In one sense Kant appears to follow here a long philosophical line of correlating art with reduced epistemic validity (from Plato's expulsion of the poets through Samuel Taylor Coleridge's "suspension of disbelief" to Kendall Walton "quasi-emotions"). Kant would seem to endorse the idea that art manifests an effort to attain an appearance of truth and not truth itself.

Indeed, the aesthetic tradition, before and after Kant, underlines the intimate link between art and appearance: "the beautiful has its being in

pure appearance. But an inherently true end and aim, as is readily rec-
ognized, must not be achieved by deception ... only the truth can create
the truth," writes Hegel.[66] For him, beauty should have a direct relation
with spirit. This demand is backed by his study of the fine arts, whose his-
tory, he claims, reveals that the spirit can too easily lose its grasp on the
beauty of art. The recruitment of art to the demands of spirit is far from
self-evident. Even if art is not necessarily deceptive, art is limited to "only
one sphere and stage of truth." Art is limited both in its specific content
and in its form, which disables it from fully "bringing to our minds the
true interests of the spirit."[67] But subsuming the present Kantian case
of the trickster under this art/appearance pairing is misleading. Kant is
interested in the *mode of disclosure* of morality by way of beauty and can-
not be concerned with what transcends this mode (i.e., with the repre-
sentational status of art in relation to nature). Furthermore, had art in
general been absolutely irrelevant to the disclosure of morality due to its
immanent interestedness, deceptive *appearance* per se would have been
inconsequential with regard to the matter of morality and the question
of morality's relation to beauty. Hence the sense in which interrupting
art's *appearance* as nature affects art's place within the moral domain does
not easily come in line with Kant's demand that art look like nature (i.e.,
with Kant's position that under certain conditions the beauty of art can
elicit moral feelings).

Put differently, in exposing its fabricated nature, Kant appears to uni-
versally deny the possibility that art can arouse moral interest. Yet his
claim that "the purposiveness in [art's] form must seem as free from all
constraint of chosen rules as if it were a product of mere nature"[68] clearly
implies that art is engaged in exhibiting beauty rather than in feigning
it. Kant seems to suggest here that the simulation of free form equally
enables the observer to appreciate beauty's receptivity to the moral. Art,
even if by means of deception, reveals the supersensible, which is art's
true object of concern. Thus, while artistic beauty may appear devoid
of morality, the ultimate achievement of art is ethical: it attains the sem-
blance of nature (even though we are conscious that it is art). In other
words, artistic beauty exhibits an attunement to the moral because it
discloses a moment that cannot be described as either false or true, as
either right or wrong, and this moment, I propose, touches the origin of
beauty, where the indeterminacy of the cause of beauty is precisely what
links beauty to the order of moral ideas.

But how does attaining the semblance of natural beauty turn art into a
domain of attunement to the moral? Art elicits a moral interest because

its deceptive appearance forces the subject to go beyond sensibility, to develop an ability to be directly interested in the idea that is exhibited by the object of appreciation yet is unconditioned by the object's existence. Deception turns out to be not just a threshold for exhibiting the supersensible but also a yardstick, a shibboleth distinguishing the subject who is completely immersed in charms and semblances from the observer who can take a direct interest in beauty as such.

While the singing of a nightingale and the singing of a manipulative yet gifted young man are sensibly two different practices, they are equally beautiful and hence qualified to arouse a moral feeling. It is not the actual link of the beautiful thing to a moral idea that interests Kant but rather "beauty's own characteristic of qualifying for such a link, which therefore belongs to it intrinsically."[69] The human singing that imitates the singing of birds exemplifies *an effort to exhibit* the indemonstrable idea of purposiveness that the natural object equally exhibits. Learning that the human voice can produce singing just as magical as that of the nightingale elicits a moral feeling in the attentive listener, as the singing exhibits the idea of a maximum, of human capacity beyond its natural limitation. Kant's argument suggests that this idea of reason is intrinsic to the beauty of the singing, as human singing can equal the beauty of nature, thereby qualifying to become an object of moral interest. In this respect the listener who loses interest after discovering the deception in a way fails to grasp the point about art.

When facing artistic beauty, we create the conditions "for the efficacy in the sensible world of a morally directed freedom" even if the finality attributed to beauty is not in itself of a moral nature.[70] Vocal beauty exemplified in the deceptive imitation of a bird's singing aims, no less than "true" bird singing, to touch the kernel of lawful harmony. Art cannot be said to be deceptive per se as the deception allows art to be as beautiful as nature. The human effort involved in deception therefore makes it susceptible to, rather than incapable of, raising moral feeling. For this reason Kant recommended that art should look like nature even if we remain perfectly aware that its origin is in fabrication.

The intricacy of the singing example hence lies in the fact that Kant does not take the counterfeit bird singing to manifest a Platonic exemplification of artistic deception. Rather, it shows that the mere effort-unto-beauty of human singing, an effort undertaken in a way that does not address the listener through mere charms, discloses the truth in beauty, a truth that prevails regardless of questions of authentic or inauthentic (i.e., deceptive) performance. This is therefore the paradox that

Kant, whether deliberately or not, articulates: while the artistic product under consideration (the beautiful singing of the young man) is taken to be devoid of moral interest because it deliberately aims at the listeners' liking, this deliberation will make the singer's imitation of nature successful and will hence assign it moral value. This deceptive imitation, when effective, elicits the listeners' moral interest by reason of the natural beauty of a nightingale's singing. The deception that distinguishes art from nature thus serves as the very platform for producing beautiful singing through the indeterminable purpose of a true nightingale's melodies. The artistic product, in its effort-unto-nature's-beauty, can hence raise a moral interest through its deceptive exhibition of a natural form of beauty.

In his book on the politics of aesthetics, Rancière writes of the *poetic* or *representative regime* in the arts (a regime that breaks away from the *ethical* regime of images established by Plato) that it isolates the particular forms of art called *imitations.* "These imitations are extricated, at one and the same time, from the ordinary control of artistic products by their use and from the legislative reign of truth over discourses and images."[71] Imitations, claims Rancière, do not belong to the domain of practical reason or of truth but to the domain of *normativity* that defines the conditions according to which imitations are good or bad, adequate or inadequate, following principles such as verisimilitude, appropriateness, and correspondence. Unlike the representational regime, the *aesthetic regime* is one that shifts the balance from the relation of appropriateness between image and norm to the image in its material, sensible mode of being. The shift between the two regimes, as analysed through Rancière's enlightening mapping of the history of looking at the arts, is marked by Kant. In line with Rancière's observations, this chapter has shown that it is only when art is no longer considered in terms of more or less successful imitation of nature, when it is free of considerations of appropriateness, that its beauty may open the space of morality for its spectator. The imitation of the vault of heaven inhabited by angels, executed through perspective painting and blots of blue paint in Mantegna's fresco, can incarnate the idea of infinite benevolence because the sensible exhibition in the image of celestial beauty is *true to this indeterminate idea of reason* rather than true or false.

To raise a moral interest, art should be committed to contriving a way of crafting an object so that it exhibits purposiveness through its beauty. Kant himself suggests a solution in this direction that can reconcile the effort-unto-truth-to-the-idea with the deceptiveness of the image. The

deceptive image reveals a certain *know-how*, a dexterity in practice by means of which the image can equal nature: "a product of art appears like nature if, though we find it to agree quite *punctiliously* with the rules that have to be followed for the product to become what it is intended to be, it does not do so *painstakingly*."[72] The artistic image requires a making described by Kant as "punctiliousness" yet effortless. The moral interest we have in the beautiful hence relies on the artistic know-how that enables art to appear as nature not by successful imitation but through a different order of commitment to truth.

The kind of commitment at stake is connected to the way deception may aim at truthfulness ("agree quite *punctiliously* with the rules") rather than at simulation per se. For artistic beauty to be moral, it cannot rely on epistemic truth, as conceptual truth is an irrelevant ground for art's successful production of beauty. Its truthfulness must exceed the sensible and suggest a supersensible domain where the moral import of artistic beauty can reveal itself. The demands of truthfulness to an idea of reason, be it specifically moral or not, are thus reconciled with the deceptive nature of artistic beauty, since a moral interest in beauty would produce an indifference to the distinction of the true from the fictional or false. And this takes the effortless and exact work of an artist.

By exploring these dimensions of morality in the domain of beauty, I have argued that beauty reveals a singular position with regard to morality, as the origin of beauty resides where indeterminate ideas of reason are demonstrated in particular aesthetic ideas or in specific forms. Since beautiful imaging does not depend on definite concepts for the image to be judged beautiful, beauty allows a direct involvement of moral ideas in the aesthetic domain, thus touching the subject's moral attunement at the heart of his sensibility. Being true to the moral idea means being true to that which cannot become articulated knowledge and yet regulates the way the image is constructed. Being attuned to morality hence entails being truthful to the vacuous place at the origin of morality, a place affirmed through art and in the artwork, enacted in the effort to produce and appreciate beauty. Through the analysis of Kant's conception of beauty and morality, we saw how the cognitive faculties that produce a judgment of beauty by defying definite knowledge and definite moral concepts as their grounding, disclose, through this defiance, the indeterminate yet real place of morality in the aesthetic subject.

3

By Way of Truth

Freud's discovery calls truth into question, and there is no one who is not personally concerned by truth.[1]

When asked in his seminar of 1970 in what respect he maintains that knowledge and truth are incompatible, Jacques Lacan answered that "nothing is incompatible with truth: we piss on it, we spit on it. It is … a place for the evacuation of knowledge and all the rest."[2] This harsh verdict on truth is not due to disbelief in its substance or in its real effects but in fact demonstrates the opposite. When cleaving oneself to truth, one can be driven mad because nothing is incompatible with truth; truth tolerates everything and resists any manipulation. Truth can thus be presented as the place for the evacuation of knowledge, as knowledge's waste site. Those practices that strive towards the place of truth through knowledge must be on their guard: "one does not marry truth; there can be no contract with her, and even less can there be any open liaison."[3] Truth is inescapable, even if it appears untrustworthy, deceptive, misleading, and – above all – unattainable. Which truth is it, then, that divorces itself from knowledge, that appears deceptive and unattainable?

Truth is of concern to everyone, and a practice that does not concern itself with truth is vacuous. A concern with truth, as Plato had already noticed, is the foundation of ethics, which is why Plato, assuming a dissociation of art from truth, sentenced art to a fate of being an empty, futile practice. The aim of this chapter is to link this waiving of truth in the fabrication of an artwork to the affirmation of another truth. In other words, what is moral in art cannot be measured by a truth identified with epistemic knowledge or through the distinction of the true from the

false. And yet it should be granted that "art is the bringing-into-the-work of truth."[4] Our investigation in this chapter will move through a few stations that attach ethical value to a truth that is not *episteme*. Immanuel Kant and his aesthetics serve as the first step in affirming the association of non-epistemic truth with the moral dimension of the aesthetic domain. In the previous chapter, the discussion of Kantian perceptions regarding beauty and morality suggested that the moral interest in artistic beauty is elicited when art's disavowal of determinate knowledge allows art to disclose the place where beauty touches through sensible images the place of indeterminate moral ideas. Through Kant's example of the imitation of a bird's singing it was suggested that the deceptive gesture works as a shibboleth in distinguishing the subject who remains with the semblance, and hence abstains from experiencing beauty, from the subject who treats the deceptive threshold as disclosing the commitment of art to purposiveness without a determinable purpose.

The commitment to truth has traditionally constituted the foundation of epistemology and has been separated from questions of morality. In contrast, the question of art's commitment to truth has always played a role in determining art's ethical stand. But what can be the place of a truth that is of immanent concern to art and is constitutive of art's ethical status? The history of aesthetics suggests a variable picture of the relations between truth and art. It spans from Aristotle, for whom the truth of poetry is attributed to the felicitous arrangement of parts, to Arthur Schopenhauer, who claimed that art enables access to the noumenal realm of the will (i.e., art is capable of truth that no other domain is capable of). The range of diverse views on the relation of art to truth nonetheless relies on an implied shared assumption: that art's mode of engagement with truth reflects on art's ethical status and on its relevance to moral values. Here, again, the span of views is wide: art's relevance to social values can be denied because of art's adherence to fiction,[5] or the extravagant inclinations of art can make it seem morally pernicious: "art ... is incapable of truth. Its essence is mimetic, and its regime is that of semblance. This incapacity does not pose a serious problem (contrary to what Plato believed). This is because the *purpose* of art is not in the least truth."[6] Whether the non-commitment of art to factual or realistic truth is denigrated or championed, art's position towards truth is associated with its ethical or unethical standing.

These initial intuitions regarding the indisputable assumption that art's commitment to truth is inseparable from art's moral standing will be examined in the present chapter in relation to a number of issues.

To begin with, the relations between ethics and knowledge of the true are considered. Although these relations have a complex history that is beyond the scope of this work, the history of the disengagement of ethics from determinate, pre-established knowledge does pertain to our present concern. In Aristotle's *Ethics*, the practical reason that consti- tutes us as ethical beings both presupposes certain knowledge and yet is also indifferent to it. The good is not an immanent trait of action but is attainable through action, and "as a condition of the possession of the excellences, knowledge has little or no weight."[7] For instance, in deciding whether an action is a product of deliberation or choice, a quantum of reasoning is needed. Aristotle writes that "courage is a mean with respect to things that inspire confidence or fear ... But to die to escape from poverty or love or anything painful is not the mark of a brave man, but rather of a coward."[8] A good quality cannot be conceptu- ally accounted for nor defined by pure reason. Courage requires prior knowledge to be implemented in action, yet to decide whether a given action is courageous is a different matter that is indifferent to that knowl- edge. The moral truth of a good action is distinct from a truth equated with theoretical knowledge.

Aristotle's ethics suggests a separation of theoretical from practical knowledge, a split between knowledge of concepts and knowledge of the good action. The history of the relations between conceptual knowl- edge and ethics, as exemplified in Aristotle, was later addressed by René Descartes, who took the commitment to truth as constituting the foun- dation of epistemological enquiry. For Descartes, scepticism proliferates in those who wish "to separate the false beliefs from the others," and when considering the grounds that warrant a belief with regard to the perception of things, we should "concentrate only on knowledge, not on action."[9] Practical reasoning that supports moral action is thus separate from knowledge of the possibility of falsity. So the history of Western phi- losophy accepts in different modes the separation of practical and theo- retical reason, a separation that does not seem relevant to the case of art.

But first, to restitute the link of the aesthetic to ethics, it should be remarked, even if in general terms, that the ethical itself has undergone a radical change. Within the sphere of ethics, the good has always been the eternal object of the philosophical quest. A turning point in this universal quest was marked by the abandonment of the good as deriving from an ideal or godly source that imposed the law prescribing the good. Once the divine law or the idea of the good as the regulator of moral behaviour was relinquished, ethical practice became the foundation of

a good that is defined only in terms of a collective social aim.[10] Secular
ethics (the foundations of which are formulated by Kant) underlines a
crucial aspect of the idea of the good. The certainty of the good can-
not be allotted to a strictly external source, as the moral law and the
practice of freedom emerge from practical reason in the subject.[11] Kan-
tian morality is constituted by a universal set of conditions immanent
to thought. The good is not derived from an external authority but is
assigned to the human subject aspiring to do the good according to the
dictates of an inner agency. Kantian reasoning in grounding moral deci-
sions to act is significant in establishing the coordinates for an ethics
concerned with a non-epistemic truth. While the moral law presents a
universal imperative produced by pure practical reason, the voice of the
law approaches the subject as an unattainable alien agency. The law that
speaks in an alien voice would hence always retain its unattainability with
relation to the morally acting subject. An ethical position consequently
involves both the imperative voiced by a universal Other and the subject,
whose reason enables the imperative to find its mode of implementation
yet is never fully subjectivized. This point may clarify why the meaning
of the demands imposed by the law are never fully known by the subject
of the law, and yet the subject is required to act in a way which is truthful
to the law.

From Descartes onward, we encounter an equally secular god gener-
ated by reason. Consequently, we face an ethics involving a subject who
is split between the universal truth imposed by the law and the inability
to attain the position from which the law speaks. This Otherness deter-
mines the status of the moral law and the source of its absoluteness.

If the law is unattainable as knowledge, if the law cannot be subjec-
tivized, what is the meaning of being true to the law? This is where art
comes in: since, with regard to art, both morality and truth are denied,
art may suggest another way of grasping the possibility of being truthful
to the moral law. This chapter, dedicated to articulating the conditions
for a non-epistemic truth, establishes the foundations for addressing the
ethics of the artistic act in terms of non-epistemic truthfulness. The fol-
lowing are the basic coordinates around which the discussion will revolve:

a "It is only when it is false that knowledge is preoccupied with truth."[12]
 Lacan's statement establishes the idea that false knowledge, or the
 threshold of the negation of knowledge, works as a condition for pro-
 ducing truth and affirming its place vis-à-vis knowledge. This psycho-
 analytic idea will be presented as the practical (ethical) consequence

of art's independence from reality; the fact that art can be fictional, uncommitted to knowledge about what the world is like, allows it to touch the question of truth from a singular position.

b "If a truth cannot originate from its being given, it must be because it has its origin in a disappearance."[13] The second coordinate in this exploration of the ethical implications of artistic truth is the idea that truth cannot be shown. Yet for truth to have its origin in disappearance, truth must be identified with the event of disappearance of what takes place, while taking place. This is the notion of truth that Alain Badiou introduces in his writings, as what proceeds as the trace of a vanished event that was not given before its vanishing. The ethical consequence of such a notion of truth for art is that in the artwork we come across a trace of something that is abolished at the moment of its expression. Truth does not refer to a transcendent event but rather to the event of disappearance itself.

c "The objective reality of the moral law cannot be proved through any deduction, through any endeavor of theoretical reason, speculative or empirically supported, and hence could not ... be confirmed through experience and thus proved a posteriori, and yet is – on its own – established."[14] The third coordinate, whose implications will be fully explored in chapter 5, employs Kant's conception of the moral law, which implies that claiming that art is ethical entails an artistic practice positioned in relation to an aesthetic law. This law, like any practical law, necessitates an artistic act to exhibit it, even though the law itself remains unexhibitable. This paradoxical relation with the law, the fact that actions are committed to a law that cannot be demonstrated, is disclosed by artistic practice in a singular, striking way.

The present chapter will develop these three coordinates. Art is committed to truth that cannot become articulated knowledge and yet declares its presence through fiction. Art is committed to a truth that disappears with the very act that constitutes it. Art is ethical in the sense that artistic creation exposes the paradoxical implications of being subject to a law, a law that in this case takes the form of an aesthetic imperative.

a. Knowledge ≠ Truth

To grasp the full weight of the ethics involved in the artistic act, truth should be seen as independent of knowledge. Only by severing knowledge

from truth will deception and fiction be marked as conditions of truth. The meaning of this independence of knowledge from the true can be revealed through the art of trompe l'oeil. In this unique case, faithfulness to the object and its representational nature is severed from truth. In a paper originally published in 1986, Louis Marin refers to trompe l'oeil as simulacrum, as distinguished from mimesis or representation. Representation is a matter of control over reality and its objects, as exemplified by the use of perspective to achieve an effect of reality. In representation, the spectator's grasp and control of his or her field of vision are at issue. Trompe l'oeil is simulacrum because it stupefies the gaze; it "darkens the mirror, closes the window."[15] It has to do with the presence rather than the absence of the object because trompe l'oeil is "a 'black' painting ... a represented space that expels from within itself, onto its own surface, the objects that the painter seeks to paint on it."[16] Marin demonstrates that neither mimesis by perspective nor trompe l'oeil is interested in or focuses on the object or on the way the object really is. The difference between them is that mimesis, through the absence of the object it accentuates, enables the observer to focus on the subject in a position of power. In contrast, trompe l'oeil, through the presence of an object on the canvas, reveals the painting as dark, as showing nothing but the abstractness of the present.

This approach to trompe l'oeil, as simulacrum and thus an alternative to representation, is also clearly articulated in Jean Baudrillard's work on the subject: "There is no nature in trompe-l'oeil, no countryside or sky, no vanishing point or natural light. Nor is there any face, psychology, or historicity. Here all is artifact; the vertical field constitutes objects isolated from their referential context as pure signs."[17]

Both Baudrillard and Marin expose the representational emptiness of trompe l'oeil, claiming that the truth revealed when the painting is darkened (from nature, psychology, and history) is metaphysical, relating to the idea of simulacrum and reflective of the nature of reality without showing that reality. A work of art that contains no knowledge about reality and its object, that carries no representational value, that is not committed to the object of nature, is destined to be excluded from the realm of art. Thus trompe l'oeil, according to Baudrillard, "is no longer painting. It has become a metaphysical category."[18] Significantly, according to the theory of simulacrum, trompe l'oeil constitutes an artistic gesture rather than an act of artistic creation because it hollows out the world of representation. Trompe l'oeil presents a different case than abstract or formalist art, which despite its representational emptiness does not

remain outside the realm of knowledge. Its epistemic value is measured in terms of the *ars poetica,* in terms of what this art conveys about the art of painting itself. Trompe l'oeil is, however, no longer regarded as a painting, not simply because of its deceptive quality. Through this deception it undermines all knowledge about the object and about the representational game in its entirety. Through trompe l'oeil we learn neither about the world of real objects, nor about the subject who positions himself or herself in relation to the object, nor about the making of art.

Trompe l'oeil cannot be painting because it does not convey any knowledge about the world. The idea of simulacrum ascribes another truth to trompe l'oeil art, a truth that does not involve knowledge of any kind, thus revealing that art can be truthful without conveying knowledge. Knowledge and truth do not occupy the same structural position. Trompe l'oeil, in betraying the knowledge it allegedly conveys about the object, is rehabilitated in terms of a different truth that is not necessarily tied to representation. The simulacrum theorists that assign a different form of truth to trompe l'oeil necessarily relinquish the singularly *aesthetic nature* of the truth effectuated. The truth they propose is no longer aesthetic but rather of a metaphysical nature. In contrast, it is my aim to restore here the truth of art in singularly aesthetic terms.

The possibility of effectuating a truth that does not reside in the domain of knowledge embodies a move that is immanently psychoanalytic, even if the notion of truth as severed from knowledge is not unique to psychoanalysis. It is rather symptomatic of many orientations of thought in the twentieth century, as will be discussed shortly. We can refer to what may seem like a minor example to clarify the relevant orientation toward truth. Jacques Derrida in his *Truth in Painting* referred to Paul Cézanne's obligation to say the truth in painting. For Derrida, saying the truth in painting does not mean saying the truth in general but rather refers to articulating the relations established between art and a truth that belongs to a totally different register in a way that is singularly painterly. Derrida relates to Cézanne's saying that the truth in painting is a promise, a *passé-partout* determining the status of the event of painting, without being committed to what this truth is. "Its performance does not promise, literally, to *say* in the constative sense, but again to 'do'. It promises another 'performative' ... with no descriptive or 'constative' reference, the promise makes an event (it 'does something' in uttering)."[19] This promise to say the truth in painting is not a speech act, which would require that "Cézanne should mean to say something and one should be able to understand it," a condition unlikely to be fulfilled by Cézanne. In

Cézanne's case, the truth in painting does not say what truth is or how it is rendered. Rather, truth is tantamount to the artist's signature through his act of painting, thereby creating an event of truth. This approach to the relation of art to truth is akin to Martin Heidegger's notion of art as the becoming and happening of truth. Truth is always concealment since "untruth" is always its other illuminated surface. Truth is a mystery, the unbounded region of epistemological darkness.[20]

Truth is set apart from epistemological determinacy by a school of thought that constitutes more than an anti-Cartesian alternative. It sets the foundation for a rethinking of the relations of art to truth, which will be developed further here on the basis of Lacanian thought. Within the psychoanalytic framework, a reconsideration of truth is suggested through the possibility of a truth that appears beyond knowledge, outside the control of the master signifier (marked as S_1) and as a certainty that has a real rather than a symbolic or epistemological presence. In his 1969–70 Seminar XVII, Lacan presents four social discourses (of *the master, the hysteric, the university,* and *the analyst*). In each of the four discourses, knowledge, marked formally by Lacan with the sign S_2, has a different value. This value is determined by the relation established between knowledge and the place assigned in the discursive structure to truth.

$$\text{Agent} \rightarrow \text{Other} \qquad S_1 \rightarrow S_2$$
$$\overline{\phantom{\text{Agent} \rightarrow \text{Other}}} \qquad \overline{}$$
$$\text{Truth} \qquad \text{Product} \qquad \cancel{S} \qquad a$$

This fundamental structure of four functions (on the left) is used differently by each discourse (on the right, the discourse of the master). In the discourse of the Master, knowledge (S_2) is located in the place of the "Other," indicating that the master is in need of the knowledge that is in the possession of an Other. This Other, according to Hegel, is represented by the bondsman. Knowledge possessed by the slave is assumed by the master so that he can appear to be in control of his world.

The discourse of the hysteric locates S_2 in the place of the "product." The hysteric, in her address to the master, aspires to show that the knowledge the master claims to have is not really in his hands; she therefore strives to show that knowledge is what the master lacks. Knowledge for the hysteric serves as a way to retreat from the master, and thus it stands in the place of the product; in the case of the hysteric, the knowledge isolated as what discourse produces is undermined, suspended.

The discourse of the University locates S_2 in the place of the "agent"; knowledge serves as the raison d'être and initiating force of this

discourse, "the command, the commandment, this place initially held by the master, that knowledge has come to occupy."[21] The disparity in this case between the place of truth and the location of knowledge shows that the university discourse that commands the subject to "keep on knowing!" cannot guarantee that the knowledge gained will overlap with the truth of the knowing subject. The knowledge conveyed remains irrelevant to the subject to whom knowledge is addressed (that is, to the student represented by a: the a studied). The university is interested in maintaining the master's priority, whose sign, S_1, appears in the place of truth. The truth about the subject, who is instructed to cherish knowledge within the social link established by the university, is that he/she is controlled by a master rather than by the love of knowledge because the love of knowledge cannot be satisfied in the university.

The discourse of the analyst is the only one that locates S_2 (knowledge) in the place of truth. However, it is not the analyst who, in the discourse of the analyst, obtains knowledge. The knowledge assigned to the Other in the discourse of the master, however, is not the same knowledge assumed in the analytic situation. In the discourse of the master, he does not consider the slave's knowledge as relevant to himself; he is interested only in using the fruits of that knowledge for his own benefit and welfare. The kind of knowledge produced in the analytic situation is a wholly different matter. Its point of departure is the knowledge *assumed* to be held by the analyst, and its end state is the knowledge produced by the analysand (the subject in analysis). I suggest investigating the difference between the two kinds of knowledge, and in particular the knowledge constituted by the analytic process, in order to articulate a relevant understanding of the truthfulness of art.

Lacan establishes the point of departure for considering knowledge's relation to truth through Hegel. In Hegel's *Phenomenology of Spirit* knowledge is not known from the outset but is produced dialectically. While the Hegelian discourse appears to aim at absolute knowledge (at the moment when the knowledge held by self-consciousness will merge with the absolute truth of the spirit), the history of knowledge reveals something else: it reveals that absolute knowledge is in fact avoided. At the basis of the Hegelian dialectic, claims Lacan, is the severance of truth from knowledge, a fact Hegel does everything to elude. While self-consciousness is assumed to emerge as absolute knowledge, knowledge for Hegel cannot know itself. If knowledge ever does culminate in absolute knowledge, "it will only be to mark the annulment, the failure, the disappearance at the conclusion of the only thing that motivates the

function of knowledge – its dialectic with *jouissance*."[22] That is, knowledge that knows itself, knowledge that merges with truth, makes truth disappear (since the truth is identified here with the cause of seeking knowledge, that is, with jouissance), and thus Hegelian discourse works throughout history to constantly deflect such a possibility. The progress of the schools of thought in history that Hegel follows in the *Phenomenology* around the relevant structures of consciousness – from the master and bondsman to the stoic, the sceptic, and the unhappy consciousness – reveals this deflection. Each consciousness confronts its own division in the demand to cancel its unsubstantial existence on the one hand, and the "return of consciousness, and, moreover, into itself as the actuality which it knows to be true" on the other hand.[23] Regarding the *unhappy consciousness*, for instance, Hegel insists that the moment of pure (universal) thought, the moment of coming into possession of the object of consciousness, is bound to be a moment of incomprehension, of coming across something alien that always flees beyond comprehension. Regarding the bondsman, knowledge in his possession is outside the desire of the master (who is blind to it). But knowledge is not in the possession of the slave either, as his knowledge also has blind spots due to the other consciousness of the master, unto whose service the slave's own knowledge is put.

Hegelian knowledge is *produced* through an act of consciousness, as distinct from Cartesian knowledge, which is *assumed* by consciousness. Cartesian knowledge, even when subjected to an act of doubting, acquires a universal validity once produced. Once the certainty of the cogito is assumed it can incorporate knowledge that satisfies the appropriate epistemological criteria (of being clear and distinct). For Hegel, the preliminary position is that of the master achieving his certainty of mastery through a false notion of the slave, that is, through misrecognition of the other[24] (the consciousness confronting him), the bondsman, as unessential.[25] For the bondsman, on his part, desire is the desire of the master, thus enabling his lord to have the pure enjoyment of the thing without having to work to attain it. The master's ability to enjoy is entirely dependent on the other's consciousness, on the bondsman's intimacy with the world of objects and on his knowledge of how to yield benefit from his work. Only after a few more rounds between master and bondsman will the latter come to realize that through his consciousness qua worker, the independent being of the object could constitute his own independence.[26] The dialectic that constitutes self-consciousness as dependent on another's consciousness or on the object's resistance to its

own negation is a dialectic that produces the truth about the exchange between lord and bondsman as constantly keeping a distance from absolute knowledge.

In psychoanalysis, the analyst, acting in response to the discourse of the analysed subject, enables the production of knowledge. Yet the knowledge produced in analysis is not something that can be articulated by the analyst. As knowledge is produced in analysis for the analysand, it is always eclipsed by the act/presence of an Other (which is not the analyst, as the analyst concedes the position of the Other that knows) without whom this knowledge cannot be produced. When knowledge is articulated in the utterance of the analyst, through interpretation for instance, it cannot represent the truth of the analysand: "interpretation ... is an enigma that is gathered as far as possible from the threads of the psychoanalysand's discourse, which you, the interpreter, can in no way complete on your own, and cannot consider to be an avowal without lying."[27] Knowledge proposed by the analyst through false or correct interpretations does not in itself reflect the truth of the analysand; yet the effects of this knowledge on the analysand will disclose the desired truth.

This is the enigma of knowledge: its truth is uttered without that truth being reflected in what is stated. The articulation of truth as knowledge cannot but annul the place of truth. Truth can therefore be only half-said, a recognition that applies to all four discourses and that establishes the ground for the inevitable severance of truth from knowledge. Knowledge can only approximate the place of truth. If truth can only remain half-said, the knowledge that relates to it cannot be articulated but must reflect an acknowledgment of this half-said status of truth. From the point of view of the master's discourse, both the lord in Hegel and the Lacanian analyst assume knowledge that has the status of a *quotation*. It is a knowledge that depends on the Other and is eclipsed by the Other's necessary presence. The production of knowledge is conditioned by the fact that the analyst becomes "the pledge and the hostage" of the knowledge produced through the cogitations of the psycho-analysand. Similarly, in the discourse of the master, the desire of the master is the desire of the Other, since it is the desire that the slave anticipates.[28]

The structure of every discourse is determined also by what discourse produces (at the lower right side of the scheme), and this product is either made use of or overlooked or even rejected. In the master's discourse, the product, marked as the *a*, is rejected, symbolizing the object ignored by the master. The *a* is the object that cannot be made sense of

and is not articulated by the participants in the discourse, and yet whose effects on the discourse are crucial. In the discourse of the master the *a* signals the excess value produced in the exchange between master and slave, an excess that cannot be incorporated into any subjective position the discourse assumes. This excess, not included in the knowledge given to the use of the master, will eventually "turn the wheel" on master and slave. The discourse of the analyst is, however, a discourse that puts the *a*-object in the place of the agent "as much as this object *a* designates precisely what presents itself as the most opaque in the effects of discourse, as having been misrecognised for a long time, and yet is essential."[29] The effect of this positioning of the analyst as acting from the place of the object that marks the cause of the subject's desire (exemplified by Lacan through the function of the *dummy* in a game of bridge) is what enables the analyst to produce knowledge that will eventually occupy the place of truth. In the analyst's discourse, the overlooked element in the master's discourse is given the essential position, while other discourses suppress its effects. For example, the Lacanian hysteric camouflages her own enjoyment by developing painful bodily symptoms (she appears as the barred subject who does not know what causes her pain); knowing nothing of her own enjoyment produces the unaccounted-for *a* in the place of the truth of the hysteric discourse.

"When I speak of knowledge as having its initial locus in the master's discourse at the level of the slave, who apart from Hegel has shown that what the slave's work will yield is the master's truth? And, no doubt, the truth that refutes him … the only way in which to evoke the truth is by indicating that it is only accessible through a half-saying [*mi-dire*], that it cannot be said completely, for the reason that beyond this half there is nothing to say."[30] The discourse of the master reveals the incompatibility between truth and knowledge, as the knowledge at the hands of the slave constitutes the truth about the master, who remains ignorant of this fact and of this knowledge. In contrast, the discourse of the analyst brings knowledge to the position of truth, where truth cannot be articulated as knowledge but only half-said. The two discourses reveal that truth functions as a hole in articulated knowledge, and the desire to attain knowledge is always a way of either exposing or camouflaging this fact.

Knowledge is articulated through the signifier; in contrast, truth is where the object of enjoyment is hidden, where the cause of desiring knowledge is located. This formulation is crucial to our quest for the evanescent truth of art. Had truth been just absent, rather than hidden, articulating what we know would have required nothing else. There

would have been no need to add that what we know is true, as truth would overlap with articulated knowledge, thus becoming redundant. This point is elaborated in Lacan's Seminar XVII, within the discussion of the role of negation in the context of his criticism of Ludwig Wittgenstein. Lacan writes of the *Tractatus* that in it "nothing can be said to be true other than the agreement with a [grammatical] structure … Grammatical structure is the world. And all that is true is, in short, a composite proposition comprising the totality of facts that constitute the world."[31] In this picture truth is equated with its articulation in a grammatical structure. Since an assertion announces itself as truth, to say of something that it is true or false is tautological and is meaningless, as it states something that is necessarily true. For Wittgenstein, the true depends only on being stated; it is a fact of language and not something internal to a proposition. The event of saying something constitutes it as a fact. The proposition "it is daylight" is not true as a fact but as a fact of stating it. Lacan stresses that this view of truth deliberately aims at rejecting metalanguage.

Wittgenstein, according to Lacan, ignores the fact that desire always involves an Other whose position cannot be occupied by the subject. The Wittgensteinian operation relies on the philosopher wanting to be the Other and capture the Other's desire from within language itself. In such a manner the factuality of "it is daylight" will be ascertained while ruling out undesired, metalinguistic implications. In wanting to be the big Other of logic, Wittgenstein, by equating truth with the fact of stating, hides the desire of the Other. Hence Wittgenstein cannot allow for effects of language that exceed what is said. Such is the logical (material) implication of a truth that can be drawn from false propositions (and that has been the source of many perplexing paradoxes). If the false can imply the true, in addition to implying the false, and if what is implied is true, the entire implication is also true.[32] This possibility is rejected by Wittgenstein because it entails that the Other of language cannot be identified with the logic of true propositions, that there is truth beyond what is articulated as true, and that the true can be about anything. Wittgenstein would also reject the possibility of a falsity implied in a true proposition, and Lacan claims that when this possibility is rejected, truth becomes an attribute of a whole genealogy of propositions. Is this an inevitable outcome of Wittgenstein's disposing of propositional contents in articulating the structure of propositional statements?[33] Lacan claims that the problem lies with the philosophical wish to save the truth, which in the case of Wittgenstein takes this form. Yet by making truth "the rule

and the foundation of knowledge, there is nothing left to say, at least nothing that concerns truth as such"[34] – the rock of truth is avoided or refused. But is this the only way of saving truth?

While philosophy has tended to put the weight of truth on the signifier, thus making being dependent on what the signifier says, psychoanalysis places truth in the opposite side of what is articulated. Truth is in the dream when we wake up from it, and is in reality when we dream.[35] Truth cannot be incorporated into articulated knowledge.

b. Truth Lies in Its Disappearance

In a short lecture presented before an audience of Lacanian psychoanalysts, the philosopher Bernard-Henri Levy referred to the ethics of the secret in our political and cultural life. Levy claimed that while epistemologically secrets are conceptualized through the opposition between veiling and unveiling, this may lead to a clear fixating on the veiling, as only what is veiled can be unveiled. This fixating constitutes an ontological retreat in which the ineffable dwells; that is, it forces us to adopt a metaphysical position towards secrets, treating them as immanently veiled. But "we must see appearing as a mode of being of the secret, forgetting as mode of being of alétheia, and vice versa, ad infinitum." Levy hence calls for deontologizing the question of the secret, stating that "at bottom, the real secret in this affair of the secret is that there is no bottom."[36] Levy's almost anecdotal approach to secrets points to Heidegger's alétheia, to truth as the disclosure of what is concealed.

In his essay on "The Essence of Truth" Heidegger addresses the relation of truth to its forgetting: "but the forgotten mystery of Dasein is not eliminated by the forgettenness; rather, the forgettenness bestows on the apparent disappearance of what is forgotten a peculiar presence."[37] The mystery to which Heidegger refers is the one that lets Dasein's orientation towards concealment be concealed. If *alétheia* is disclosure, one may surmise that concealment entails untruth, or that concealment undiscloses truth and can therefore be forgotten. However, "concealment is then undisclosedness and accordingly the untruth that is most proper to the essence of truth."[38]

The Heideggerian idea that "the 'non' of the primordial nonessence of truth, as untruth, points to the still unexperienced domain of the truth of Being"[39] means that concealment is older than disclosure and appears as the presence of what was first of all concealed. This presents a conception of truth that reverberates significantly in Lacan's way of

raising the question of truth. Not only is truth present in the very event of its disappearance (rather than in the historical vacillation between *léthè* and *alétheia*), but concealment as the disappearance of the forgotten does not eliminate the forgotten. Following this line of approach to truth we can say that art, as a domain of concealment, is bestowed with the peculiar presence of truth throughout its historical modes of disclosure. Art appears to wilfully let truth disappear through its involvement with modes of fiction-making, with make-believe, realism, and verisimilitude. Art appears to entertain ambiguous relations with epistemic truth, with possibilities of cognizing the world. Art is, however, not *ruled* by concealment but is rather a happening of truth that is, by definition, committed to the half-said.

Badiou's and Lacan's conceptions of truth suggest that truth takes place in the very act that makes it disappear (from the domain of knowledge). In Lacan, as we have seen, the moment of divergence between the truth of the subject and the knowledge supposedly held by the analyst gives way to the moment when knowledge attains the place of truth outside the domain of knowledge articulated through the analyst's interventions. Here the subject recognizes that, in truth, knowledge cannot be held nor articulated by the Other/the analyst. Thus knowledge and truth can reside together in the discourse of the analyst, because knowledge is never *articulated* as truth but is *produced* by the desire to know the truth of the subject and by the subject. The moment truth is disclosed is also when it disappears as unknown and unknowable to the Other. The knowledge attained in analysis is hence the knowledge of the subject's desire, a knowledge that cannot be said and it hence constitutes the half-truth of the analyst discourse. The knowledge conveyed by artworks is knowledge of the desire for art, a knowledge that cannot be articulated but only through the half-said truth of fiction, make-believe, and verisimilitude.

A somewhat similar dialectic is constituted by Badiou, whose conception of truth shows why "a truth-process is heterogeneous to the instituted knowledges of the situation."[40] Hence truth cannot be reduced to knowledge and should be identified with a moment of rupture with knowledge. The moment of rupture occurs when a subject faces something he or she cannot manage and requires an inventive reinscription within a situation of that which cannot be incorporated into it. Badiou identifies this rupture in terms of a singular material event, which cannot be reduced to the law that controls given situations. One of the domains of the occurrence of truth thus defined is art and creation, and

the question is how ruptures in the event of art disclose truth. Badiou, like Heidegger, does not see ruptures as sufficient in themselves to remedy the forgetting of truth. Puzzling, unexplained, undecided, and questionable things within readily familiar situations can remain in the realm of the inessential. What is required, then, according to Badiou, from ruptures in the texture of knowledge, for truth to be disclosed?

A subject for Badiou is a "someone" a spectator in the domain of art, "whose thinking has been set in motion, who has been seized and bewildered."[41] The "someone" is caught up in a truth process, where he or she is both himself or herself and in excess of himself or herself "because the uncertain course of fidelity *passes through him*, transfixes his singular body and inscribes him … in an instant of eternity."[42] The someone is hence a referent of knowledge taken up in the immanent break of a truth process; he is the mark of what cannot be reconciled between his own (instituted) situation and the becoming of truth that "passes through that known multiple that he is."[43] Thus truth is something that emerges when one is facing an event that requires a readaptation of a situation. The subject in a given situation (in politics, science, art, or love) is caught at the moment of immanent rupture in the knowledge of a situation, and this rupture is called *truth*. For Badiou, the subject, in his or her position of self-preservation guaranteed by a law, is ruptured by a unique possibility that cannot be adapted to his or her simple self-persistence.

Persistence hence should be rethought: it is the mingling of the singularity that cannot be known with the persistence of what is known. Badiou links this notion of truth with Lacan's ethical imperative "do not give up on your desire!" This imperative equally demands that the subject subsists in his/her willed situation while also being caught in it as an event of truth.

Badiou's conception of truth stresses truth's unknowable nature, on the one hand, and the fact that the only way to learn about truth is through the rupture it creates in what is known in a given situation, on the other. Badiou later uses the notion of communication to discuss how one can learn about truth. Truth, unlike supposition, cannot be communicated. To be admitted into the composition of a subject of truth can only be something that happens. Thus, since truth requires an encounter in order to occur, the ethics of truth is absolutely opposed to the ethics of communication.[44]

The present discussion of Badiou's and Lacan's conceptions of truth is designed to clarify why truth is that which cannot be articulated as knowledge and yet only the event of transmitting knowledge may create

an effect of truth. By articulating knowledge so that it creates the effect of the half-said, by disclosing a rupture that cannot be dismissed in terms of the familiar situation, knowledge will be able to reside in the place of truth without the former overlapping the latter.

Truth has a vanishing nature, claims Badiou; it "proceeds as the trace of a vanished event; a situation immanently supplemented by the becoming of its own truth."[45] Truth is not interpretation because it is not ruled by meaning. This distinction from interpretation explains why analysis is not the discovery of truth: "the sole remaining hope is that analysis would consist in forcing a knowledge into truth through the risky game of anticipation, by means of which a generic truth in the process of coming into being delivers in fragmentary fashion a constructible knowledge."[46] The aim of analysis is to produce knowledge unto truth while acknowledging their non-coalescing nature. Badiou thus predicates truth in a way that should account for its divergence from any articulated knowledge. Truth, as a rupture, outside of the self-persistence of the subject, cannot be given to articulated knowledge, nor can knowledge overlap truth.

Why do we need the recognition of truth as rupture to produce an effect of truth? Lacan in Seminar XVII claims that "the love of truth, is the love of this weakness whose veil we have lifted, it is the love of what truth hides, and which is called castration."[47] Castration marks both the truth one desires to unveil and the veiling itself, but in what way? Lacan concludes this seminar by formulating the idea that *truth has the structure of fiction*. Castration is such a fiction, portraying the event of concretely depriving the subject of an organ or piece of enjoyment. Castration is not only the weakness or lack disclosed but also what is hidden by truth, which means that the love of truth produces a myth by which truth is veiled. In other words, the love of truth produces something behind the veil to be unconcealed, but this something, when unveiled, is a fiction. Castration holds the power for propelling the entire machinery of the human psyche because it half-says the truth about the subject. Castration is the master signifier of the unconscious, even if it has no signified, even if does not tell a truthful event. For Lacan, the truth to which we aspire is the truth that resides in this mythical hidden kernel, which creates its effects on our lives because of our love for truth. *Castration would not occur at all, nor would truth be hidden, had we not loved truth.* Castration hence is a mythical disclosure and a signifier of lack, which the love of truth produces. It is a mythical kernel that has no reality prior to its articulation. And yet, in its very structure, it produces effects of truth on our psychic life and motivates our desire to attain truth. Earlier in his

teaching, Lacan asserted that "in all fiction correctly structured, one may touch this structure which, in truth itself, is designated as that of fiction. The structural necessity of every expression of truth is really a structure which is the same as that of fiction. Truth has a structure of fiction."[48]

This notion of truth refers to the (disjunctive) structure of utterances through which the love of truth is carried out, more than to the content of statements. These utterances obey the general structure described in chapter 1: the truth is that I am lying: it is through mythical fictions that truth can be told. This understanding of truth should be further anchored in Lacan's analysis of the content of myths. Myths show no interest in the birth of individuals but rather focus on the genesis of man's fundamental relations of nourishment, the invention of human resources such as fire and agriculture. The myth questions the rapport of man with a sacred power of malignance or beneficence. The myth tells of how man came to be related with a sacred force, and through the myth the power of signification is manifest. It is the power of the signifier, says Lacan, that can exhibit mythical relations: "through the instrument of language a number of stable relations are established within which there can be inscribed something that is much larger, that goes much further than actual utterances. There is no need for these utterances, for our conduct, for our acts, to be inscribed within the framework of certain primordial statements."[49] The idea of truth having the structure of fiction is connected to the fact that truth is revealed through the articulation of a structure that seizes something of the impossible. Myth, as the establishment of an impossible relation between man and something much larger, is hence a demonstration of the true, and the love of truth is precisely what is needed for a myth to be articulated. In articulating the impossible story about mankind, the relation between the desire to know and the hiddenness of truth in fiction necessarily takes on the structure of myth. Hence truth has more than one visage yet is invariable, with that invariability exhibited in the structure of impossibility it produces. Truth is revealed in something impossible and real that we get hold of through myth without being able to articulate this truth apart from the myth because the myth is committed to telling the primordial impossible relation of man to the universe.

The claim of art to truth does not mean that we "become all of a sudden mad about truth, about the first pretty face encountered at the first turn in the road."[50] Within the artistic work, our desire to know meets the kernel of myth, positing the bare impossibility of articulating truth through knowledge. It is this impossibility of exhibition that constitutes what we call here, after Lacan, truth as a structure of fiction.

Following this line of thought, a similar approach to the effects of truth beyond the true-false divide can also be found in Kant's aesthetic theory. Since in order to appreciate objects of beauty the subject must follow an *archetype of taste* (an invariable ability that connects an idea of reason to an actual image), Kant proposes the notion of an *ideal of beauty*. In other words, an ideal of beauty is needed to explain the ability to judge beauty ex nihilo, from nowhere. The prerequisites named by Kant for having an ideal of beauty are an idea of reason (of the ends of humanity) and an aesthetic norm that by force of the imagination can be assigned to a model image. The ideal of beauty, in its relation to a norm (which is an imaginary idea of proportion or measure), is presented by Kant as an *effective fiction* that, while determining the possibilities of its exhibition, "is not derived from proportions that are taken from experience as determinate rules. Rather, it is in accordance with this idea that rules for judging become possible in the first place."[51] The ideal of beauty is fictional in the sense that it cannot be located anywhere; it is an indeterminate idea "hovering between all the singular and multiply varied intuitions of the individuals," and yet not present in any individual.[52]

This fictional ideal of beauty, rather than knowledge of beauty, is what drives us to judgment. An ideal of beauty is the half-said truth of Kant's theory of beauty: it is necessary for the articulation of a theory of taste and yet reveals the rupture between presentation and reason in the theory itself. While the ideal is fictional, its effects are truthful and can be detected in every manifestation of beauty, in every instance where beauty is captured in the image. This is the structure of fiction par excellence, which views the myth about beauty (in terms of the proportions of the human body or any other determinate rule) as the condition for creating an effect of beauty in the subject who desires beauty.

The story of truth is bound to be recounted through the safe foundations of articulated knowledge without being identified with it. In art, truth is disclosed through a fictional kernel (exhibited in a mythical story or image) by means of which knowledge is articulated. Fiction, which is itself an act of veiling truth, thus becomes the hidden thing that the desire for truth unveils. Art's being uncommitted to the true or to the false thus exhibits its desire for a truth that can only be half-said, that can only be said by way of fiction.

c. The Truth of/about the Law

In Seminar XVII, Lacan unfolds the structure of the discourse of the analyst as a discourse in which S_1, the master signifier of all knowledge,

is positioned as the effect or product of discourse. Lacan also tells us that what stands as the effect of a discourse can be rejected.[53] What is the meaning of turning S_1, which stands in the place of the agent in the discourse of the master, into the product of the discourse of the analyst? Does it mean that S_1 is rejected or played down in the discourse of the analyst? Which discourse holds the key to the truth about the law? Lacan clarifies that the truth about the law is not that of the law that plays a role in the discourse of justice. Finding recourse in justice as the source from which the law's authority is derived, is a way of misrecognizing the place the law is assigned in these discursive structures (of the master and the analyst). Under the heading of justice the law appears ambiguous and full of trappings, because it is not in the juridical terms of justice that one can find the law's true resources. S_1 takes the dominant place in the master's discourse and is the product of the discourse of the analyst because the analyst's discourse can shed light on why the law cannot be made sense of in the domain of the master, why we cannot say the truth, the whole truth, and nothing but the truth about the law, even when the law appears as the discursive agent. In the discourse of the master, S_1 stands for a pure signifier that cannot be made sense of and yet organizes our world and our knowledge. S_1 is that which conditions knowledge itself. What can be the status of any system of philosophy or of science without a signifier that ascribes to this system its raison d'etre, its constitutive force? "nature" for Spinoza, "god" for Descartes, "reason" for Kant, and "father" for Freud are such master signifiers that hold together the entire system of knowledge, even if in themselves they have no determinate signifieds and can be assigned variable cognitive content. Yet these master signifiers function as the axis without which the system would collapse. We cannot tell what is behind S_1; we know only that it appears as a principle of lawfulness, of authority and regulation, as the arche-sign that organizes knowledge.

The law structures the master's discourse, assigning authority to the master's words, and hence S_1 stands in this discourse in the place of the agent. For Lacan, the master's discourse is the paradigmatic discourse that implies that the law is part of a discursive structure and cannot be withdrawn from discourse, and yet Lacan says in Seminar XXIII, "The real is without law. The true real [*le vrai réel*] implies the absence of law."[54] The real for Lacan is jouissance, and the question is how can the law regulate jouissance and yet be absent from jouissance? As the aim of psychoanalysis is to articulate something regarding this real, does it mean that in the psychoanalytic discourse the law is dysfunctional?

The master's discourse assigns to S_1 a totally fictional role, as the source of the organization and authority of knowledge, S_1 organizes knowledge while remaining outside its scope. In contrast, the discourse of the analyst assigns to S_1 its truest role – that of the *permanently deferred*. In the analytic situation, S_1 is first located in the place of the analysand and then with the analyst: "I have often insisted on the fact that we [analysts] are not supposed to know very much at all."[55] In analysis the analyst relinquishes the position of knowledge and hence the possession of S_1 as what directs the treatment. At first, the analyst tells the analysand, "*Away you go, say anything whatsoever, it will be marvelous.* He [the analysand] is the one that the analyst institutes as subject supposed to know ... And the transference is founded on the fact that there is this character who tells me – me, the poor bastard – to act as if I knew what it was all about. I can say anything whatever, it will always produce something."[56] The analyst and the analysand assume, at different moments, that the other knows something. S_1 hence refers to the assumption that the other knows, an assumption that undergoes constant vacillations throughout the analysis. However, this readiness to risk oneself through the other does not explain in what sense S_1 is produced in the discourse of the analyst. After all, the source of knowledge is clearly the participants in the analytic situation, whereas S_1 should stand for the hidden signifying source of knowledge itself.

Significantly, S_1 cannot be identified with what the analyst stands for in terms of his/her practice. The knowledge of psychoanalysis held by the analyst is powerless in relieving and giving sense to the suffering of the analysand. The analyst stands in the place of psychoanalytic knowledge, which turns out to always fail in relation to the case at hand. Thus, entrusting S_1 to the analyst, who, through his/her formation as an analyst, can assume psychoanalytic knowledge in every analytic encounter and who can know something about the truth of the subject, would maintain the discourse of the analyst within the confines of the discourse of the master. Psychoanalysis, however, questions the possibility of such psychoanalytic knowledge being applicable or useful to the particular subject who seeks the fruits of this knowledge. An analyst who is content with psychoanalytic knowledge is unlikely to be of help to the one represented in the analytic situation as a barred subject (\mathcal{S}) – the subject split between the knowledge that comes from the Other and the real kernel of truth that seems to escape knowledge or signification. If the discourse of the analyst does not rely on the knowledge originating from the psychoanalytic master signifier, what function is left for S_1? As we have seen,

in the analytic situation, the knowledge of the Other is assumed, and thus S_1 must be kept part of the analytic dialectic as it definitely holds some of the relevant strings.

S_1 that appears to manage knowledge in the discourse of the master turns out to regulate something other than knowledge in the discourse of the analyst. What does this change of position reveal about the nature of the law? Psychoanalysis consistently assigns a predominant place to the One: the signifier of the law, of authority, of the categorical imperative, is put in the forefront (from the father of the primordial horde in Freud to the Name-of-the-Father in Lacan). S_1 at the bottom right hence does not mark the limit of the psychoanalytic discourse. S_1 is the law of the Other inasmuch as the subject's desire is the desire of the Other. In other words, through the discourse of the analyst we discover that when truth about the law is not occluded by imaginary signification (in terms of justice or the good), when knowledge does not cover the place of truth, the law that aims to regulate stands separate from (and is impotent towards) what it should regulate: the cause of desire. The discourse of the analyst is concerned with the cause of desire, with the question of origin (marked by a), and this cause and origin are distinct from the continuity assumed by the law, even though the law aims to manage whatever the cause of desire produces in the life of the subject.

The discourse of the analyst hence illustrates something crucial about the relation between the law and the cause; it reveals the truth about the law by placing the law in relation to the origin of the law and in relation to what the law cannot regulate. The law, which aims to regulate what lies as its cause (the absolute jouissance of the primordial father), also establishes the place that approximates the truth. Truth remains unavowable in relation to the law, that is, in relation to the element of jouissance that the law aims to regulate and that always remains as the capricious, tricky dimension of the law. The cause is unaccounted for; otherwise, it would be continuous with a law that allegedly governs it. There is a cause, claims Lacan, only where there is a *failure* of the law.[57] In this discourse of the analyst, where knowledge attains the place of truth, the effect of this attainment is that the law is positioned at the other end. Where knowledge is disjointed and the truth is only half-said, it will not be possible to make one's way back into structural laws that allegedly incorporate the cause. What is implied in the discourse of the analyst (on the bottom line) is hence the reverse of the deceptive control of the law in the discourse of the master (on the upper line): $S_2 \rightarrow S_1$. This structure, where knowledge occupies the place of truth at the left and

the place of the law (master signifier) is on the right, reveals why the discourse of the analyst represents the unconscious. In other words, disconnected knowledge and the dynamism of the work of truth constitute the place of the unconscious discourse, a discourse that "is responding to something that stems from the institution of the discourse of the master himself."[58] S_1 is not the law of justice, the social law of ethnography, or the law of science. It is not the law that regulates a given situation in terms of an empty ideal, but the law whose truth lies in its origin, the law that constitutes the ethics of psychoanalysis. The law in the discourse of the analyst fails to regulate the object of jouissance at the origin of the law, which is why the truth about that origin is kept outside the control of the law. The end of this law is an absolute regulation of what cannot be regulated, which in Freudian terms is called the Oedipus, and this failure of regulation has nothing to do with circumstances of family, systems of justice, or social values.

This solution for the place of truth, knowledge, and the law is suggested in the context of Lacan's discussion of truth in Seminar XX. There Lacan makes the following argument: "The truth sought is the one that is unavowable with respect to the law that regulates jouissance."[59] The cause of the law is the subject's jouissance and, hence, the truth about the law cannot be approximated by speech (even if the subject is demanded "to say the whole truth and nothing but the truth"). Since the truth about the cause of desire cannot be said, truth should not be confused with the real (i.e., truth is a half-saying of a jouissance that is unavowable). The law of jouissance (which sets limits to it) can never be implemented: "it [truth] can only be told on the condition that one doesn't push it to the edge, that one only half-tells it."[60]

When knowledge of the order of S_2 appears in the structural place of truth, it means that knowledge about truth does not attain an ideal but rather is hollowed out by a truth that has the structure of fiction. This structural merging of knowledge and truth can mean only one thing: that the law regulating the subject's jouissance, the absolute manager of the attainment of knowledge, is a false notion, a necessary effect at the moment when knowledge attains the place of truth. Kant was mistaken, claims Lacan, in thinking that the whole truth about jouissance can be affirmed. Kant assumed that the subject, when asked to be truthful to the tyrant and deliver his rival or enemy to the ruler, affirmed what the moral law requires, that is, said the whole truth. Kant could not see that the truth cannot be wholly told, which makes his moral injunction disturbingly immoral. This blindness on Kant's side sparks reservations in

all of us. The absolute law controlling what can be known of the truth is hence the product of the discourse of the analyst, because it discloses the route taken by the law from the place of meaningful authority to the blind capricious regularity which controls jouissance while being constantly fooled by it. In this sense Kafka's "Before the Law" produced truth structurally in exactly the same way, exposing the fact that while the regulating facade of the law is apparent, the cause of the law remains outside this regulation, behind (or rather at) the gate of the law.

This alienation between the law and the cause is what psychoanalysis discovered, since the case of each particular subject creates a hole in knowledge, an irreducible enclave in what can be known or said. Hence S_1, the law that aims to regulate and structure desire through a false continuity and control, is necessarily impeded in every analytic situation. To approximate something of the subject's truth, of the cause of desire, the law must fail in its attempt to produce modes of actions and subjective practices. *The truth about the law is that it immanently fails to correspond with any human practice.* This is the truth about S_1 unveiled by the discourse of the analyst.

Art is a domain where the impossible place of the law as a necessary regulator of jouissance and as what fails in this regulation, in the sense described above, is practically disclosed. This is the truth that art half-says. Art does not reject the law but is true to the law as an absolute yet impossible regulator. In the fifth chapter of this book, I will consider the possibility of artistic creation in the shadow of the Second Commandment (of the Decalogue), which prohibits the creation of images. Art in general, and certain art practices in particular, forcefully exhibits the fact that the law cannot absolutely regulate, in the sense that it cannot regulate what it aims to regulate. Art before the law is hence committed to half-telling the truth about the absolute law. This law universally aspires to regulate human actions but always remains indeterminable, falling short of practice itself.

The death of the father of the primordial horde, as described by Freud, did not free us from the law. Its persistence is demonstrated through the natural successor to the primordial father in the religious god who deserves to be loved. The death of god is not a permissive occurrence but a paralysing one. While the living primordial father forcefully prevented enjoyment from his sons, the law of the dead father or of a dead god prohibits enjoyment by way of the law of the word.[61] The law is needed for the subject's ability to enjoy, and yet the law does not merely introduce a restraint on jouissance, nor is jouissance the transgression of the

law. The law as a signifier, as the voice of morality, is not the other side of jouissance or of desire. It is only by way of the law that jouissance, as the cause of lawfulness, is situated. This is why the discourse of the analyst places in the forefront the particular object that eludes knowledge, that perforates the law with that which necessarily renders the law empty of sense yet powerful.

This chapter has addressed the question of truth in its relation to the law and has unfolded the case for art as revealing the truth about the law. The law as the regulative principle of action contains a kernel of jouissance, identified with the law's origin and cause, which cannot be articulated or avowed. Hence the truth about the law is that there is something about it that cannot be said but only partly said. The truth about the law needs the support of semblants, of fiction, and of myths. These are forms of half-saying that clarify that what can be known or said about the law is not equivalent to its truth. Art, the practice that adopts modes of expression beyond the epistemic distinction between true and false knowledge, is the practice that in this sense can transmit the truth about the law. Beyond epistemic truth lies the possibility of knowledge to which art can commit itself ethically. It is this positioning that will enable the art that deceives to become capable of being truthful to that which cannot be articulated and yet to which every artwork, as every human practice, is committed. I will therefore turn in the next chapter to the deceptive artistic mode par excellence: trompe l'oeil.

4

By Way of Deception

(WRITTEN WITH EFRAT BIBERMAN)

Surely, as I said just now, this would be most correctly called true falsehood –
ignorance in the soul of someone who has been told a falsehood. Falsehood in
words is a kind of imitation of this affection in the soul, an image of it that comes
into being after it and is not a pure falsehood. Isn't it so?[1]

a. Trompe l'Oeil: Ultimate Realism or Its Extreme Reverse?

When King Henri VIII, in search of a fourth wife, asked Hans Holbein,
the court painter, to draw portraits of young women for him to choose
the most beautiful among them to be the next queen, he was in for a
great disappointment. The king soon realized how deceptive a visual
image can be: Ann Cleve, the chosen beauty, turned out to be far less
attractive than her portrait suggested. Thus, the painting that was meant
to function as a transparent representation turned out to be misleading
and unfaithful.

This case exemplifies the naive assumption that, granted the limi-
tation of any representation, aspects of reality can be pictorially
reproduced as much as modified or manipulated. Against this ideal of
accuracy (which fluctuates throughout the history of art), art manifests
a variety of deviations, as well as possibilities of error and failure. But
there is a counter-practice designed to overstep the inherent limitation
of a faithful visual rendering, a practice that may erroneously seem to
be part of the representational tradition and an attempt to excel in it.
This is the case with works of art that explicitly attempt to deceive the
observer into believing that the representation *is* in fact the object itself.
A paradigmatic story that aims to reveal the essence of this artistic prac-
tice is the one about the famous competition between the two Greek

painters, Zeuxis and Parrhasios. According to the legend, while Zeuxis succeeded in misleading the birds into trying to peck at his voluptuous painted grapes, the great Parrhasios misled not simply an animal, nor even another human, but a skilled painter: Zeuxis himself. When shown the painting, the latter tried to unveil Parrhasios's painted curtain, in an attempt to reveal what he thought would be the "real" painting hidden behind it. Unlike Holbein, whose official task was to provide the king with an accurate depiction, these ancient Greek painters had the ambition to achieve a perfect reproduction, an ambition that was motivated not by loyalty to truth but by a wish to deceive the viewer. The present chapter presents the truthful effects produced by deception and argues that these truthful effects are associated with the deceptive mode of trompe l'oeil because it is the ultimate artistic practice that discloses the essence of the aesthetic (representational) imperative "Produce an image true to reality as given!" Trompe l'oeil reveals and sustains, through its deceptive semblance, the relation between creative practices and aesthetic laws.

Trompe l'oeil, under the representational imperative, paradoxically does not convey knowledge about its object (knowledge of beings and their world), nor knowledge of correct modes and methods for reproducing reality. Truthful effects do not depend on knowledge, and the unfolding of truth is not equivalent to an articulation of knowledge. Trompe l'oeil is a practice, like any other practice, that does not seek to attain knowledge but truth. The practice of trompe l'oeil will show that knowledge is always missed. Once the effect of deception is attained, our eye is trapped in a way that cannot be identified with what is known of the world or what is known of modes of reproducing the world. Knowledge is likewise irrelevant once the deception of trompe l'oeil is exposed because trompe l'oeil is a practice in which deception necessarily fails. In other words, the dynamics created by a practice, as in the practice of *work* assigned to the Hegelian slave, do not and cannot attain a moment when the subject's position is identified with knowledge of an object. When work is completed the slave is no longer in control of the object; the object remains alien to the cognition of the one who works, the one who carries out a practice.

The work of the slave, says Jacques Lacan, does not produce knowledge but only the truth of the master, a hidden truth that "needs to be unfolded in order to be legible."[2] That is, it is the work of the slave, and the slave's relation with the product of his work, that will disclose the truth about the master's discourse. Work in the service of the imperative does not produce knowledge for the subject nor for the Other. Truth is legible

in the domain of work because knowledge about work and its products is at the hands of the slave as practical yet unarticulated knowledge, while this knowledge is inaccessible to the master. Similarly, in trompe l'oeil, creation in the service of the representational imperative relies on the master not knowing what reality is like so the master falls into the trap of deception. However, the practice of trompe l'oeil, relying on something that remains hidden, produces, through the creative process, truth about the nature of representation: that representation is a demand that cannot be attained. Thus, in trompe l'oeil, which unlike mimetic artworks counts on truth being disconnected from knowledge, knowledge must be parenthesized (both from the master – the receiver – and from the practitioner) for truth to be revealed. To appreciate a trompe l'oeil, knowledge is suspended to meet the object unmediated by concept or method.

Routinely we assume that the appearance of truth created by artworks is a product of the implementation of knowledge; for example, perspective paintings create an appearance of three-dimensional space by relying on knowledge of how to use geometry to create the correct effect according to the law of perspective. Louis Marin, in his book on representation, establishes the grounds for defining a distinct place for trompe l'oeil in its relation to representation. He claims that the object of mimetic art is absent, which constitutes the condition for mimetic painting functioning as a window to the world. In contrast, the object of trompe l'oeil is annihilated, which Marin describes in terms of simulacrum and the blackness of the painting. Mimetic art is disengaged from its commitment to the object, thus making way for the elements of the representational exchange, such as the gaze, vision, and surface, to occupy the field of art's claim to truth. Marin maintains that mimetic representation does not make us believe in the presence of the thing itself in the picture; instead, "it *lets us know* something about the position of the subject thinking and contemplating the world, instructing us, as theoretical subjects of truth, about our rights and our powers over the 'reality' of 'objects.'"[3] This displacement of the observer to a place where, with the support of knowledge, the world can be contemplated from a distance cannot occur in trompe l'oeil, where we face the shock of the presence "of a Beyond that no one can represent in figures."[4]

Marin's analysis suggests that trompe l'oeil brings about the presence of the object away from the support of knowledge. For Marin, the object made present by trompe l'oeil cannot be the object of representation, as is the case in mimetic art, but only the metaphysical object of abstraction, which is thus outside aesthetic considerations. But there is another

possibility for rethinking the way trompe l'oeil unfolds the truth of the object through peculiar modes of presentation so that trompe l'oeil turns out to reveal an immanently aesthetic mode of unfolding truth. The object of artistic deception imposes a presence that transcends the question of true or false, present or absent, and in this transcending that is peculiar to art, trompe l'oeil severs the truthful effect of the artwork from what the observer knows or can know about the represented reality.

> The point is not that painting gives an illusory equivalence to the object, even if Plato seems to be saying this. The point is that the *trompe-l'oeil* of painting pretends to be something other than what it is.
> The picture does not compete with appearance, it competes with what Plato designates for us beyond appearance as being the Idea. It is because the picture is the appearance that says it is that which gives the appearance that Plato attacks painting, as if it were an activity competing with his own.[5]

The paradoxical affinity between apparent deception and effects of truth reveals something fundamental and singular regarding artistic practice: an effort-unto-truth that acknowledges its immanent failure, which I suggest should be identified with the ethical standing of the creative act. Plato condemned painting for its deceptive nature, for pretending to bear knowledge it actually lacks. This knowledge is rightfully attributed to the skilled craftsperson, not to the maker of falsified shadows. Thus Plato offers a sharp distinction between the truth, which is the desirable object of philosophy, and the elusive and deceptive image of art. Trompe l'oeil stands as the ultimate example of art's deceptiveness. Yet as seen in the above-cited passage from Lacan, the menacing power of a trompe l'oeil lies elsewhere. Even for Plato, the illusory function of the trompe l'oeil does not imply the *faking* of a real object by means of pretence but rather a competition with the philosopher's ambition of obtaining the truth. Trompe l'oeil images pose a threat to philosophy not because of their mimetic value (conveying knowledge about reality), established through mere appearance, but because they unfold a truth about causes that lie beyond appearance, a truth that belongs solely to the philosopher. Thus, art is condemned for its effort-unto-truth (while employing the wrong means) rather than for its deceptive nature. We saw in a previous chapter that for Immanuel Kant also, the deceptive image reveals a certain know-how, a dexterity in practice by means of which the image can equal nature. Beauty, for Kant, requires an effort that Kant described as "punctilious" and "painstaking."[6]

Lacan's claims above can hence be accommodated with these observations regarding Plato and Kant. Lacan challenges two routine ways of understanding the artistic case of trompe l'oeil. First, he indicates that the import of trompe l'oeil has nothing to do with the artistic drive towards mimetic illusionism or realism, even if this practice makes the truth about mimesis legible. In the case of trompe l'oeil, as in any case of reproducing reality (e.g., traumatic recurrence), the replication of reality does not have factual reality as its measuring standard, nor does it convey knowledge about reality. Second, while trompe l'oeil may appear to be the ultimate case of achieving truthfulness by means of pretence, thus establishing its truth outside the domain of philosophy, trompe l'oeil in fact configures a truth that competes with the truth to which philosophy aspires. Trompe l'oeil is measured in relation to the Idea rather than in relation to the reality it deceptively reproduces.

In his *Handbook of Inaesthetics* Alain Badiou describes the relation between art and philosophy in terms of the relations between the hysteric and the master, as presented by Lacan in Seminar XVII: "the hysteric comes to the master and says: 'Truth speaks through my mouth, I am *here*. You have knowledge, tell me who I am.'"[7] Regardless of the master's reply, it will always encounter the hysteric's dissatisfied response: "that is not yet *it*," thus "barring" the master from his mastery. Similarly, art declares its disappointment with any solution the philosopher may propose to account for the artistic claim to truth. Badiou attempts to circumvent this inevitable failure by rethinking the truth of art as philosophically relevant yet distinct and singular compared to philosophical truth. The history of this relationship between art and philosophy, according to Badiou, displays a variety of modes by which philosophy unsuccessfully attempts to grasp the singularity of art. Philosophy is unsuccessful because its solutions do not respect the demand that art's truth be both singular (unique to artistic modes of expression) and immanent (to the artistic forms themselves). This lack of success can also be formulated in terms of philosophy's unavoidable attempt at a universalization of truth, a solution fundamentally alien to the interests of art. By viewing art either as incapable of truth (a didactic approach) or as the only practice capable of truth (a romantic approach), or by placing art in a domain entirely devoid of any claim to truth (the classical-Aristotelian schema), philosophy is pushed into the position of the castrated master who fails to satisfy the hysteric.

Following Badiou's analysis, this chapter aims to extrapolate the relation between trompe l'oeil and the truth to which philosophy aspires as a relation that reveals the singularity of art. We shall claim that the

truth disclosed through deception is unique to art, and we will attempt
to show how this truth is relevant to the position of art in relation to the
law formed to regulate artistic practices.

Trompe l'oeil is assigned a non-trivial and even paradigmatic position
in the intricate struggle of art towards truth. It appears to have nothing
but a false surface, but, similarly to the radical doubt that produces the
certainty of the Cartesian cogito, trompe l'oeil gains its substantiation
through the radical subtraction of everything but its facade as a form of
display. In other words, while trompe l'oeil is deception par excellence,
by way of negating every aspect of truthful representation and effective
verisimilitude, it turns out to affirm a truth regarding the real object
involved in representation (as suggested by the analysis of negation pre-
sented in the first chapter).

Let us linger shortly over the nature of this artistic genre, which shows
a striking persistence in art history. Trompe l'oeil persists in art history
in what seems like compulsive repetition, like reproduction of a petrified
kernel, which suggests it cannot be easily dismissed as esoteric, manner-
ist, or manipulative. Unlike other artistic genres such as portraiture or
landscape painting that have undergone great modifications, reflecting
changes in style or subject matter, trompe l'oeil artworks appear to tran-
scend such contingencies and are scarcely influenced by artistic modes
or movements. Their shared goal of deceiving the spectator has led
trompe l'oeil artists to employ similar modes, rendering them immune
to historical stylistic changes. Thus, a painting of a letter rack painted
by Samuel van Hoogstraten in the seventeenth century (Illustration 2)
resembles in many respects the letter rack painted by John Fredrick Peto
in the late nineteenth century (Illustration 3) in ways that exceed the
common subject matter. Likewise, Parrhasios's curtain can be said to
resemble the effects produced by the highly crafted shades (made of
cardboard) of the contemporary artist Thomas Demand (Illustration 4).

Neither the changing faces of objects in reality, nor changes in the his-
tory of art seem to affect this artistic practice. In other words, it appears
that images that deceive our eye function as pure signifiers in the sense
that they cannot be examined in terms of their accord with a certain
object in reality that these images are designed to render.

The persistence of trompe l'oeil throughout art history suggests an
essential function it fulfils that is indifferent to historical changes (an
indifference that attests to the distance of trompe l'oeil from concerns of
representation). We argue that trompe l'oeil, through absolutely deny-
ing the relation between the truth of art and images' representational

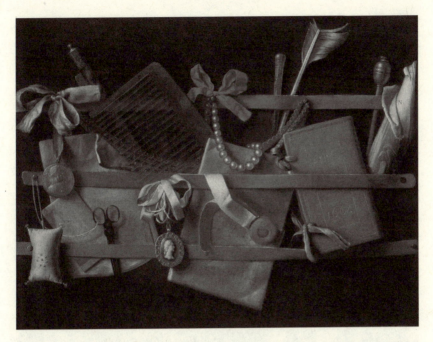

2 Samuel van Hoogstraten, *A Trompe l'Oeil of Objects Attached to a Letter Rack*, 1664. Johnny van Haeften Gallery, London, UK. © getty images/Bridgeman

value, affirms a place of truth for art. This truth is affirmed in relation to an absolute imperative that art immanently fails to satisfy.

The artwork of trompe l'oeil thus manifests the following duplicity: in its attempt to trick the observer into believing it is the real thing, it acts in total commitment to the power of representation; yet trompe l'oeil exposes the absolute deceptiveness of this commitment. Trompe l'oeil replaces the claim to representational truth with radical deception (adopting extreme possibilities of feigning the real thing and not merely its appearance), thus seeming to epitomize Plato's conception of the artist's degraded pretence. Yet trompe l'oeil takes this pretence a step further by actually *exposing* the deception immanent to representation (trompe l'oeil is equivalent to the contradictory utterances "this is the thing" and "this is not the real thing but only its deceptive semblance"). Trompe l'oeil is a mode of negating representational truth in practice, a negation that affirms that art speaks the truth from a different place than that of representing well or truly. Art can substantiate its form

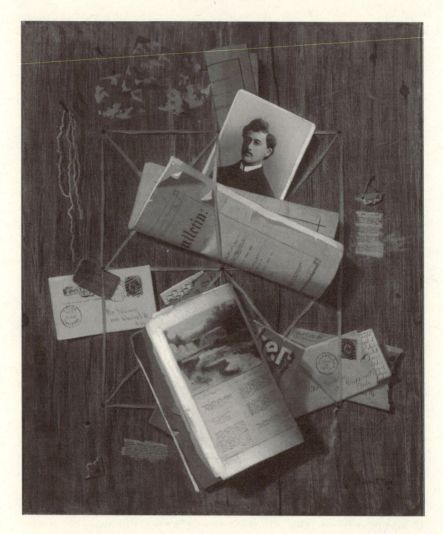

3 John F. Peto, *Office Board*, 1885. George A. Hearn Fund, 1955 (55.176). © The
Metropolitan Museum of Art.

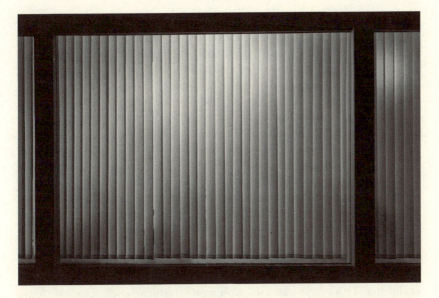

4 Thomas Demand, *Fenster/Window*, 1998. C-Print/Diasec, 183.5 × 286 cm. © Thomas
Demand, VG Bild-Kunst, Bonn/Sodrac, Montréal

of appearance only by denying the value of this appearance, thereby
affirming a place from which the artistic form originates. Trompe l'oeil
aspires to the place where the image is not, and this is the place of the
thing ("it").

If art cannot speak from the side of truthfulness to the object (as it is
a deception) nor from the side of deception (since it practically exposes
the deception) – the two possibilities exhausted by trompe l'oeil – where
does art speak from?

As indicated above, visual expressions of trompe l'oeil appear across
the boundaries of time and place: in Pompeii's floor mosaics; in the
Renaissance architectonic illusions, as in Sandro Botticelli's studiollo of
Urbino; in baroque Dutch still life paintings; and in American art of
the late nineteenth century. Although trompe l'oeil paintings appeared
mostly around the fifteenth to nineteenth centuries, it is still a relevant
term for discussions of contemporary art, from super-realism to the
works of Jasper Johns. Contemporary artists such as Peter Fischli and
David Weiss and Thomas Demand have also been viewed as taking part
in this genre, gaining world acclaim for the art of deception.

Trompe l'oeil also holds the constant attention of art theoreticians and of philosophers of art. Ernest Gombrich, W.J.T. Mitchell, Richard Wolheim, Arthur Danto, Jean Baudrillard, and Louis Marin have referred to the question of trompe l'oeil as touching on crucial problems in art theory and aesthetics. As was already shown through Marin, trompe l'oeil is claimed to occupy a particular place in relation to the mimetic tradition, manifesting the extreme inversion of the mimetic drive. The interpretations given to trompe l'oeil artworks are diverse, suggesting a variety of readings. Yet by and large they share the view that trompe l'oeil, although by definition an attempt to deceive, has an impact that cannot be exhausted in terms of deception and its exposure. Unlike Marin, art theoreticians tend to approach trompe l'oeil in strictly representational terms or in light of visual considerations, rather than by posing the question of the truth effectuated by trompe l'oeil. Gombrich, for instance, typically claims that trompe l'oeil elicits "a visual experience of a kind that we know from our encounters with reality."[8] We are surprised to react to a painting in a similar way as we would to an encounter with a real thing. This accentuates the observer's cognitive compliance with the visual deception but also locates trompe l'oeil on the same axis as other works that aim to achieve realism. Hal Foster refers to super-realism as what "seals (the real) behind surfaces … embalm[s] it in appearances."[9] Both Gombrich and Foster point at the connection between trompe l'oeil and a deeper sense of reality, but in opposing manners. While Gombrich claims that these paintings have a "reality-like" appearance, for Foster this same quality that Gombrich indicates in fact blocks the real object behind appearances. The opaque nature of trompe l'oeil is explained by both in terms of the dialectic between the illusionistic form and the object of representation, which, in the case of trompe l'oeil, remains reality itself.

To establish his argument, Foster offers a reading of Lacan's concept of the gaze in Seminar XI (*The Four Fundamental Concepts of Psychoanalysis*). Foster attributes to Lacan the view that human vision incorporates two positions. The first relates to geometric perspective, which positions the subject at a geometric point from which he/she masters the object of observation. The second position assumes an inverted relation, when the subject notices the gaze of the Other in the picture, thus turning himself/herself into an object of observation. "It is in this way that the eye may function as *objet a*, that is to say, in the level of the lack."[10] According to Lacanian terminology, object *a* (which takes on various functions throughout Lacan's teaching) denotes an object of lack, which obeys a peculiar logic and arises only as a place of absence. Following Lacan,

Foster mentions the story of Zeuxis and Parrhasios, concluding that "the animal is lured in relation to the surface, whereas the human is deceived in relation to *what lies behind* ... This is so because the real cannot be represented; indeed, it is defined as such, as the negative of the symbolic, a missed encounter, a lost object."[11]

Foster's reading of Lacan points at an important aspect of the real as an object of lack (object *a*): it is an object that does not lie behind or beyond the screen but is affirmed through the *negation of the surface*. In the encounter between the screen in its visible aspect and the subject, the subject realizes something excessive about the image, that the seen object does not exhaust visuality. The image or screen of the seen object must be negated for something invisible to be disclosed *visually*.[12] For Lacan, the invisible is the object *a*, the place on the canvas marking the place from which the observing subject is being looked at, a position he or she cannot occupy. This absent gaze cannot lie beyond the visual field but rather is an excess produced in the visual field itself. Through the materiality of the screen the gaze is disclosed as the impossibility of knowing what the Other sees in me from the position where I am not. In this sense the screen must disclose the place of a lack in the subject's field of vision. Trompe l'oeil attempts to mark the presence of the subject through this object-in-reverse revealed in the actual image through the meticulous reproduction of the object's appearance. According to this view, trompe l'oeil remains within the game of representation yet is committed to the object lacking from the visual field, thereby signifying the failure of the representational episteme. This approach is diametrically opposed to the conception of simulacrum, which indicates the lack of any foothold in the deceptive image, claiming that the image provides a flat, smooth face of opaque visuality, resisting any attempt to locate the subject within it.

As mentioned above, one expression of the tendency to identify trompe l'oeil paintings with falsehood is through the contrast with realist art. Whereas trompe l'oeil aims at deceiving the spectator by simulating the appearance of objects, realist paintings strive to convey knowledge about these objects. Thus, according to Mitchell, the "spectator of the realist representation is not supposed to be under the power of representation, but to be using representation in order to take power over the world."[13] The spectator of the trompe l'oeil work, in contrast, is captivated by the illusionist mode of representation.

Mitchell refers to a caricature drawn by Roger Bollen, depicting two fish examining an ornamented lure. One fish comments on how funny

it is that humans do not manufacture realist baits, while the other fish replies that a realist lure wouldn't be fair. Mitchell claims that the humorous aspect of this caricature is

> that it lures us into the trap of a paradox, revealing us to ourselves as caught in contradictory attitudes about images. If we take the "naïve realist" view of the image and replace the ornamented lure with a realistic imitation of a bait, we are "caught" violating the most ordinary, empirical common-sense lore of fishing – that fish have their own standards of realism, and those standards are not ours ... If we take the "sophisticated conventional-ist" view of the cartoon, we still have to explain why some conventions *work* and others don't. And the question takes us away from our own values and goals, right back into a realm we can call "nature," a region which seems to impose independent constraints on our conventions.[14]

Thus the caricature captures a paradoxical characteristic of our attitude towards realism in art: a surplus of naturalism is bound to misfire because the subject/observer, with his standards and beliefs, is part of what constitutes the illusion. It is only partial resemblance, recognized as mere resemblance, that can be considered realistic.

These various ways of interpreting the image's relation to the world tie the illusionistic art form of trompe l'oeil to specific effects on the observer's grasp of reality, on the way visual manipulation can affect representation and representational value. Thus, the visual deception in trompe l'oeil is seen as an artistic constraint that carries its effects on reality-as-seen, represented or mediated by visual devices. In a similar spirit Danto discusses the consequences of the typical trompe l'oeil depiction of low-value money notes through its effect on how the observer reconsiders the meaning of art's exchange value.[15] These illustrations depict trompe l'oeil as a way to paint that employs extreme possibilities of illusion-making, in order to intensify and affect how reality-as-seen is conceived. In one way or another, these analyses confine the truth of art to what art communicates. Thus, a portrait adds to our knowledge of a certain person's self through his visual characteristics; a work of trompe l'oeil that depicts the surface of a message board reshuffles our beliefs about the nature of visual dimensionality and, at the same time, our notions of the contingencies and hierarchies that make up our reality. Such modes of approaching art exhibit a conception of truth as equivalent to visual knowledge and investigate the way knowledge is articulated

through a specific system of representation. Within such a conception, deceptive art serves to intensify the mimetic effects produced by representational games by bringing these effects to extremes.

In contrast to this notion of truth that emerges through deception's effects on the way visual reality is seen, both Marin and Baudrillard take a different route, linking trompe l'oeil to the philosopher's dilemma about truth's intricate relation to the image or word. However, this is done at the price of severing the truth about trompe l'oeil from visual knowledge and from visuality per se. To continue our previous discussion of simulacrum theories in chapter 3, we now examine the truth conceptions emerging from such views. For Baudrillard, the truth elicited by trompe l'oeil cannot be identified with a positive visual effect on depicted reality; rather, truth emerges when our knowledge about the world is effectively manipulated through the absence presented in the artistic act. The problem posed by trompe l'oeil requires an approach transcending the consequences of the true-false opposition,[16] as the truth value of trompe l'oeil coincides neither with the materiality of the painting nor with its representational impact. Trompe l'oeil "can do anything, mime anything, parody anything. It is no longer painting. It has become a metaphysical category ... a more profound simulacrum than the real itself."[17] Trompe l'oeil, due to its unreal effects, transcends the confines of the reality represented (and is thus transformed into a metaphysical phenomenon that uses visuality to transcend reality). What is the status of this transcending of the sensible or the visual? For Baudrillard, if the visual qualities of the reality depicted necessitate such transcendence, the significance of the trompe l'oeil image lies in its voiding effect.

Does Baudrillard's radical position entail the Platonic view in inverse form, as it implies that the metaphysical Idea competes with the reality within the picture, having the upper hand? Does the success of the image lie in emptying out its reality for the sake of the Idea, thus offering a genuine alternative to philosophy by way of a reduced image? Is there a difference between art that competes with the philosopher by conveying a false picture of a true idea and art that by definition dissociates itself from truth? The case of trompe l'oeil appears to suggest that, to sustain its truth relevance, the image must be deprived of an artistic value, and yet we aim to go beyond both Plato and Baudrillard and anchor the question of truth produced by visual deceptions in painterly considerations, thus inscribing the truth of art in its actual unfolding through artistic practice.

In view of the tendency to consider the impact of trompe l'oeil beyond the moment of deception, the nature of deception, in its success as well as in the moment of its unveiling, should be considered. If trompe l'oeil aims to portray another reality, how is the deception overcome and that "other reality" attained? And if its deceptive strategy is only momentary, why is deception considered the determining factor in judging these artworks? Baudrillard attributes the transcendence characteristic of trompe l'oeil to a hole in the picture of reality. Trompe l'oeil suggests that not all is within reality itself; something transcends the picture of reality and gives trompe l'oeil its metaphysical standing. Baudrillard thus clarifies that there is something regarding which trompe l'oeil does not deceive and that deception creates a hole in the picture of reality so that another (metaphysical) order of things emerges. We will now attempt to explore this non-deceptive aspect of trompe l'oeil within the domain of psychoanalytic reasoning, in order to formulate eventually an understanding of the truth trompe l'oeil is committed to.

What does the observer encounter when standing before a trompe l'oeil? In the encounter with a trompe l'oeil artwork, the observer is likely to see a disrupted object, such as a turned-over painting or an exhibition that is not yet fully prepared, as in the work of the Swiss artists Fischli and Weiss. The viewer, unaware of the deception, initially attributes the disruption to a mistake made by someone else: the artist, the curator, or the museum's staff. But then doubt arises, and the spectator wonders whether something is wrong or whether she is deliberately being misled. This moment of hesitation sometime leads the observer to try to touch the canvas's two-dimensional surface, or to examine how others react to the artwork in question. Finally, the viewer realizes the mistake on her part, as well as the part played by the insidious image in instigating the deception. The certainty striking the subject at the moment of the unveiling of the deception is intensified by the doubt experienced before the deception was exposed.

How is the observer's hesitation when facing a work of trompe l'oeil to be understood? What is the difference between the subject's certainty vis-à-vis the image viewed as the thing itself and the certainty that follows the moment of recognition, which can be phrased as "I have been deceived"?

When viewing Fischli and Weiss's 1994 installation in the Sonnaband Gallery in New York, which looks like a show under construction, the visitor finds herself wondering whether her visit is premature and the show is not yet on. The visitor experiences the same uncertainty and

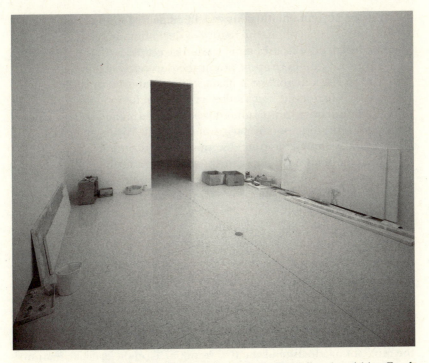

5 Peter Fischli and David Weiss, *Empty Room*, 1995–6. T.B. Walker Acquisition Fund, 1996. © Collection Walker Art Center, Minneapolis.

embarrassment the mythical Zeuxis might have felt upon trying to remove Parrhasios's painted veil.

This invariable pattern of response to trompe l'oeil artworks, which involves both hesitation and certainty, suggests a clue to understanding this artistic case and its truthful effects. These truthful effects, however, should not be dissociated from the signifying materiality of trompe l'oeil, which can be traced back to both Baudrillard and Lacan. While Lacan attributes Plato's attack on painting to "appearance that says it is that which gives the appearance," Baudrillard claims that trompe l'oeil presents "an opaque mirror held before the eye, *and there is nothing behind it* … This phantom of tactile presence … gratifies the eye and at the same time deceives it."[18] The truth of trompe l'oeil, unlike various realistic effects that visual deceptions may create, is registered in the structure of the signifier/image itself.

b. Truth beyond Painting: Trompe l'Oeil as Negation of Painting

For Baudrillard, trompe l'oeil is a paradoxical image, as it constitutes an exceptional case in relation to a number of relevant painterly categories. Within the category of realism, claims Baudrillard, trompe l'oeil is "too much like the things as they are,"[19] and hence, as a representation, it fails to convey a truth about reality-as-seen. The representational scene and representational space are abolished. Within the category of illusionism, it cannot shed its deceptive facade, and thus its illusionistic value is momentary. The almost tactile presence of things is but a momentary phantom. Within the category of the aesthetic, trompe l'oeil is not pleasurable: "the pleasure they procure is thus not the aesthetic one of a familiar reality ... it is the acute and negative pleasure found in the abolition of the real."[20] Trompe l'oeil is therefore of a questionable aesthetic status; in fact, it renounces artistic values usually linked with the art of representation.

In view of this negation of painterly and aesthetic values, Baudrillard' conceptualizes trompe l'oeil as a metaphysical category situated outside artistic concerns. Metaphysically predicated, trompe l'oeil produces an ironic pleasure, as "the enjoyment of *trompe-l'oeil* comes from an intense sensation of *dejà-vu* and of the eternally forgotten, of a life that preexists the mode of production of the real world."[21] Trompe l'oeil is metaphysical because it refers to what cannot be, gaining its particular significance through the domain of abstract ideas. Trompe l'oeil is metaphysical, claims Baudrillard, in the sense that the negation of painterly attributes discloses another truth. Characteristics such as depth, light and shade, and perspective are all violated, leaving behind "ghosts that haunt the emptiness of the stage."[22] Therefore, trompe l'oeil paintings are empty signs that reject reality as well as any other artistic categorization. This claim leads Baudrillard to conclude that the essence of trompe l'oeil is not the presentation of something that the observer will confuse with a real object. The goal of trompe l'oeil is to reveal to us "that 'reality' is never more than a world hierarchically *staged*."[23] Baudrillard's solution proposes the notion of simulacrum as a way to understand the essence of these paintings; they make "a more profound simulacrum than the real itself."[24]

The emptiness of the image goes beyond the emptiness of appearances, thus constituting the truth of trompe l'oeil at a different register. In this sense trompe l'oeil never deceives us into believing that reality is there even though there is nothing in the image itself that suggests the

presence of the invisible. Trompe l'oeil exhibits the idea of something real through an impeccable, complete image of an object in reality. And yet the fascination of these paintings is still constituted by a missing substance. Trompe l'oeil artworks, like the church or a bank, cover this absence, thereby confirming its existence. Just as the bank is organized around money it does not actually possess, and the religious establishment guarantees the existence of a missing god, trompe l'oeil artworks convey the adequacy of reality to the painted image, momentarily covering its absence. The secret disclosed by trompe l'oeil is that reality is inexistent. Truth cannot be defined except in negative terms as the truth produced when reality is emptied out of its constitutive objects.

Trompe l'oeil does not leave the observer indifferent; it has gripping effects like "the discovery of the mirror image by the child ... like an immediate hallucination of its own body as preexisting the perceptual order."[25] The captivating effect of the deceptive image in its excessive appearance seizes the observer for a moment, but even when the observer loses hold on the reality seen, the image continues to arrest him by means of the black hole, the nothing now met on the canvas. Trompe l'oeil, unlike the sublime, does not allow the image to fall out of consideration due to the failure of imaginary means. What one gets from the image, even after exposure of the deception, is grounded on what one sees. "As the physical impulse to seize things, itself then suspended and thus become metaphysical, the tactile hallucination is not that of objects but of death."[26] The gap between the excessive appearance and the tactile hallucination transforms the viewer's response, disengaging her gaze from what is seen. What first appears as an anodyne object to be touched and feasted on turns out to reveal a blank canvas with the same meaning of "childhood, the Double, preexistent life, death,"[27] contributing to the effect of loss of reality. The canvas persists even while the reality is lost.

Trompe l'oeil, thus described, obeys a logic similar to the one behind the cogito. Just as the cogito strives for the instauration of the I by emptying its domain of all thought content, trompe l'oeil strives for the instauration of the image by emptying the imaginary domain of all representation content. This negation affirms what Baudrillard refers to as the metaphysical meaning of trompe l'oeil. Childhood, the double, preexistent life, and death are repetitive themes, which Sigmund Freud had also associated with the death instinct. Freud claims that what is beyond the pleasure principle is disclosed in the emptying out of the scene of reality, which is sustained as a scene in which the encounter with death is activated.[28]

Baudrillard indeed stresses the vicissitudes the viewer must undergo for this truth to be disclosed. The truth about reality as simulacrum includes the phase of deceiving the eye, as through this phase the hollowing out of the universe eradicates both the eye as seeing and the seen world. "The eye instead of being the source of the exhibited space is nothing more than the interior vanishing point at which the objects converge ... Nothing to see: it is things that see you ... they bear themselves before you like your own hallucinated interiority."[29] The nature of simulacrum does not affirm being but rather discloses reality itself as a hallucination. Baudrillard thus predicates the observer's position vis-à-vis trompe l'oeil as the position of "no longer." There is no longer reality, no longer the seeing eye to provide a stronghold for the image. This "no longer" conveyed through the trompe l'oeil is tantamount to the new philosophy of simulacrum. Trompe l'oeil, as the absolute case of simulacrum, does not create a discontinuity in the image but only affirms, through a perfect image, the unavoidable emptiness in every imaging. And in relation to an empty image the observer cannot be certain of anything but her own death.

If Kant complemented the aesthetic impact of the failing image (of the sublime but also of artistic beauty) with ideas of reason or with aesthetic ideas, Baudrillard gives up on the aesthetic because, in the context of a theory of simulacrum, there is nothing beyond the image but emptiness itself. In other words, we have arrived at the kernel of what is revealed by trompe l'oeil, which, more than any other art form, raises the question of truth effects that transcend what the image makes to be seen. It is by affirming the truth effects of deception as singular and immanent to art that the case of trompe l'oeil will be accounted for in aesthetic terms, and we turn to psychoanalysis to ground this move.

From a psychoanalytic point of view, truth in the real, that is, truthful effects that are half-said and cannot be equated with knowledge, appears as the odd element in the continuous facade of signifiers or images. It is the subject/observer who constitutes the odd element in the smooth facade of trompe l'oeil images, and tracing the vicissitudes undergone by the observer of trompe l'oeil opens up a restitution of the aesthetic dimension of truth. The odd element in trompe l'oeil resides in the move from doubt, instigated by deception, to certainty in the truth of the image, a truth affirmed by an image that says, "This is not the object but deception," an image that truly confirms that the object cannot be known through what is seen. We will demonstrate that the moment of

negating reality, when deception is exposed, is a moment of gaining a certainty in the truth of the image. It is an image that, under the imperative to represent as accurately as possible, reveals an inability to convey knowledge about the world, and this failure is where the truth effectuated by the image is affirmed. Later in this chapter we counter the idea of the object depicted by trompe l'oeil as redundant (once the deception is revealed) by bringing in Lacan's definition of the masochistic object. By addressing the observer's certainty and the status of the material object of art, the artistic and metaphysical sides of trompe l'oeil will be re-associated in order to describe the observer's quest for the truth of this art form.

c. The Viewer Deceived ... and Ascertained

The impact of trompe l'oeil is often presented as unexhausted by the brief moment of "being deceived," while the nature of the deception is variably interpreted. Some interpretations vitiate the moment of deception in favour of its subsequent implications. If trompe l'oeil aims to positively affect our visual reality, it may seem that its deceptive dimension should be undermined or at least marginalized. In other words, following such an interpretation, the deception per se is insignificant prior to its effects on the way we perceive reality. Similarly, for most philosophers, the moment of negating all knowledge, which culminates in the Cartesian certainty of the cogito, acquires its importance only when the *res cogitans* regains clear and distinct knowledge. Yet unless the truth about trompe l'oeil is intimately tied with its deceptive moment and with the logic structuring deception, its peculiar impact is lost. When the eye is deceived into a false conception of reality, the logic of deception discloses its singular truth.

The vicissitudes of doubt and certainty bring to mind Freud's description of what can elicit an uncanny affect in the subject. In his famous treatise, Freud depicts situations that might elicit an uncanny feeling, such as when one is facing an object that cannot be distinguished as animate or inanimate, or when one is unable to determine whether an image in a mirror reflects another person or oneself.[30] The moment of hesitation, claims Freud, is responsible for the special affect of anxiety, which is not alleviated even when the hesitation is dissolved. The example of Diego Velasquez's *Las Meninas*, and the unabating curiosity this painting raises in its observers, can be linked with this same hesitation regarding who

the object of the painter's gaze is: the external observer? The scene? The royal couple? With Freud's uncanny we also face a sequence where hesitation is embedded in moments of certainty. Thus, after a primary moment of certainty ("this is a beautiful girl," to use the example from A. T. Hoffman's "The Sandman"), a moment of doubt ensues ("the girl seems to be too closely manipulated by these men"), followed by a con- clusive certainty ("I have been deceived by a mechanized doll!"). A simi- lar hesitation is characteristic of the experience of trompe l'oeil, where the observer's hesitation as to the nature of the image or situation at hand elicits a moment of anxiety followed by certainty.

A similar structure of hesitation preceded and followed by different forms of certainty is also suggested by Kant in his discussion of how the moral law discloses its presence: "Suppose someone alleges that his lustful inclination is quite irresistible to him when he encounters the favored object and the opportunity. [Ask him] whether, if in front of the house where he finds this opportunity a gallows were erected on which he would be strung up immediately after gratifying his lust, he would not then conquer his inclination. One does not have to guess long what he would reply."[31] The moral law tilts the balance to the morally correct side in a moment of certainty that oversteps any momentary hesitation (without reducing the importance of the hesitation for the moral judg- ment). It introduces what seems to be a different kind of certainty than the one qualifying the preliminary state of the subject: his unequivocal inclination to a lusted-after object. What element enables the subject to move from one certainty to another by way of hesitation?

A moment of moral dilemma between the power of moral law, which takes the form of an imperative guiding the will, and the pathological inclination of the subject to an object of lust gives way to persuasion regarding the proper course of action. Kant assumes two certainties: one derived from pathological predilections and the other determined by moral conviction. Here we turn back to psychoanalysis to explore the implications of these two orders of certainty with which the subject acts. We ask how subjection to the law relates to one's subjection to a patho- logical cause for desiring.

Throughout his work Lacan made reference to two modes of cer- tainty. The first is a *primordial certainty*, which arises in affects such as anxiety.[32] The second is an *anticipated certainty* gained retroactively in light of a doubt raised with regard to knowledge. Lacan qualifies the first certainty as one that *does not deceive*, as it is raised when the subject comes across the object that functions as the cause of desire.[33] This certainty

is prior to any judgment and is associated with the encounter with the pathological object.

The primordial certainty is not related to empirical factors but rather to structural considerations. Certainty has to do with an object that is part of the subject's psychic structure; it is when the subject meets himself/herself through the gaze in the mirror that anxiety, as the affect related to the origin of desire, is effectuated. It is when the subject comes across what is routinely outside his/her field of vision, seeing something of him/herself from where he/she cannot be, that the uncanny affect is elicited.

The first moment of primordial certainty hence occurs as the object comes into the subject's field of consideration when nothing hinders the subject from satisfying desire, or when the object of desire appears uncamouflaged, too bare to look at. Conversely, an empirical certainty is one effectuated when the subject employs certainties from reality to *conceal* the *object* eliciting desire. Dora, in Freud's famous case, decides to leave Freud's clinic after a pre-determined period of time regardless of anything that would occur during analysis. Her certainty that it is time to leave analysis[34] disregards anything that the analyst might say, respond, react to, or interpret. This certainty gives the subject an "empirical" cover that knows nothing of doubt. This certainty risks nothing with regard to the Other, a fact that makes it fundamentally different from both certainties previously discussed. In contrast to a certainty that camouflages desire, this chapter examines the certainties that touch on the subject's desire in an absolute manner.

There is yet another aspect of certainty that pertains to the subject's position in front of a deceptive image. In "Logical Time and the Assertion of Anticipated Certainty,"[35] Lacan refers to what appears to be a different kind of certainty. Lacan recounts the riddle of the three prisoners to whom the following proposal was made. From among three white discs and two black ones, one disc, either black or white, will be attached to each prisoner's back. The first of the prisoners to infer the colour of the disc tied to his back should move to the exit and would then be freed from imprisonment. The prisoners walk around, look at each other, wavering once and then again, and finally walk together towards the door to be set free. Each reaches the correct solution that he has a white disc on his back. The solution to the riddle is neither knowledge-dependent nor a consequence drawn from empirical foundations. Each of the three prisoners discovers he carries a white disc yet is deprived of an epistemic confirmation of this conclusion (the prisoners are not allowed to talk to

each other). And yet the prisoners move to the door with certainty, even if they hold no irrefutable evidence to back their conclusion but only the power of the inferential move they have undertaken. While the prisoners must go through an entire process of inference to solve the riddle (which is beyond the scope of this chapter), we will elaborate further on one aspect of the process: the relation between the certainty reached and the doubt or hesitation that led to it.

Initially, each prisoner assumes what would happen if he had a black disc on his back. This false assumption is necessary to develop the correct divination of his actual state. Hence the certainty attained depends on a sophist process, on false suppositions necessary to attain certainty ("had I been black, the others would have walked to the door right away"). Then, negating the possibility of being a black, the prisoner starts walking to the door, but then, when he sees the others do the same, a doubt sets in: could it be that the others' certainty stands on firmer grounds than his since unlike him they see a black disc on his back? The possibility of being black after all makes the prisoner suspend his movement in a moment of doubt. The doubt introduced into the process thus stipulates the possibility of arriving at a solution, and yet a certainty is attained that must be prior to the doubt interposed.

Unlike Cartesian certainty, which necessitates doubt as its condition, for Lacan the certainty is logically prior to doubt, even if the moment of certainty is suspended by the prisoners' moment of doubt. Doubt in this case does not mar certainty, instead demonstrating that the certainty disclosed is based on the fact that each prisoner weighs his decision in relation to the other prisoners. The certainty attained by the prisoners does not abolish doubt completely but rather points at its essential role. It is a certainty born in doubt, yet not as its logical consequence: "while doubt has, since Descartes' time, been integrated into the value of judgment, it should certainly be noted that – for the form of assertion studied here [in a moment of conclusion] – the latter's value depends less upon the doubt which suspends the assertion than on the *anticipated certainty* which first introduced it."[36] Doubt suspends the conclusive certainty and reveals the certainty as anticipated. Lacan's interpretation of this riddle stresses that its solution is certainty rather than knowledge, and this certainty is logically prior to doubt even if it must be suspended by moments of doubt to reach its final purpose – freedom.

Kant's solution to moral dilemmas is logically similar. Suppose one is demanded by his prince, on the threat of a penalty of death, to give false testimony against an honest man whom the prince wishes to ruin.

The subject who aims to act morally will suffer deep misgivings when morality requires him to overcome his love of life. Kant claims that while the voice of reason might be decisive in this context, the certainty in acting right can never be apodeictic, as no action taken will extinguish his love of life and hence fully comply with the law. Kant claims that it is not the bottom-line action that counts but the fact that "he congnizes freedom within himself,"[37] a freedom associated with the presence of the moral law of reason. The objective reality of the moral law cannot be confirmed through experience and yet is established with certainty. Hence this certainty must be assigned to the a priori presence of the law and not to its enactment in experience. Moral certainty is thus enabled by the moment of hesitation ("should I betray my friend or defend my own well-being?"). Yet this hesitation establishes the moral law as prior to any such wavering. What can we learn, in relation to the certainty of being deceived, from the status of certainty as non-epistemic yet negotiated through a moment of doubt?

In his 1964–5 Seminar, Lacan refers to the idea of deception and to the correlation between the deception, the observer's awkward moment of hesitation, and the anxiety that ensues as a moment of certainty. He writes that "truth is based only on the fact that speech, even when it consists of lies, appeals to it and gives rise to it."[38] This principle will enable us to substantiate the truth produced by visual lies and will facilitate our understanding of the structure of this truth, necessarily attained through moments of false suspensions.

The deceptive image, consisting of a visual lie, presents a hole in reality that gives rise to a truth about the split nature of the image itself. This divide is between the lies the image actually conveys, which suspend the viewer's assurance regarding what is being seen, and the truth disclosed by the deceptive image. A similar split can be seen in the example of the prisoners, a split between what each succeeds in surmising and the doubt originating from the other prisoners' actions. Similarly, the Kantian moralist experiences this split between what he is inclined to do and what is voiced in him as reason. While, for Kant, the moment of doubt or the danger of giving in to lustful inclination is necessary to ascertain the presence of the law, the doubtful interval guarantees the prior absoluteness of what has been denied for a moment ("It *is* art after all!" says the deceived museum-goer. "My action *is* moral!" says the person who was almost led astray by temptation. "I *am* a white!" asserts the prisoner.). The certainty attained is not epistemic, yet is real, and is reached through doubt that discloses, through false possibilities, the

a priori presence of certainty. This certainty is the certainty in the split reality of the image, or of what is seen. In other words, the certainty emerging from and by way of doubt is the odd element that interferes with the smooth facade of what is seen, indicating the truthful effect of the "other thing," which appears as a determining factor. The observer's movement from certainty through doubt to certainty introduces that "other thing" whose truthful effects are noticed as odd elements in the facade of the image. In this sense the certainty attained is ethical. It is stipulated by the practice of doubt and by false appearance. But in what sense is the nature of this certainty ethical?

The situation vis-à-vis the deceptive visual image is structurally identical to that of the subject confronted with the liar's paradox: "I am lying to you." Lacan analyses the statement "I am lying" by separating the "I" of the *enunciation* (the "I" of the act of speech) from the "I" of the *statement* (the "I" as the content of what is spoken). "From the point at which I state, it is quite possible for me to formulate in a valid way that the I – the I who, at the moment, formulates the statement – is lying."[39] The idea here is that "the *am lying* is a signifier, forming part, in the Other, of the treasury of vocabulary in which the I, determined retroactively, becomes a signification, engendered at the level of the statement, of what it produces at the level of the enunciation – what results is an *I am deceiving you*."[40] Lacan merely claims that while the I of the statement is a deceiver, the I who states it says the truth. In fact, the I is instaurated as the truthful effect of the deceptive utterance and is not given in the formal self-presence of the utterance. The certainty of the I is not the certainty of what is stated, because what is stated is denied truth; and the certainty of the I is not that of the act of stating, because there is falsity in the mere stating. This substantiates what is left out of the deception – the I itself, split between saying and being talked about, which is an I that, whether saying what is true or what is false, is certain.

Let us retrace this move in different terms. The I as signifier, while reducing the subject to no more than an utterance, restitutes something of the being of the subject through the signifier, saying, "I am the one who is lying," because when I state something from the place of the I, I cannot but lie. The I as a signifier receives its signification retroactively, as the one who is present in the statement as the one who lies. While the I of the statement is attempting a lie, the I of the enunciation is saying, "I am deceiving you, and that is the truth you will encounter with absolute certainty when the effect of my utterance comes full round."

A salient example of this division of the subject is the case of the cogito, where the subject's certainty depends on the punctuality of the fact of thinking. The subject is certain of nothing but his/her own act of enunciation or thought, while what constitutes the entire statement, attributing existence to the thinking subject, already amounts to the content of this thought: I think: "I am." The truth of the cogito is the truth that returns to the subject as a message in inverted form. By stating that one is thinking and hence existing, what returns to the subject is the message, "I say to myself I exist." The truth about the subject of the cogito, according to Lacan, is this very split between the I as stating even doubtful things (like attributing existence to itself) and the I as enunciating, an act of uttering that is independent of knowledge. This is the truth about the speaking and thinking being: that it is certainly speaking and thinking. The only certainty the Cartesian subject has is the certainty of the "I think," which, similarly to the statement "I am lying" described above, is a minimal punctual certainty "of being certain only of the absolute doubt concerning all signification."[41]

Can the deception of trompe l'oeil be understood in similar terms? Trompe l'oeil is an image that simulates reality but says something non-deceptive about representation. The certainty, the truthful effect of trompe l'oeil, arrives following the observer's hesitation when facing the image. Wavering between a hole in the wall or an image of one, between a beautiful girl or a mechanized doll, the observer eventually distinguishes between the image, which introduces false information, and the truthful act of imaging. The image acts as a signifier conveying to the observer: "The truth is: I am deceiving you." The image of deception does not disappear once its nature is revealed, and its status as a remnant of the deceptive moment is thereby maintained.

The psychoanalytic insight regarding the relation between deception and truth is significant for our understanding of the impact of trompe l'oeil, situating it in the domain where the reality of the unconscious is enacted. The image of deception is truthful since, like the subject of the unconscious, it always lies. The unconscious produces formations that are made to elude the mastery of the Other. Unconscious formations are substitutive expressions of what cannot be directly presented. Unconscious formations (like a symptom or a slip of the tongue) deceive the subject into misrecognizing his or her own truth. Likewise trompe l'oeil is a deception that aims to elude the visual mastery of the Other (observer). But what is presented as a lie returns in inverted form as

truth. The observer of trompe l'oeil is thus committed to the truth of the image, which reveals something by lying.

While René Descartes had to summon god as the Other backing his certainty, images of trompe l'oeil need not go that far. While Descartes could have grounded his certainty on the signifier alone, instead he guarantees his certainty by addressing himself to his god, thus ascertaining what is already certain: the truth of the subject as thinking. Descartes could not endorse a certainty unsupported by knowledge.[42] Both Descartes and, later, Freud knew that doubt assures the presence of thought. The assurance that a thought is present also ensures that "someone thinks in his [the subject's] stead."[43] Freud remained with the certainty of the subject of the unconscious, whose thought is absent from the domain of the ego (the unconscious is where the "not-I" thinks), while Descartes believed certainty must be substantiated by the knowledge of the Other.

The image of trompe l'oeil is itself grounded on the split subject produced by the certainty imposed by the image. The "not-it" of the image is produced after the appearance of doubt, which is the manifestation of the unconscious, in the image.[44] The observer faces an image that says, "I am what the image announces itself to be." The moment of doubt introduces the possibility that the image conveying "I am" is in fact "am not," that its truth of being lies elsewhere. The ensuing certainty indicates that the observer is in the position from which she is ready to receive the "I am deceiving you." The certainty in the deception, which is also the certainty in the presence of the unconscious, in the truth that returns after negation, means that what is true cannot be told. It can be disclosed only through the telling of lies. The observer is responsible for receiving the deceptive utterance and turning it into an encounter with truth itself, the truth of being deceived by the image. Through being deceived, the subject gains knowledge of what reveals itself as the absent truth of the image.

The observer of trompe l'oeil thus fulfils a crucial function in relation to these artworks. As the addressee of deceptive images of art, she returns their true signification in inverse form. This position is similar to that of the analyst in the psychoanalytic situation, who awaits the deceptive formations of the unconscious to return their true signification to the subject. Only through being addressed to a viewer can deceptive images gain their truthful impact, just as a symptom or a dream is deceptive until placed within the analytic situation between the subject and the Other, the analyst. A symptom, presenting itself as what is imposed on the subject, making her life miserable, is returned to the subject as

something that is for her a source of enjoyment from which she is reluctant to separate. This truthful effect of the deceptive formation of the symptom is produced once the certainty in the painful presence of the symptom gives way to the certainty of its immanence to the subject's enjoyment.

The structural similarity between trompe l'oeil and the subject facing a lie or a false declaration suggests why the observer is captured by the moment of deception. "The correlative of the subject is henceforth no longer the deceiving Other, but the deceived Other. And this is something that we are aware of in the most concrete way as soon as we enter the experience of analysis."[45] While a deceiving Other, like Descartes's evil demon, could arrest the subject in permanent doubt, the deceived Other enables the subject to reach a certainty unsupported by knowledge. This deceived Other, like the observer lured by the art of trompe l'oeil, cannot ascertain knowledge but can reveal the truth of trompe l'oeil, which is the truth about the deceptive image. It is something else that speaks from the place of the object, and since it cannot be determinately contained in the image, it is marked by deception.

d. The Subject in View of the Trivial Object

Baudrillard has claimed that *trompe-l'oeil* is "too much like the things as they are," thus constituting an image that, exposed in its deception, is already more of an object than an image. In other words, the deceptive image has a material presence that cannot be discarded in the name of a more secret, hidden meaning. This aspect of trompe l'oeil will be further examined by tracing the fate of the object that deceptively declares "I am." How come an object, often on the verge of utter triviality and insignificance, draws the observer's attention to such extremes?

Trompe l'oeil artworks often present worthless discarded objects, forgotten or partially hidden. A picture of trompe l'oeil might show a piece of paper, a banknote of low value, or an insect: a mundane composition of objects of no significance. This persistent characteristic of trompe l'oeil can be traced throughout history: from the remains of a meal on the Pompeii floor mosaics to Cornelius Gijsbrechts's inverted stretcher; from Fischli and Weiss's paint cans, boots, and brushes to Thomas Demand's office environments or monochrome monotonic shades.

The valueless objects depicted in trompe l'oeil seem incompatible with the clear sense of unease that trompe l'oeil raises in the observer. How can this unease be explained? Can it be described as aesthetic discontent

that replaces the pleasure traditionally associated with our experience with art?

In Seminar X Lacan describes anxiety as *affect*, that is, not of the order of the signifier. While the signifier stands for a differential dialectic between S_1 (representing the subject) and S_2 (representing all other signifiers, derived from the Other), anxiety is produced by the Other in a non-dialectizable manner, as absolute, lacking in nothing. The subject is given to anxiety when she fails to see herself represented in the Other. Anxiety is aroused when the subject is confined to a domain outside any meaningful dialectic, encountering no object to return her gaze. Anxiety is imposed on the subject from a realm beyond her ability of attributing sense to the Other; hence, as a *primordial affect*, anxiety does not deceive. Thus, we claim that anxiety is raised when the subject fails to meet her gaze in the Other, a moment demonstrated by Lacan with the example of the person in a seat in the theatre, awaiting anxiously the raising of the curtains, not knowing what is to be revealed behind the screen: "It is what we always expect when the curtain rises, it is this quickly extinguished brief moment of anxiety, but which is never lacking to the dimension which ensures that we are doing more than coming to settle our backsides into a more or less expensive seat, which is the moment of the three knocks, which is the moment the curtain opens. And without this, this quickly elided introductory moment of anxiety, nothing could even take on the value of what is going to be determined as tragic or as comic, that which cannot be."[46]

Lacan assigns a non-deceptive presence to anxiety because anxiety as affect is not a product of interpretation and is prior to the conceptual distinction between the comic and the tragic, between good and bad; rather, it is imposed on the subject by that to which sense cannot be attributed. Roberto Harari, one of Lacan's interpreters, describes this absolute domain of an Other of which sense cannot be made, a domain imposed on the subject through anxiety, in the following terms: the desire of the Other is what turns back, ungovernable, towards the subject, thus arousing anxiety. A dimension of devouring is thus manifested and lurks behind anxiety.[47]

Anxiety emerges when one faces the Other as absolute, as divulging no point of support for the subject. The subject in front of an opaque, incomprehensible Other occupies the masochistic position, the position that Freud describes as that of the discarded object;[48] the subject is making himself "appear as pure object, black fetish."[49] The masochist is a subject who incarnates himself as object, "whether he turns himself into a dog under the table or a piece of merchandise, an item that is treated

in a contract by giving it over, by selling it as one among other objects that are on the market, in short, his identification with this other object which I called the common object, the object of exchange."[50]

In trompe l'oeil the picture appears to be much like the discarded thing, which often seems to be falling out of the picture: a piece of paper pinned to a board, a ladder soon to be removed. How is the object, soon to be discarded, related to the Other to whom it is conveyed as the thing itself? The observer faces an object that presents itself as wasted, as negligible. Such an object signals that the Other is complete, that in relation to that Other the image is a trifle that marginally contributes to the wholeness of the Other. In other words, the image of the object, rather than signalling that the image can fill in for whatever is missing in reality, brings the message back in inverse form: there is nothing of significance in the picture. The image cannot fill the lack in the Other, because the Other has no need of this object – the Other lacks nothing. Therefore, the anxiety that emerges when one faces a trompe l'oeil has to do with the danger that the lack will be lacking; that the deceptive object is trivial because it reflects the lack of a lack in the Other, the Other in its absoluteness. In this sense the unease accompanying the encounter with a trompe l'oeil reflects the trifling status of the object in the image vis-à-vis the absolute demand for resemblance to or duplication of the real object. The object in the image is negligible; it falls too short of the demand, thus accentuating the presence of the absolute imperative: represent! (an imperative that it most patently fails to satisfy).

Lacan refers to the notion of *a passage to act* as the moment in which the subject finds herself identified with the lack that the Other does not lack. In Freud's famous case of the female homosexual,[51] the girl throws herself onto the rails after encountering her father on the street and meeting an utter indifference in his gaze. She is reduced to a fall-out object for her father, who wants nothing from her and for whom she is nothing. At that moment, rejected, cast off, she throws herself from the stage. Such a moment produces anxiety in the subject, claims Lacan, as anxiety is raised when the Other is presented as lacking nothing, as the one from whom the subject can be discarded. The trompe l'oeil artwork is situated in a similar position: it is the discarded object in view of the absolute Other.

The truth about visual deception does not lie behind appearance, nor can it be identified with the way things appear. This is the truth conveyed by the deceptive screen that says, "I am lying," while reflecting the truth about the false image. The image is deceptive in the sense that

it presents an object of surplus in more than one sense. It is an object left over from the act of deception, the product of a meticulous act of overly detailed representation (signalling an unnecessary object that it is impossible to get rid of). Trompe l'oeil exposes the truth about the moment in which the empirical object appears redundant vis-à-vis the absolute Other, vis-à-vis the law.

The Lacanian reversal of the interpretation of Plato's disapproval of painting now gains its full justification. Trompe l'oeil indeed competes with the philosopher in that it reveals that truth can reach us only in its inverse form, through deception, by being half-said.

5

By Way of Prohibition

He [Lacan] has primarily called ethics of psychoanalysis a doctrine of the super-ego, that is to say, a demand going against adaptation, a demand to return to a primary satisfaction, and hence a demand for a jouissance ... It is to reunite the Kantian "you must" and this demand for the return of jouissance. He called the ethics of psychoanalysis a doctrine of the superego that has nothing to do with a morality that is finally but a poultice of adaptation. When Lacan refers to Aristotle's *Nichomachean Ethics* it is in order to demonstrate that in the end morality, like wisdom, is what gives us a guide that makes us fail in the domain of our relation to the *Umwelt*. It is the disposition of the demand of jouissance for a moderation that attempts to carry us back to harmony, whereas the doctrine of the superego is centred around the disharmonic factor.[1]

In the quote above, Jacques-Alain Miller refers to the psychoanalytic conception of the law as the basis for psychoanalytic ethics. Psychoanalysis is committed to a distinction between ethics and morality, and to the Freudian idea that the law operates as a constant reminder of jouissance, because it is only under such conditions that the true relations between human actions and the law are disclosed. The ethics of psychoanalysis yet relies on the Kantian notion that the moral law cannot be adapted to and allows little place for comfort or immediate satisfaction in the moral domain. For Immanuel Kant, the moral action is tied with happiness as an idea of reason (rather than as an actual experience), which is not necessarily attainable by the moral subject. Adherence to the moral law promises neither happiness nor a good life; it contradicts our desire and yet touches the kernel of our being (in which reason prevails). The law has a Thing at its moment of institution, which has to do with a

forbidden kernel, an object excluded so that moral action can endure.[2] The disharmonic factor is as primordial as the law itself, and it is by replacing moral values (as marking the end of the law) with jouissance that the cause and fate of this disharmony may allow man to stand ethically in relation to the law.

This chapter first addresses the general psychoanalytic terms for understanding the place of the law. Then, the second of the Ten Commandments is examined as a possible formulation of the *aesthetic imperative*, which in its application to art is phrased negatively. The negative structure of the imperative and the significance of the commandment in relation to actual practices of art render it a law distinctive of the artistic domain.

In his teaching Jacques Lacan has continuously stressed the need to distinguish between ethics and morality, the first involving jouissance and the other pleasure. Kant is explicit on this point in saying that good and bad and other moral values "must be determined not prior to the moral law ... but only after it and by means of it;"[3] otherwise, the good is too easily equated with what is agreeable to one's desires. This necessary distinction between ethics and morality does not stem only from the Kantian suspicion that humans tend to attribute moral value to what agrees with their sensibilities but also from the vacillations detected more generally within philosophy in its approach to the question of the good. Lacan indicates signposts throughout the history of philosophical conceptions of the moral law, attesting to the need to distinguish morality from ethics.

The psychoanalytic distinction between ethics and morality sheds light on the radical difference between Aristotle's morality and Kant's idea of the law[4] by revealing a radical turning point identified with the publication of Kant's second critique. Before the appearance of the *Critique of Practical Reason*, the moral law converged with the human endeavour to attain the good. With Kant, the law was redefined as an empty form, fundamentally alien to human practices and inclinations and devoid of specific moral content. Along with this radical disparity in the conception of the law, Lacan views Kantian practical reasoning as a break from Aristotelian ethics, jouissance as a rupture in the pleasure principle, and ethics as a diversion from the demands of morality.

Morality, claimed Lacan, is grounded on the idea that somewhere there was a good in which the law resided.[5] Aristotelian (Nichomachean) ethics is based on such a correlation between pleasure and the good and on the idea that "following a correct channel in this register of pleasure

will lead us to the conception of the sovereign good."[6] Positioned in this light, the tragic drama of antiquity raises the question of the correlation between the law, pleasure, and the good by presenting law-abiding characters in catastrophic situations while the audience of the tragedy enjoys a cathartic experience.[7] Aristotle was the first to raise the problem of the relation of pleasure to the final good, and he established this relation on ethos, that is, on ordered habits "brought together in a Sovereign Good, a point of insertion, attachment or convergence, in which a particular order is unified with a more universal knowledge, in which ethics becomes politics, and beyond that with an imitation of the cosmic order."[8] Aristotle's stress on pleasure and the benefits to be drawn from an ethical order, which he believes were based on a correlation of ethos with the sovereign good, later are transformed into what Miller has called a "poultice of adaptation." In this Miller refers to modes of tying morality to the pleasure principle, in order to avoid the encounter with the fundamental question of ethics that touches the subject's relation to the law. Since the moral law "has the structure of an *enunciation without a statement*," as Alenka Zupančič puts it[9] (it is a form of something said with no determinate content or demand), the subject is thus put in a predicament. As the law does not indicate what obeying it entails, it brings the subject, as is shown later, beyond the pleasure principle.

The shift to Kant's law and away from the Aristotelian idea of an ethical order leading straightforwardly from the study of characters' actual norms to an overall cosmic order 'constitutes a significant break in the history of ethics and the moral law. Kant, in whose statements Lacan finds the very soul of ethics, marks the moment in which the collapse of the correlation between ethos and the morally good led away from religious morality and produced a secular philosophy of morality, without giving up on the universal absoluteness of the moral law. Lacan indicates a distinction Kant makes between the good feeling (*das Wohl*) and the good (*das Gute*). With this distinction Kant already accounts for the idea that some pleasures are outside the "correct tone"[10] and should be avoided, and that the well-being of the subject does not coincide with the idea of the good but rather is made to serve the subject in camouflaging the moral conflict at stake.[11]

Lacan points out that this separation of the moral law from the direct consequences that seeking the good has on human actions and prosperity has repercussions seen in many situations encountered in capitalist and post-capitalist society. This can be illustrated with the familiar experience of having to make an immense effort to work less or to enjoy not

working. Thus we have the worker ready to go on hunger strike in order
to work less, and the yuppie prepared to work hard climbing ski lifts and
carrying heavy ski equipment the whole day in order to enjoy his/her
vacation. While pleasure may seem to emerge from obeying the impera-
tive "enjoy!" it turns out the imperative of the law lies beyond the plea-
sure principle. As much as one tries to enjoy not working, as required of
a capitalist on vacation, one's well-being appears more and more distant
and unattainable. These are also signs of the profound rupture that has
removed the possibility of pleasure from human practice, a rupture that
subtracts nothing from the fact that everything one does is regulated by
the promise of and striving for enjoyment. That is, being ready to starve
oneself to attain a better life retrospectively shows that already in Kant,
the futility of seeking pleasure meets the logic of death. Only with death
at the horizon of the imperative is the enjoyment gained by a hunger
strike revealed.

Sigmund Freud has suggested that work has a significant role in the
economics of the libido, as it offers the possibility of displacing a large
amount of libidinal components.[12] Lacan introduced the idea of a rup-
ture between pleasure and the effects of human struggle for the good in
a way that can illuminate the vicissitudes of the absolute moral standard
in relation to human habits and norms of action. The rupture also shows
that the moral absolute is in itself a source of enjoyment, even if one
attained by painful actions or by roundabout futile acts. Through exam-
ining the shift from Aristotle to Kant, Lacan has revealed a profound
new meaning for ethics as well as reconsidered the place of the moral
law within the subject's libidinal economy. Libidinal satisfaction or jouis-
sance can reside in the very same place where the law appears to prevent
the possibility of pleasure.

a. The Place of the Law in Psychoanalytic Thought

Well now, the step taken by Freud at the level of the pleasure principle is to
show us that there is no Sovereign Good – that the Sovereign Good, which
is *das Ding*, which is the mother, is also the object of incest, is a forbidden
good, and that there is no other good. Such is the foundation of the moral
law as turned on its head by Freud.[13]

From a psychoanalytic point of view, the break between pleasure and
jouissance opens up the possibility of another ethics. This ethics is built
on the logic that allows enjoyment in the striving for the good, the same
good that requires relinquishing enjoyment: "to have the jouissance of

something ... is to be able to give it up."[14] Freud had already articulated this logic in his discussion of the notion of the superego. Freud demonstrates that the superego, contrary to our expectation that it would be hostile to satisfaction, "an obstacle to the fulfillment of wishes,"[15] in fact fulfils the opposite function. If the superego is the psychic representative of external authority, a psychic agency that insists on the subject's renunciation of instinctual satisfactions, it reverses the order of things expected to hold on a moral scale. Conscience and guilt, rather than causing a renunciation of forbidden wishes because of a command from an internalized moral agency, are understood by Freud as resulting from the psychic presence of a forbidden wish for satisfaction. Affects such as guilt are produced by the superego, thereby indicating the proximity of the superego to the id. The superego imposes its rigid demands only in order to allow the forbidden wish its due place: "conscience is the result of instinctual renunciation, or ... instinctual renunciation (imposed on us from without) creates conscience, which then demands further instinctual renunciation."[16]

This compulsive nature of the law of the superego reveals the proximity between being a moral subject who obeys the dictates of the moral authority and jouissance. Based on Freud's concept of the superego, Lacan constructs an ethics of psychoanalysis within which he develops a conception of the law according to the following coordinates:

1 The function of the pleasure principle is to guarantee the distance between morality and the origin of the law. Being too close to the Thing at the origin of the law will bring about painful affects.
2 The moral law demands the renunciation of satisfaction in the name of that to which the moral law gives form.
3 The moral law gives form to what lies at its origin: *das Ding*, or the object of prohibition that knows no law.
4 This *Thing* at the origin of the law, giving rise to action, turns the law into a disharmonic factor in the life of the subject, leading her astray in her moral pursuit. Obeying the law, even if painful (in terms of the pleasure principle), is enjoyable to the subject and hence contradictory to the law.
5 The law is universal and absolute; dimensions of the law that sustain it are in constant incompatibility with human practices.

The pleasure principle has a regulative function, which is why, claims Lacan, Freud formulated his pleasure principle in terms of moderation and of keeping stimuli to a minimum: "Jouissance is this something *in*

which the pleasure principle marks its traits and its limits."[17] Morality should be understood, then, in terms of limits, while jouissance assumes a moment of absolute freedom. The subject, given to the regulation of action according to the inclinations and satisfactions of the pleasure principle, is unable to act freely. Yet freedom resides in her, albeit as a foreign presence, marking the crucial instance of absolute willing in the human psyche.[18] The pleasure principle, to follow Freud, is a principle of moderation that imposes a subjectification on the element of absolute willing in the human psyche, and hence a renunciation of jouissance. Jouissance, similarly to the Freudian concept of libido or sexual drive, knows no limit and acknowledges no subjectivity. Jouissance defies the interests of the ego or of the subject. Thus, associating jouissance with one subject is in itself a mode of defying its absolute boundlessness. As Lacan has claimed, freedom for Kant, similarly to jouissance in psycho-analysis, marks the place of the absolute, the Thing from where the drive to attain the morally good emerges.

The distance between the absolute freedom to will (an absoluteness to which jouissance is linked) and the limit imposed on the demand for freedom (a limit with which pleasure and displeasure are associated) constitutes the foundation of Lacan's distinction of ethics from moral-ity. While the former has to do with the acknowledgment of the place of jouissance, which knows no social tie and is prior to all relations, the latter has to do with the refusal of absoluteness for the sake of social meaning and moderation. The place of the moral law in relation to maxims of action can be understood in similar terms. Born at a moment of absoluteness, the law produces only partial satisfactions. The law, established at a moment of absolute freedom, can be applied to moral practices only if the hold on the law is slightly loosened. Approximating the law is already compromising its demand. A paradigmatic example Lacan gives in this context is that of Georg Wilhelm Friedrich Hegel's master and slave. The master became master and the slave became slave at a mythical moment of absolute freedom in the fight to the death between two subjects. The one not willing to stake his life falls into a state of dependency with respect to the other. The master, in order to be a master, is ready to wager on his life and thereby loses access to the sources of enjoyment. This is evident in the case of the master, who is not just anyone in the city, says Lacan. The master, if he wants to remain master, must subject his body to severe discipline and cannot indulge his body even in his time of leisure, as he has other things to do than abandon himself to jouissance.[19] Already in Hegel, abandonment

of jouissance marks the horizon of death that enables the acknowledgment of mastery.

The jouissance of the master is hence a phallic jouissance, which is attainable only through castrated (indirect) satisfaction in an object of desire. The law evacuates jouissance from the place of the master, even if the master initially fought to the death for his prestige, that is, for the ability to enjoy his title and mastery. The jouissance evacuated from the place of the master is accessible through the place of the slave, who has access to the object of jouissance because he has the savoir faire; he knows how to enjoy the fruits of his work. The jouissance deferred, relocated in the place of the slave (located in the slave's body, which the master can indirectly use), is a jouissance "we will never know anything about."[20] Jouissance, claims Lacan, is a substance. It introduces the subject to the real and yet cannot be attributed to or put into a subject; it cannot be compared quantitatively to other things and does not recognize categories (man/woman, slave/master).

The ethics formulated by Lacan involves the absolute "fight until death" of the subject, which ties the master to the advent of the law. Lacan claims that Hegel was short-sighted in weighing the consequences of the fight to the death as it did not actually bring death into play but only the master's right to sanction death to the slave. What is it, asks Lacan, that the master saves in the slave by keeping him alive? It is the jouissance that only the condition of the slave gives access to (even if, once the slave is formulated as a subject, we will never know anything about this jouissance). The possibility marked by the slave of gaining access to jouissance functions as the reason for keeping him alive and as the absolute cause of the primordial law that is assumed by Hegel. But Hegel, just like the master, cannot say anything about it. The fight to the death for prestige and meaning on the side of the master was nothing but a lure; it was actually a fight for the jouissance of the body through lawfulness (which is why in the history of society, it was first the master who had the right to enter marriage on his own accord). The jouissance hidden in Hegel's dialectics thus refers to the absolute yet inaccessible cause of desire and the law. Jouissance is a substance, implanted in one's body, the cause prior to the imposition of the law, of constraints, and of subjectivity. Ethics hence describes the way in which the speaking being positions herself in relation to what is prior to the principle of pleasure: jouissance, which has to be assumed rather than known in order to allow access to it through the law.[21]

The place of the law lies between jouissance and pleasure, which becomes evident "from the moment that the operation of social struggle

simply introduces the fact that the relations of bodies are henceforth dominated by this something which, moreover, is called the law."[22] The law indicates the preordained limit on the master's enjoyment, thus marking the limits on the absolute master. The master could kill the slave, but death is actually not brought into play in the dialectic of master and slave; the master could enjoy the slave's body to exhaustion, but jouissance remains unknown to him. The master's power is understood to be absolute in the sense that this power is never enacted, never put into practice. He has the freedom to enjoy whatever, whenever he wishes, but the law moderates the absolute freedom to act. The law functions as a reminder of the moment of absolute freedom, of the moment when the fight until death could have been enacted. It functions, in other words, as a reminder of what cannot be, of what cannot be known, once the master, embodying the law, has arrived. Once the master has arrived, death is not an option, and the Hegelian master fighting to the death and enjoying absolute freedom to enact his authority is one of the myths describing the origin of the law where the substance of jouissance was attainable. But "freedom is the law or the necessity that posits the self outside of itself,"[23] which means that the advent of the law marks the immanent presence and restraint on freedom.

Lacan returns to Kant's distinction between well-being and the good in order to clarify the relation of the subject to the absoluteness of the law. He claims that *das Wohl*, the well-being of the subject, her comforting small pleasures, have a regulative function with regard to *das Ding*, resolving the tension it introduces. To follow Kant, the law, when conveyed in rules of action, regulates the distance between the subject and the primordial Thing; the law is the cause for human speech and practice. Lacan shows that the Thing cannot actually appear in the codex of ordered rules of behaviour, as the object of good action, but is encountered only at the horizon of the regulating domain of the law, thus marking the pleasure attained as always contingent and partial. The law is hence needed to regulate the tension created by the proximity to the Thing at the root of the law, even if the law itself posits partial things like meaning and prestige as its direct aims. Thus the mother, the primordial object of incest, does not appear in the Decalogue apart from her social incarnation as the loving parent who should be respected. While *das Ding* is what lies at the root of the law and conditions the possibility of speech, it is never represented as such. The commandments already presuppose a primordial prohibition that "regulates the distance between the subject and *das*

Ding – insofar as that distance is precisely the condition of speech ... the condition of all social life."[24] Regulated action is necessarily conditioned by that which makes the law. The concepts of the sovereign Good, death, and jouissance – all are ways to exhibit the absolute *das Ding* that virtuous actions of humans can regulate and commensurate.

According to Lacan, Kant marks the high point of a crisis in ethics where the law is the only way open to us to know about the Thing. "Without the Law the Thing is dead."[25] The Thing at the root of the law is exhibited in Kant's thought, where we find the idea that the law is grounded on a logic of universality that can cause trouble for the moral subject. Kant writes, "So act that the maxim of your will could always hold at the same time as a principle of universal legislation,"[26] expressing a demand for a general applicability he takes to extremes, pursuing it to the limits of its consequences.[27] What renders the law is not the fact that it imposes itself on everyone but rather that it is not valid in any case if it is not valid in every case,[28] and to encounter this total demand of the law, the subject must exclude everything having to do with drive or sentiment, elements that Kant qualifies as "pathological." The law is encountered when the subject is facing no object of pleasure or displeasure, at the place where the law is totally the domain of the Other and no longer the domain of the subject – this is where the subject is demanded to act morally.

To withhold the unconditionality of the law means that the law is practised in face of an impossible relation between an absolute demand and a practical restraint that the articulation of the law imposes. This gap is somewhat humorously reproduced in the Sadean version of the law, which states, "I have the right to enjoy your body without limits."[29] The Sadean law of jouissance indicates how the subject is implicated in an impossible call for total freedom (a total freedom implied in any absoluteness), as the one consenting to the Other's freedom to enjoy the subject's body. Whether the law expresses an absolute right (to enjoy) or an absolute duty (to avoid enjoyment), it equally excludes the subject from the domain in which he or she can operate with the law. Obeying the Sadean law means consenting to exploitation by the Other; obeying the Kantian law means evacuating the subject's domain of any mark of subjective desire or wish. In any case the absoluteness of the law is fatal for the subject, implying death (eradication of the subject) rather than freedom to act by the law.

The law derives its force from an Other who sustains the absoluteness on which the law sets itself. While maxims protect the subject from the absolute demand of the law, they also fail to suggest an action that will

satisfy the demand. Hence the law splits the subject between the *enuncia-tion* of the law as laid before the subject as absolute, and the *statement* of the law in which the subject of the law is implicated as incompetent. The subject can never be a subject of the statement, who actually implements the imperative. Therefore, the object of the moral law is an object that cannot be exhibited in any action. No practice can exclude the subject's enjoyment at the limit of what the law decrees as the absolute enjoy-ment of the Other; no practice can implement the demand for absolute reciprocality (which, for Kant, is the condition for acknowledging the genuine universality of the law). To use Lacan's terms, no practice of the law can be absolute to the extent that "the commandment requisitions us as Other."[30] The absoluteness embedded in the imperative already excludes the possibility of compliance. When exhibited concretely in objects of our experience, these objects cannot reflect the law but can serve as dim or deformed images of the law as absolute. The law as expe-rienced is "a 'half-law', just as the categorical imperative is a 'half-said.'"[31]

b. The Second Commandment as Law

"It is to the extent that the commandment ... preserves the distance from the Thing as founded by speech itself that it assumes its value."[32] My reading of the Second Commandment as the aesthetic law par excel-lence is based on the approach exemplified by this quotation. The Second Commandment is a law constituted through negation, as an imperative *not* to do something, and as such can reveal the truth about the moment in which the creative act is implemented. To disclose this truth, we should be able to characterize the absolute freedom in rela-tion to which the commandment introduces a restraint. Thus we should qualify the Thing of art that is the cause of creation and determines its particular ethics, and examine how the negative structure of the impera-tive illuminates something singular about art that distinguishes it from other social practices.

> Thou shalt not make unto thee any graven image, or any likeness of any thing that is in heaven above, or that is in the earth beneath, or that is in the water under the earth: Thou shalt not bow down thyself to them, nor serve them: for I the Lord thy God am a jealous God, visiting the iniquity of the fathers upon the children unto the third and fourth generation of them that hate me; And shewing mercy unto thousands of them that love me, and keep my commandments. (Exodus 20:4–6)

The Second Commandment confronts us with a historical moment proscribing the making of images of god, "forbidding all presentation of the Absolute"[33] and of anything in nature that reflects the absolute. The commandment highlights the inherent incompetence of images that aim to exhibit a godly presence. If such imaging persists, it will produce no more than misleading pretensions. One cannot make an image on earth of what is beyond earthly existence. The attempt to do so will entail one of the following: a false image or an image emptied of what it aims to represent. And yet, similar to the Platonic expulsion of the poets, which, as discussed in the first chapter, affirms the poet's power, the biblical imperative that forbids any attempt at depicting god thereby also affirms the power of the image.

The commandment does not state that the image is immanently false but that the Hebrew god cannot reside in something material, whether natural or fabricated. The commandment literally suggests that the only way to avoid a false representation of god is by avoiding the creation of images altogether. The commandment thus implies the power of the image in representing, through what is seen, an idea of god as that which cannot be represented. In short, by prohibiting the imaging of god, the power of material presentation is formally denied as false, thus affirming the reality of what is excluded from the presentation. The commandment thus conveys a dual message: a material thing cannot represent a godly entity, and, at the same time, an image can represent something of the godly, which is why such representation should be proscribed. These incompatible facets of the imperative are the consequence of its negative form. The imperative negates the power of the image to represent god, thereby affirming the power of the unthought.

And yet, had there not been a question regarding the possibility of imaging god, had man not been attempting to picture god, such a prohibition would not have been necessary. The imperative nonetheless does not negate the embodiment of any god in an image but only of the god of the Israelites, thereby affirming both the power of exhibition the image possess and its moral consequences. Since the Jewish law imposes an extreme demand on the believer to refrain from imaging altogether, its form of absoluteness determines its ethical standing. The Second Commandment does not restrain specific human acts but suggests a proximity to the primordial origin of the law. While the command to respect one's parents relates the law to a range of human practices (thus suggesting infinite occasions for obeying or transgressing the law), the Second Commandment conveys the absolute emptiness of the moral law.

Its negative structure does not apply to its propositional content (commanding man to refrain from imaging specific objects in definite situations). Rather, it reveals the implications of a negative imperative for our understanding of the source of the imperative. The commandment is about the absolute status of the law of creation rather than about the variability of imaging practices.

In Seminar VII Lacan refers to the commandments as being grounded on the very possibility of speech.[34] Prior to the commandment there is a moment of determination around the fundamental prohibition of the object of incest. The subject is not assumed to wilfully choose between obeying and transgressing the law but is assumed to take the unconscious decision to renounce the forbidden object. In formulating the law, a preliminary prohibition is already assumed as its prior condition. Hence, as mentioned previously, one can respect or disrespect one's parents, but one cannot obey or transgress the law prohibiting incest that institutes the commandment "honour thy father and thy mother." That law is intransgressible even if people practise incestual relationships. This was Freud's discovery in "Totem and Taboo," that aiming to obey the law can produce transgressive practices, can cause enjoyment of what the law denies. The absolute form of the law is hence separated from its content. In every act of submission to the law, not only is the moment of renunciation reproduced, but the cause for this renunciation is also brought to life. Every act of renunciation, based on the possibility of speech, is also a mode of reviving the Thing, which, if relinquished, would produce laws that can be transgressed.

In a later seminar Lacan explains what logically happens at the moment that necessitates the advent of the law.[35] For there to be law, there must be a language with which to articulate it. But a Thing external to the world of nature is also needed, with regard to which differences (as between right and wrong) will be generated. For a law to be enacted, something must be posed outside the system. In the case of the law of sexuality, Lacan, following Freud and Claude Lévi-Strauss, terms this external factor incest, or the cause of desire. Lacan's analysis of the law refers to this external point as ex-isting[36] the structure: it conditions the structure yet must be deducted from the structure by which it is sustained. This ex-istence is inscribed by prohibition: incest gains its meaning through its prohibition (which is, obviously, an act of speech) even if the object of jouissance, named incest, is *external* to the law regulating sexual relations. The law of sexuality, unlike its cause, already presupposes differences, such as those between male

and female, made possible through language. The sexual difference is introduced by language that creates a rupture between the sexes. This rupture is constituted by the phallus, the pure signifier of the difference between the male, who *has* the phallus, and the female, who *is* the phallus.[37] We know of this difference between having and being, or between male and female, not because these differences come together in a sexual relation, but because the uninhibited sexual rapport (incest) substituted by the sexual law (which prohibits incest). In other words, once the difference between male and female is present in discourse, a sexual relation is excluded. This non-rapport between the different genders cannot, however, be attributed to language or to social discourse as having destroyed what had once existed, as such a rapport had never actually existed (a relation in the social/sexual sphere already assumes difference). This is one crucial point regarding the place of the law as understood in psychoanalysis: the oppressive, coercive dimension of social existence is but one factor accounting for the relations of the subject with the Other of the law.

The advent of language grounds the difference between the sexes on the assumption of a prior jouissance (embodied in the possibility of incest) in a moment of sexual relation that transcends differences. The sexual law imposes sexual difference by way of crossing this difference assumed by the law, and its power is derived from the assumption of a relation, prior to the imposition of the law, that is lost. Hence the second point in Lacan's analysis is that the law is based on a difference instituted by language and that this difference refers to a prior fictional moment of rapport. The law marks the fact that only once a difference is introduced can the idea of a rapport become a myth.

The third point in Lacan's analysis is that of defining the law as a law of desire: "It is here that there is this distance in which it is inscribed that there is nothing in common between what can be stated as a relation which lays down the law ... a law that is coherent to the whole register of what is called desire, of what is called prohibition."[38] Lacan indicates that the law is sustained by desire, and hence the power of the law is necessarily directed at the cause of the law, at the moment that institutes the aim of desire. The prohibition, posited at the original limit of the law, functions as a cause of desire, bestirring in the subject the desire to enact the law, to find the practice that will resuscitate the Thing that caused the law to be formulated in the first place.

The final point in Lacan is based on his claim that this identity between the law and desire "derives from the effect of language, from everything

that establishes the *demension* of the truth from a structure of fiction."[39] *Demension* is Lacan's neologism (*de* + *lie*, i.e., the negation of *mentir*[40] or dimension + lie), which refers to the disclosure of truth through appearance or lie. Truth is not contrary to semblance, and so *demension* refers to the dimension of truth that supports a semblance and is supported by a semblance.[41] That is, while the appearance of the law is deceptive, it retains something of truth by the force of the semblant.

Lacan's structure can be represented by Figure 5.1.

Figure 5.1. The structure of the law.

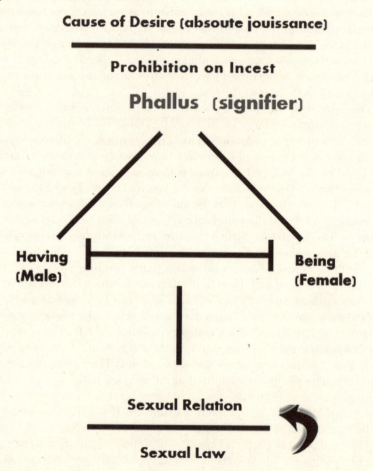

The law regulates a practice characterized by non-rapport. And yet the non-relating partners are brought together by a law instituted on a false picture. The law, with the absolute power of incest at its horizon, presents the distance between male and female as unbridgeable, as if without the prohibition on incest, absolute jouissance would have been possible. The introduction of the law creates the possibility of social (and sexual) practice by suggesting a moment prior to the prohibition in which the distance was not there. According to Lacan, through the myth about what created this unbridgeable difference, something regarding the truth of the law is revealed.

Applying the same structure to the Second Commandment (Figure 5.2) exposes the place of the law in relation to artistic creation. The commandment assumes a god that can be seen as external to the system

Figure 5.2. The structure of the aesthetic law.

of representation.[42] A god that can be seen stands for absolute jouissance at the horizon of imaging, a jouissance that will return on the scale of desire in the form of a desire to create an image. The Second Commandment as law thus substitutes the god that can be seen with an image that, like the phallus as a signifier of sexuality, signifies the symbolic lack in every imaging.[43]

Our notion of a god that can be seen is attained through the god we hear about in the prohibition on imaging him, which means that the commandment suggests two modes of imaging. One mode of imaging is that of incarnating god in the image – a mode whose products will be assessed on the scale of representation, according to degrees of falsity or misrecognition. The other mode of imaging is that which avoids the image of god for the mere making of the image, granted that the presence of the absolute can thereby be affirmed.

This logic behind the introduction of the law can be demonstrated through the scene establishing the relation between god and Moses and between god and the Israelites. The Israelites were requested to carry the message of god, yet this god, when appearing at the Sinai revelation, is distant. This is a god who is neither seen nor directly perceived but who only creates remote visual and auditory effects. The people "hear the sights and look at the sounds"[44] but only from afar. Only Moses is momentarily able to see god in the burning bush, but this elusive moment immediately leads Moses to look away from the sight. God cannot be seen, but the Bible creates the space in which a myth about the image of god can be located. Between the encounter with god through the burning bush and the revelation of Sinai, something takes place regarding the very possibility of imaging god. This interval constitutes a moment in which the myth of the law is instituted. When in front of the burning bush, Moses turns his head away, in order not to see the face of god, the god presumably still within the elected one's field of vision, thereby suggesting that Moses was on the verge of actually seeing god. In contrast, the people at Sinai are positioned outside the limits of where god could have been seen and are privileged with a series of impressive effects that provide indirect visual representations of god's power and magnitude. This same god would soon impose a law on their lives, as a god of whom no imaging should be ventured.

What is the status of the image following the prohibition on imaging? The images created may seem to follow a law that limits the desire to image god, but, in fact, the legislative discourse that prohibits imaging introduces a fundamental difference between the making of images of gods, which necessarily represent false gods in the material image, and

the making of images that elude the measure of representation. Thus we can distinguish between the creation of images that aspire to represent the absolute (pretending to "have it" – and one never does) and the creation of images that present the "being" of the image as one that is immanently committed to exhibiting what cannot be thought or represented. The image produced under the law registers a lack in relation to a jouissance that had nourished the creation of the image. Significantly, the commandment warns us that imaging god either as celestial or as what imbues nature is equally prohibited. God has no image and cannot be represented by any visual form. In psychoanalytic terms, the attempts to camouflage the lack of the object of desire produce false images; those images that do not camouflage the lack may prove to be equally menacing with regard to prohibition, as they half-say something of the absolute, by divulging its unexhibitable nature.

The paradoxical relations between prohibiting the imaging of the absolute as expressed by the law and affirming the power of the image through the law's negative structure institute the ethics of creation. It is an ethics of the possibility of making when making is not possible. This is law as desire, which enables the subject to act because jouissance (an image of god) is at its limit. The ethical dimension to which art is committed is manifested in an aesthetic imperative that conditions the artistic act but also eclipses its true power. The Second Commandment stands as an *aesthetic imperative* because it manifests the paradoxical trade-off between the making and the impossibility of the making, the intersection at which art is located.

The prohibition on the imaging of god has nourished numerous ideological movements, struggles for power and control, and diverse theological positions. Suffice it to mention the iconoclast revolution in eighth- and ninth-century Byzantium,[45] the rejection of icons in the Protestant Reformation, and claims regarding the hegemony of vision that characterizes Western culture according to postmodern thought.[46] These diverse historical moments illustrate the fundamental difference between creating images and flatly rejecting them, and the opposition between word and image, with a favouring of the former. The image is seen as something that creates phantoms, misleading representations that lead the subject away from the authentic grasp of civilization, while the word, in its immanent respect for the unexhibitable, opens alternative vistas of creation.

Throughout history a wealth of images have provided variants of the interdicting commandment, and these reveal that the commandment against the making of images holds a paradoxical relation with

the practice it forbids.[47] One of the most famous instances of an artistic depiction of god is no doubt Michelangelo's *The Creation of Adam* (1508–12), at the Sistine Chapel. The fresco's depiction of god demonstrates a tradition that assesses the possibility of incarnating god in the image. In what way, though, does the image of god incarnated in man convey the absolute dimension? It has been claimed that two of the angels beneath god are Lucifer and his mate Beelzebub, who envied man for being created in the image of god and were therefore sent by god to the inferno.[48] Hence the image contains not only the holy and the divine but also its evil opposite. It has also been claimed that it is the image of god himself that simultaneously represents the evil power in the fresco. In attempting to identify the feminine figure embraced by god's left arm, previously interpreted as Eve or Mary, this critic claims that she is the other side of god, feminine by nature and associated with evil.[49] The division of the agency of god into its holy and evil parts produces a sort of dismembering of the figure of god as depicted in the image of man, thus revealing that god could not be completely embodied in one unified human-like image, as there remains a residue that eludes the image. Michelangelo's fresco is driven by a desire that can by no means be identified with the incarnation of god in a bearded elderly man. The painter paints man moulded in god's image, whilst avoiding depicting god in that one image. The picture thus embodies the painter both avoiding god and depicting god in the image of man and thus superseding both. In other words, the fresco depicts the biblical scene of the creation of the world, in which god provides the stage instructions for an event in which he plays no part.

The imperative not to create pictures paradoxically exposes the unremitting drive to produce them and hence the necessarily liberating effect of transgression. Similarly to the way the Kantian imperative is in constant struggle with the pathological dimension of man's desires and needs, the commandment to avoid imaging is in a constant state of struggle with the drive to image and with the satisfaction that imaging entails. The link between the demand made of the believer to refrain from making images, and the light shed by this prohibition on practices of depiction, implies the ethics of art. The Second Commandment, as an aesthetic imperative, touches on the fact that engagement in an artistic practice is derived from the desire to create what cannot be imaged. Without this desire at the origin of art, the law prohibiting imaging would not be there to instigate the practices that exhibit this desire.

As mentioned previously, Lacan has claimed that "desire is the law"; the law signals the object of prohibition as the object of desire. Thus,

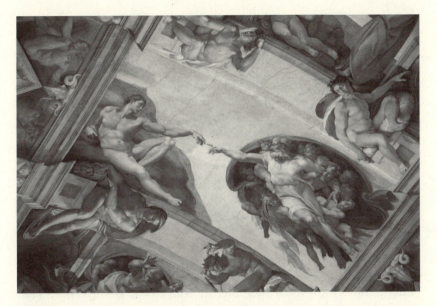

6 Michelangelo's fresco of *The Creation of Adam*. Sistine Chapel, Vatican Museum, the Vatican, Rome, Lazio, Italy, Europe. © getty images

the law both constitutes desire and marks the object that stands for the cause of desire.

Nonetheless, not every imperative formulated as absolute displays the place of desire with regard to the law. Thierry de Duve describes practices of modern art under the categorical imperative "do whatever!" This permissive imperative may appear to work according to a similar logic but in fact constitutes a crucial divergence from the biblical commandment. Unlike the biblical imperative of prohibition, which implements the voiding power of negation in order to instate an ethical place for creation, this modern imperative expresses permission; that is, it expels nothing from the domain of art. The permissive imperative, unlike the prohibiting one, nullifies the possibility of encountering the object of desire.[50]

The Kantian concept of the universality of the law is mediated through maxims of action that necessarily fail in the implementation of the law. These maxims cannot contradict or comply with the imperative, and yet they are constituted by the desire to follow the inner moral voice. We are accustomed to think of the categorical imperative as universal in the sense that even if it states no specific content of the law, it prescribes

conformity of the maxim to the form of the law, which becomes evi-
dent in a moment of certainty.[51] Even if we cannot prove the reality of
the moral law from experience, its apodictic certainty cannot be disre-
garded. This certainty, according to Kant, results from the power of free-
dom actualized in beings who cognize the law as compelling for them
even if experience and inclination direct these beings elsewhere. The
law marks the possibility of a supersensible order in which lies the cer-
tainty accompanying a moral action.[52] The imperative "do whatever!"
just like the Second Commandment, displays universality in the nude,
and yet it cannot function as the voice that stands for the cause of the
desire to act in specific ways (that would conform, or fail to conform, to
the law). Even if no imperative produces a maxim that fully conforms to
the law, because the law has no content while a natural law of action must
have experiential content, the pure law gives rise to the desire to attain
the absolute freedom it suggests. "Do whatever!" suggests freedom in the
act rather than freedom as the absolute limit beyond attainment. The
problem with the imperative "do whatever" thus exceeds the indeter-
minate conformity to law (nothing can count as an act that "does what-
ever") as it cannot generate the prior desire to conform to the law. The
permission to do whatever produces no disharmony in the creative act
as anything whatsoever that is actually created would equally and fully
conform, or fail to conform, to the law.

"Do whatever!" exhibits nothing at its horizon in relation to which the
desire to create something that conforms or transgresses the law can be
ignited. "A priori, art ought to be whatever and be called art by whom-
ever, but the modality of this *ought*, of this subjective necessity, which
remains exemplary like that which Kant required for the judgment of
taste, takes the route of a negative necessity, of an impossibility."[53] Mod-
ern art, defined by the imperative "do whatever!" cannot produce an
artwork that intersects with the law. "Do whatever" does not allow the
desire for the supersensible to be enacted. *Everything* cannot be done,
and yet every act, whatever act, is the making of whatever. To function as
an aesthetic imperative the law must ignite the desire to create an object
that will exhibit what the imperative leaves indemonstrable at the limit
of its domain of legislation.

c. The Absolute Law Cannot Be Obeyed or Transgressed

The Second Commandment requires the believer to refrain from the
making of images of god. But why does this commandment receive the
position of a moral imperative of the highest degree, placed prior to

other commandments that on face value seem of superior moral order, like "thou shall not kill!" or "thou shall not steal!"? Had the commandment been no more than a prohibition on producing empty images, would it have appeared as a law of such precedence in the Hebrew moral codex? Something in the created image imposes the menacing effect against which the commandment warns. This something is neither an image nor an object and yet is constituted through the making of images.

Lacan mentions the Second Commandment in the context of his treatment of Kant's ethics and the question of how the ethics of psychoanalysis can illuminate moral philosophy. The Second Commandment reveals that the human practice of exhibition by images is an ethical practice taking place under the shadow of an imperative, that the desire to make images is produced under prohibition. This is part of the fundamental claim of psychoanalysis regarding the place of desire in one's ethical positioning: "practical reason is sustained only by giving a specification of the moral law which ... is simply desire in its pure state, that very desire that culminates in the sacrifice, strictly speaking, of everything that is the object of love in one's human tenderness."[54] The Second Commandment, like any imperative, establishes a demand beyond the possibility of its transgression because it is constructed with the power of pure desire that culminates in total sacrifice. If the imperative demands such a sacrifice of everything that is human, it can be neither obeyed nor transgressed; furthermore, no human act can practically affect the law. The imperative, rather than addressing the various modes of creating images, touches the very limit of imaging. The law remains unaffected by practical maxims of action, or as Kant formulates it: "The practical rule is therefore unconditional ... For *pure [and] in itself practical reason is* here directly legislative. The will is thought as independent of empirical conditions and hence, *qua* pure will, as determined *by the mere form of law*."[55] The Second Commandment gains its place of priority because it reveals that the relation of the subject to the law is a relation of pure desire, and hence the difference between transgressing and obeying the law collapses to the point of indistinction.

The Second Commandment is an imperative that establishes and outlines the very possibility of creating images. It prohibits the making of images in order to outline the possibility of an image that cannot be imaged. In other words, the commandment institutes the difference between the god one sees and the god one hears by introducing the signifier "image." The commandment thus functions as an intermediate between the prohibition on imaging god, and god as the limit of the very possibility of imaging. The aesthetic imperative, like every law, is the

summoning of the subject to act, and yet for this summoning to have an effect in practice, it should be embedded in an absolute cause. Hence, if god is imaged, in a human or natural form, this would create the false notion of a god that can be seen. The subject is hence summoned to create a false image, thereby making a place for the god that cannot be imaged.

While the word instates the appropriate barrier between us and god, the picture reveals the possibility of capturing a prohibited aspect of god. The commandment portrays and recommends the paradigmatic state of affairs in which we stand in front of the burning bush, turning our gaze away. Above all, the power of the commandment is in portraying the possibility of thinking about the limit beyond which nothing can be imaged.

The making of images should not be conceived as a transgression of the commandment but as an attempt directed at the origin of the law, at the field where the formidable presence of a god is everywhere. Since no act of creation can be universalized to represent the law itself, images are in their *statu nascendi* created by what is intolerable to the law. Images are by necessity modes of acting in the name of what the imperative excludes, which is why the Second Commandment does not distinguish between kinds of images. And yet, once produced, an image captures the subject of the law since every image necessarily raises the impossibility of embodying or imaging the Idea that gives the law its form.

To return to Lacan's reaction in Seminar XI to Plato's protest against deceptive images, he claims that for Plato the image does not compete with genuine appearances but with the Idea itself. Thus, at the moment that reveals that we are facing just a representation, what is discovered is that the image actually seems to be that something else that it pretended to be a moment earlier.[56] The image reveals that having a resemblance with the object and being that object maintain no rapport. The deterring power of painting is derived from its capacity to appear different from what it actually is, to be merely an appearance. Thus the painted image with its deceptive facade elicits what transcends the imaginary function of the image. It elicits this thing whose appearance the picture cannot visually embody but the thing is given to visual attempts to gloss it over, whether in an image of god the father, of Eve, or of Lucifer. The Second Commandment is hence an imperative that cannot be transgressed and yet constitutes the foundation for our creative efforts. Furthermore, the commandment refers to an image that cannot be produced and yet marks the possible danger of creating an image that will divulge something of the reality that it fails to represent.

In Kant we find the assertion that due to the pure status of the moral imperative, it can be neither transgressed nor realized. For Kant, the moral law is given a priori; its causal determination has no bearing on the way causality operates on objects of experience. The moral law and whatever is causally inferred from it can be attributed only to the noumenal domain, an attribution that stresses the distance between what is formally assumed by the moral law in its pure formality and what can be empirically inferred. If we follow Kant's reasoning, we see that complying with the law unconditionally is impossible. The moral law generates ideas of reason that allegedly direct our attempt to act in a purely moral mode, but even then the law does not describe modes of behaviour.

Since the law is a priori and precedes the question of the possibility of its implementation, the moral law has the status of what cannot be directly known, or transgressed, even if one can act in a manner that disrespects the conditions founding the law. Let us now elaborate further the difference between the law of pure practical reason and the law as realized in maxims of action through the imperative "love thy neighbour as thyself!" The imperative can give rise to a number of maxims indicating ways of implementing this law. For instance, envying your neighbour in a deadly manner appears to flatly oppose the spirit of the imperative. Helping the neighbour out appears to be compatible with the imperative. And yet this reasoning is irrelevant to the status of the pure law not only because of the imperative's absolute formulation but also because it can be served both when seemingly obeyed and when seemingly transgressed. Wishing the happiness of my spouse, claims Lacan, requires that I sacrifice my own,[57] which means that wishing the well-being of our *Umwelt* goes against our fundamental drives. And yet even when the subject does something that runs counter to that with which she is satisfied, she still gives satisfaction *to* something.[58] In other words, it does not matter how the imperative to love one's neighbour is being satisfied; acting in the name of the imperative gives satisfaction *to* something. This is a necessary conclusion from the nature of the drive (it always finds satisfaction, even if inhibited in its aim) and from the acute disagreement between the demand to love one's neighbour and the subject's drive for self-preservation and satisfaction in the object. Hence, the pure aggressiveness that is evidently damned by the law in fact constitutes the law's foundation and is being satisfied when one is complying with the law. This aggressiveness is associated with the total jouissance the subject associates with the other (one's fellow-human), the other imagined by the subject to derive more enjoyment from life than her. The imperative is needed to turn the structural aggressiveness of the subject towards the neighbour into a coerced love that is

but a permanent (and enjoyable) residue of the renounced aggressiveness. This is the other dimension of the alienation between the law and maxims produced to satisfy or undermine the law.

This alienation can be found in Kant in his demand that a maxim have general applicability to be considered relevant to the moral law. However, when one is formulating a maxim that does not conform to the law, the maxim does not locate its practitioners *in opposition* to the law but *outside the law.* Being greedy, for instance, is not an action or behaviour that undermines a moral law but an action outside the realm of the law. Greediness follows a maxim that cannot be derived from the law but only from other principles like interested inclination, sensuous pleasure, and pathological desire. These principles are by definition excluded from consideration when the law is enacted. Kant provides a telling example for distinguishing maxims from the pure status of the law in his discussion of the form that would make a maxim fit for a given universal law.[59] He presents the following illustration. Someone set for himself the aim of increasing his wealth by every safe means. He then receives a deposit whose owner died and left no record of the deposit being entrusted to the receiver. This is naturally a case for activating the maxim (increase thy fortune by all possible means!), and the question is whether the maxim, when applied to the case at hand, "could also hold as a universal practical law ... whether it could indeed take the form of a law, and consequently whether I could through my maxim at the same time give such a law as this: that everyone may deny a deposit which no one can prove has been made."[60] But, claims Kant, turning this maxim into a universal law would "bring it about that there would be no deposits at all."[61] Denying the deposit to which there were no witnesses is hence not a transgression of a moral law that demands one's responsibility for an entrusted deposit. Rather, the maxim of putting the increase of wealth before anything else would analytically cause a contradiction and would thus remain outside the moral domain (destroying the very notion of "deposit"). The moral implications of receiving a deposit are independent of one's knowledge or recognition of the deposit entrusted to one. If a universal law cannot be derived, the maxim guiding our action cannot be rationalized, unless the form of the law in its universal applicability disintegrates. In other words, enacting a maxim is not an action in the domain of the law, even if the action is the only manner of exposing the origin of the law and its primordial cause.

The Second Commandment prohibits the creation of an image of god, and yet it also interdicts the imaging of god in the image of man

or through elements of nature. Just like the law of incest, which forbids more than is deduced from the law itself (expanding the domain of application of the law to remote relations and not just to direct kin), the Second Commandment forbids more than is deducible from its direct reasoning ("any likeness of *any thing* that is in heaven above, or that is in the earth beneath, or that is in the water under the earth"). This excessiveness of maxims relative to the immediate dictate of the law reveals that the moral imperative is of another order than the maxims constituting the law's practical enactments. Hence, to enter the domain of the aesthetic imperative requires more than a transgressive facade. The image should expose the split between the impossibility of transgression and the immanence of failure – the split constitutive of the image that can touch our ethical being.

d. The Subject in His/Her Action Exhibits the Absoluteness of the Law

Is the Second Commandment a command to act or to avoid acting with images? We will now examine the sense in which the law, while being of a different order than human practices, nonetheless requires action to be exhibited. The imperative to avoid imaging is a demand to act with images, since, as in Kant, it is only through action that the place of pure practical reason is exhibited. We saw in the previous section that the ethical dimension imposes a predicament manifested in an insoluble conflict between will and action, between freedom and its practices, and Kant provides the means for differentiating the two orders. For instance, the affective spectrum relevant to practical reason is distinct from the subject's state of sensation: "well-being or bad always signifies only a reference to our state of agreeableness or disagreeableness, of gratification or pain," but "good or evil is in fact referred to actions rather than to the person's state of sensation."[62] The domain of the law admits specific affects whose presence in the subject of the law is indicative of the presence of the law (such is the affect of anxiety discussed in relation to trompe l'oeil in chapter 4).

Despite the immanent distance between the absolute abstractness of the law and the actions that aim to satisfy the law, practical reason in its pure state is not devoid of an object, and when Kant discusses the concept of the object, he distinguishes the object that determines our desire from the object involved in the question of "whether we may *will* an action that is directed to the existence of an object if making this object

actual were under our control."[63] In other words, unlike the object that stirs our will, the object of higher purpose is presupposed (even if not referred to originally, as with pure reason) because the actions subject to the law of freedom as "determinations of a practical reason will be able to take place only with reference to the world of sense."[64] Kant believes that for the law to generate the concepts of truth and evil, the subject of the law should consider the object that will be produced if a certain action is willed. The subject must have in mind the limit of the law or the object the law can produce in practice, even if this object is not (and cannot be) intuited. Hence, since determinations of practical reason refer to the world of sense, the maxim generated from the law must be faithful to the object that is actualized when an action of pure will is actualized. For instance, when punished for harassing others, the subject can overcome the pain when she entertains thoughts of her own pure enjoyment secured by the aggression against the other.

The Second Commandment likewise refers to the object of pure will through the marked contradiction it reveals between the making of images (of nature, for instance) and the exhibiting of a godly order assumed in the very making of images. The subject engaged in action is bound to fail in imaging god through an object of experience, and yet the subject and object of creation are not annihilated by this fact. Through imaging in the spirit of the law, the object willed, even if unattainable, is exhibited in action. When Moses says in the name of god, "thou shalt not ...," he signals in this split act of speech (he is both the subject of the utterance and the implicated agent of its infringement) the impossible position in which he finds himself. The impossibility involved is immanent to the structure of the imperative. Had the imperative been implemented in its entirety, this would make any further action unnecessary and would entail the total aphanisis of the subject acting in the name of the law. It is because the impossibility involved is understood as a demand to act that Moses can act in the name of god. It is not accidental that Moses is the first to exhibit this limit or impossible kernel of the law when making use of images of god like water from the rock or the burning bush, which, even if they do not portray a picture of god, amount to visual images, destined to convince the Israelites to obey the monotheistic deity. That is, Moses as the subject enunciating the imperative is also the subject already caught in the act of infringing it, because his action is critical to constituting the domain of the law. Moses must find the course of action through which the godly presence will become actual in the life of the people. Freedom is the name of a necessity, says

Jean-Luc Nancy; it is independent movement in the form of a constraining logic.[65] In other words, the moment of freedom is exhibited in the will to act in order to give form to the object of the law.

Submitting to the law means enjoying the freedom of deciding "whether something is an object of *pure* practical reason or not ... to distinguish the possibility or impossibility of *willing* the action through which, if we had the ability for this (and experience must judge that), a certain object would become actual."[66] The desire involved in acting has the object of pure will as its cause and purpose. It is through action that the subject's connection with this object is established. As already stressed, the satisfaction involved with regard to the object assumed by the law is totally different from the pleasure or displeasure that ensues from what is good and useful for something or other. Pleasure and displeasure cannot by themselves be linked a priori with any presentation of an object, says Kant,[67] and it is a mistake, even on philosophers' part, to equate agreeableness with the good and disagreeableness with evil. It is another object assumed by practical laws, and this object needs the world of action to be actualized.

In a similar direction Freud assumes that even if there is satisfaction in any transgression, transgression is not in itself satisfying to the superego. Transgressing the law is not an action that could make the object assumed by the law become actual. To assume that transgressive actions are direct reactions to the law requires that an object (like originality, revolution, perfection, or infringement) is posited as prior (and heteronomous) to the law; transgression is thus no more than a mode of avoiding (rather than tackling) the Other in its absoluteness through false representations of the law. Contemporary art, for instance, is often transgressive, attempting to produce images of absolute horror or absolute violation, to show through the image what the eye cannot tolerate. How do such works (by artists such as Paul McCarthy and Jake and Dinos Chapman) relate to the aesthetic imperative? Do they suggest an alternative decree that sets the limit for the making of images elsewhere? Further?

Following Kant and our reading of the Second Commandment as an imperative that establishes the ethics of art, it can be said that such art misses the object assumed by the law, and the freedom that desire to make this object actual entails. By acting through art in order to attain an object of pleasure or revolt, we misrecognize and miss the object that the interdiction on imaging assumes and that our freely willed action enables us to desire. A similar view is implied in Jean-Luc Marion's distinction between the semblance and the original: the semblance shines

so strongly that it overshadows the original, exceeds it, and throws the original outside visibility.[68] It is the quest of the artist to find a new visible, to enable the invisible to surge in the picture (a particularly difficult task in the context of the total presentability of painting).[69] The art of painting makes something of the order of the invisible origin to be seen, and it is by way of what we see that the invisible is disclosed. So the Second Commandment is a practical law par excellence: it is a law that by way of prohibition ordains the making of images! And it is by making images by way of prohibition that the invisible object of the law becomes actual. It is through the prohibition that the pure object of the law as the cause of action is assumed, and that the image can produce its desired effect.

The imperative is not a mechanism for producing an object beyond what the imperative forbids, as a way of transgressing the law or otherwise exiting its domain. So how can the image convey that which is impossible to image by way of the image itself? This broad question addressed by philosophers such as Nancy and Marion is here restricted to the way the logic of the negative imperative produces the possibility of acting with images.

The prohibition formulated in the imperative assumes something that the human subject cannot bear to see and that should therefore be screened off. Thou shalt not make unto thee any graven image of god because if you did, you would encounter the absolute Other. But the object assumed by the imperative is made actual not because the image can make the forbidden god visible but because the image, enacted under prohibition, elicits the real presence of the absolute object *without* imaging it. The absolute idea is imaged in practice at the limit of the imperative, as its indemonstrable cause: "do not make" affirms the existence of the negated presence. This can be exemplified through the case of the Marquis de Sade at the limit of the absolute imperative: enjoy! Sade, says Lacan, imagines going beyond the limit, and this going beyond the limit can only be imaginary. We know that because the assimilation to absolute evil amounts to endless repetitions of sadistic scenes. There is nothing of the nature of the "limit" in the practice of transgression because the limit can be imagined only in terms of what is known. In other words, the tediousness of repetition of abusive scenes proves that what can be imagined are evil actions enacted for evil's sake, while supreme evil itself cannot be fantasized but can only be addressed *in theory*. Sade "proves the imaginary structure of the limit ... He doesn't, of course, go beyond it in his fantasm ... but in his theory, in the doctrine he advances in words that at different moments in the work express

the *jouissance* of destruction, the peculiar virtue of crime."[70] Sade locates himself in the domain of total submission to supreme evil, and yet the practice of submission sooner or later comes up against its limit, and Sade cannot phantasmatically go beyond the limit as no Sadean practice can exhibit the absolute imperative. The moment beyond transgression and the place of the thing that would complete our phantasy are an imaginary moment and place that pose the limit to practice. It is the prohibited image itself, actually produced, that establishes the limit of what cannot be transgressed.

In this sense, the Second Commandment is a decree that suggests no transgression but rather a possibility of imaging the limit of the moral imperative. Make images but only as long as they are able to filter the godly Thing, to prevent the possibility of the limit being broken. Images produced under prohibition, while obeying the pleasure principle, are guided by maxims that suggest practical ways of infringing on the law while respecting the limit it sets out.

e. The Voice of the Law and the Other

The psychoanalytic distinction between the *subject of enunciation* and the *subject of the statement* differentiates the subject in the position of the speaking being from the subject about whom the statement is made.[71] The subject of the law is split by the distance between the enunciation of the absolute imperative and the way the subject is implicated in the statement. This split was first described by Kant with his concept of the voice of reason, which imposes itself as external and yet is ascribed to the reason of the subject.[72] Kant's "voice of reason" is the voice of morality that sounds so clear and distinct to everyone t and yet appears alien to the subject when weighed against the principle of one's own happiness. Due to such empirical considerations the subject can turn a deaf ear to this clear voice of reason.[73] So, for Kant, the voice of reason is the signal of the fundamental alienation between interest and comfort on the one hand and moral will on the other hand.

But the voice not only is a signal of alienation but also involves the subject in a paradoxical position. This paradox can be examined through Lacan's analysis of the voice enunciating the Sadean law: "'I have the right to enjoy your body ... without any limit ...' anyone can say to me." Sade exposes the true meaning of the Kantian categorical imperative because, "in coming out of the Other's mouth, Sade's maxim is more honest than Kant's appeal to the voice within, since it unmasks the split

in the subject that is usually covered up."[74] The voice by which the imperative is conveyed is the voice that comes from where the subject is not, from the Other, even if it is the subject himself who stands as the carrier of the voice.[75] The subject implicated is in fact obliterated as subject and appears only as the subject at the mercy of the law. This is evident from the fact that, had the subject turned the tables to take the role of the one who enjoys (granted that, according to Kant, the law should be valid for everyone), the purity of the imperative would have been compromised and its absoluteness impaired. The voice sounding as the voice of pure practical reason reveals the lack of object to which the law applies, which means that it is only when the subject enjoys that the limit of the law, the impossibility of its application, becomes evident. No wonder, says Lacan, that Kant himself regretted "that no intuition offers up a phenomenal object in the experience of the moral law."[76] The Second Commandment, the ultimate form of the law applied to the domain of imaging, likewise appears as a voice that imposes its authority from without, yet in which the subject is implicated. The law requires subjective action to reveal its object.

As a divine imperative, the commandment is expressed in the voice of god's messenger, Moses. The human agency is needed because the Israelites do not yet have a definite notion of the place of the Other as the place of the law, and Moses mediates the law's total command yet senseless presence. This already creates the dimension of the voice "that runs counter to self-transparency, sense, and presence":[77] the voice as the intrusion of radical alterity. The messenger is there to embody the voice of god that commands and binds[78] to an audience that receives it as an opaque arbitrary imposition. The moral law by definition is content-less, a pure structure imposed on the subject. The voice of the commandment, in other words, is not "a voice from within" but a voice that sounds the existence of an object alien to the subject's being, to his well being. As all materiality having to do with the practical implementation of the law has been removed from its domain, the material presence of the voice of the law is assigned a substantial place. The voice of the law is capable of rendering the law a subjective presence, thus materializing the Kantian idea that ethics is grounded on the transcendental moral law present in everyone and evident to all. "The voice of the Other should be considered an essential object ... for voice is the product and object fallen from the organ of speech, and the Other is the site where 'it' – ça – speaks."[79]

In his seminar *The Ethics of Psychoanalysis*, Lacan, referring to the Second Commandment, claims that by prohibiting the imaginary function,

this imperative in practice allows the symbolic function, speech, to be implemented.[80] The Second Commandment acts as a prohibition on the making of images, on the visual embodiment of divinity, in favour of giving place to the word of god. Moses, the subject of the law and its messenger, thus delivers to the people the interdiction on imaging god by giving his voice to the word of god. It is this voice of the law prohibiting the making of images that resounds in every future act of creating an image. The maker of images meets the Other's word, the voice, at the moment when, at the limit of imaging, the object can only be voiced but not imaged. It is hence dependent on the subject who creates images to give rise, in his act, to the alien presence of the limit.

As a moral law the commandment absolutely embodies the Other, while the subject, enacting the law, is acting under a law imposed from the outside. The subject finds herself inextricably caught between being the spokesperson of the moral law and being its coerced subject, and her freedom amounts to the forced choice to act so as to touch the limit of imaging (analogous to the Hegelian master freedom to die). The relation between the speaking subject and the subject as the content of the spoken turns out to be a split within the subject who acts, rather than two dimensions of subjectivity. Thus, in stating "thou shalt not kill" or "thou shalt not make unto thee any graven image," paradoxically, these imperatives are directed at the speaking subject who receives the word as its potential transgressor and victim.

What is expressed as an absolute prohibition or permission implicates the subject as the one who is subject to the law but is incapable of enduring the boundless possibilities it suggests. The paradoxality of the imperative is derived from the fact that the absoluteness of the law is attributed to "everyone," and hence to no one. Had the absoluteness of the imperative been practised, the well-being of the subject would have been destroyed. Not only is the subject confined to his limited ethical perspective, which confronts the freedom of moral will with the possibilities of human execution, but he is also totally subject to the Other's will in the sense that only through action that fails can the object of the law be revealed. "Thou shalt not ..." gives place to the voice of reason, making the subject the servant of the Other's will, as revealed in the Sadean doctrine. Curiously, the very same logic implicating the subject of the statement under the decree of the absolute Other is shared by Kant and by Sade, with the former voicing the decree as an absolute prohibition and the latter voicing the decree in terms of an absolute permission. Negation and affirmation amount to the same thing, except that the

Sadean law reveals what the Kantian law affirms. In both cases, practising the law to its extreme implies the subject's absolute subordination to the Other's will and hence the subject's destruction.

In closing, I will illustrate the ambivalent position of the imperative with regard to creation. The imperative prohibits the making of images and at the same time commits the human subject to continue to find ways of making pleasing or displeasing images that execute and exhibit the true object of the law's decree. Lacan referred to Caravaggio's picture *The Sacrifice of Isaac* (1603) in his unfinished seminar *The Names of the Father*. Caravaggio's picture illustrates the paradoxical situation in which god brings a solution to the insoluble situation between man and the absolute Other. The presence of the Other in the practices of man traps the subject in dialectic situations, where creation is both a desired obligation and a horror. Lacan claims that Caravaggio shows us that the god that demands the sacrifice cannot be the same god that redeems Abraham's son, replacing his sacrifice with that of an animal. The painting, claims Lacan, distinguishes the god who celebrates the sacrifice from the god of the pact, the god of the word.[81] The distance between the two gods, the two fathers, can be formulated as the distance between the god that demands a real sacrifice rather than a symbolic one, a god that demands blood and refuses any symbolic sublimation, and the other god, who says, "Do not lay your hand on the boy or do anything to him, for now I know that you fear God, seeing you have not withheld your son, your only son, from me."[82] This other god suggests a moral reasoning that would theoretically satisfy or at least partially occlude the presence of the unknown real Thing residing in the unconstrained other god. This moralizing god is hence created in the image of the moral subject himself.

The composition of the picture attests to this division between the decree as a limit on the Other's jouissance and the decree as a symbolic pact with a god that compensates for unequivocal obedience beyond the pleasure principle by restoring the subject's well-being. The hand of Abraham holding the knife marks the centre line of the composition, dividing the space of the picture in two. On the one side we see god in the figure of an angel, surprisingly portrayed in the likeness of Isaac, commanding Abraham to avoid using the knife. On the bottom right-hand side of the picture we see the figure of a ram as a mythical image of the primordial father, unwavering and demanding bloodshed. This is the father represented by the beast from Freud's *Totem and Taboo*.[83]

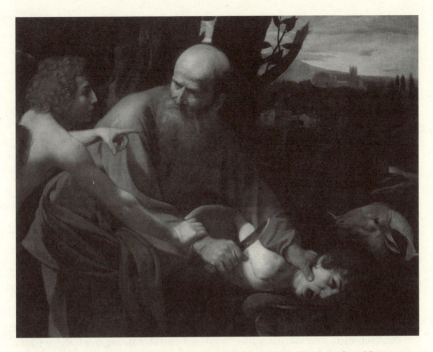

7 Caravaggio (Michelangelo Merisi da) (1573–1610), *The Sacrifice of Isaac*, ca.
1603–4. Oil on canvas, 40 15/16 × 53 1/8 in. (104 × 135 cm). Scala/
Art Resource, NY. © Uffizi, Florence, Italy.

God, through his messenger the angel, signals obedience and transgression as two possibilities that suggest benefit or loss, satisfaction or dissatisfaction, for the subject, under the mechanism of punishment and reward. But god also appears in the figure of the ram, the totemic animal representing god as the absolute Other that can be imaged only through a substitute. This is a god that establishes an imperative that cannot be made sense of and yet imposes an absolute demand: I will shed your blood, no matter what, because my command is absolute. This decree is introduced into the world of man entailing the loss of the tentative image of god as present. The god of the absolute decree cannot be present unless imaged by a substitute symbol. By the sacrifice of the ram instead of the boy, the presence of god is substituted by the symbolic presence of the image, that is, by the figure of the beast.

The dialectic presence of the Other in the image can illustrate the making of images given to the impossibility of the making. The imperative demanding an absolute relinquishing of the making of images establishes the uncompromising desire to produce images. To image god means portraying a god in our likeness, for we were made in the image of god. The commandment not to image god means that no contingent substitute can be put in the place of the imageless god who demands bloodshed.

Since the god beyond the godly imperative cannot be imaged, it can be made present only through substitutive images that function as a screen before the godly Thing. Every making of an image hence touches on the limit of the imperative, suggesting something of the enjoyment of the primordial father whose interdictions are always absolute. The pleasure we draw from images does not lie merely in transgression but is enjoyment beyond the pleasure principle that has to do with our encounter with the limit of imaging, with what cannot be imaged. Thus, the Second Commandment as an a priori, transcendental imperative that cannot be transgressed does not prohibit the making of images of god because images are empty of godly presence. Instead, the commandment sets up another possibility that is immanent to visuality and marks its limit.

The Second Commandment reveals a connection between ethics and aesthetics, between imaging and the limit on imaging. The ethics behind artistic creation enables us to rethink the making of images as both unavoidable and impossible. This association between artistic practice and the imperative necessary to ground practice enables us to regard the making of images as an infinite process of making the impossible. Hence this reading of the Second Commandment as the aesthetic law refers to the same creative desire Kant alludes to in his third critique:

> For though the imagination finds nothing beyond the sensible that could support it, this very removal of its barriers also makes it feel unbounded, so that its separation [from the sensible] is an exhibition of the infinite; and though an exhibition of the infinite can as such never be more than merely negative, it still expands the soul. Perhaps the most sublime passage in the Jewish Law is the commandment: Thou shalt not make unto thee any graven image ... For once the senses no longer see anything before them, while yet the unmistakable and indelible idea of morality remains, one would sooner need to temper the momentum of an unbounded imagination so as to keep it from rising to the level of enthusiasm, than to seek to support these ideas with images and childish devices for fear that they would otherwise be powerless.[84]

By negating as powerless any visual image, the idea of morality is nourished and revived. The negative exhibition of morality in the commandment involves no danger of fanaticism, of wanting to see something beyond all bounds of sensibility. The negative imperative preserves the sensible ground of the idea of freedom while sustaining the notion that this idea is inscrutable and precludes any positive exhibition. This is precisely where the ethical drive to create finds its due place.

Conclusion

The negation of the given or of being-in-itself ... goes toward nothing other than freedom ... Negativity is from the very first nothing other than the hollowing out of being by its own liberation.

The second negation denies that the first is valid on its own: it negates pure nothingness, the abyss or lack. It is the positive liberation of becoming, of manifestation, and of desire.[1]

These words are used by Jean-Luc Nancy to describe the implications of Hegelian negation and negativity for the affirmation of freedom and of desire. Negation affirms the absolute not as a pre-given but as what comes to be known as real to the subject by way of negation; the negation of being does not leave us with nothingness but leads to a second negation that manifests the absolute thing, formerly camouflaged by being. These words can also serve as an outline for the present study, delineating the route taken here in order to show that, under negation, art is an affirmative liberation of becoming, of manifestation, and of desire through the practice of imaging. The journey unfolded in this study traces the implications of the two negations Plato has subjected art to: *art is not true, and art is not good,* as constituting the ethics, or rather, the non-ethics of art. The first negation hollows out the representational impact of the image, thus liberating the artistic image from the object as is or as perceived. The second negation affirms (allows to be manifested) the absolute thing that is the cause of the desire to image, the object that lies at the origin of the aesthetic law commanding the subject to create images.

Art and its images, under negation, touch the origin of the law and the cause of the desire to image. Negativity releases art from its commitment to episteme (truthful knowledge of the object) and to moral values, and the juxtaposition of the two negations poses a singular domain in relation to which the ethics of art is addressed. By positing the domain of art as effectuated by two negations, art can appear as a singular practice that oversteps the difference between the true and the fictional, between the moral and the immoral. Art within this domain, affirmed by way of negation, unveils the truth about the law that regulates its practices. Art is a practice in relation to which the desire to attain truth joins the acknowledgment of the immanent failure to satisfy this desire. The implication drawn from an act of emptying coupled with an affirmative operation with regard to the absolute law that grounds every practice and the object that causes the law to be imposed is what this study marks as ethical. To be considered an ethical practice, art does not remain with the hollowing out of its images but adheres to the desire to affirm something of the order of the absolute law and the indeterminate idea – through the artistic act.

To reach this point where art can be said to exhibit an ethical position, art is considered a practice that makes place for the pure object, the absolute object that is the cause of the law (in place of the object as seen, or the object represented). This study has moved through a number of steps to illustrate the significance of linking art's ethics with the logic of negation. It has moved by way of negation to establish the affirmative power of negativity; by way of the moral (Kantian) significance of beauty to establish the relation of non-rapport between the supersensible idea and the sensible image (showing that sensible presentations, while devoid of cognitive knowledge, are truthful to the moral attunement of the aesthetic judgment). This study has also moved by way of (non-epistemic) truth where art commits itself to truth that does not aim to convey any determinate concept or knowledge about its object. The consequences of negation were also examined by way of the artistic case that most blatantly enacts a voiding from the canvas of the object of representation (trompe l'oeil); and by way of the Second Commandment that, through the prohibition on imaging, reveals the far-reaching implications of a voiding act on a practice that goes on imaging: ART.

Notes

Introduction: By Way of the Law

1 See Immanuel Kant, *Critique of Practical Reason*, trans. Werner S. Pluhar (Indianapolis: Hackett, 1996), p. 49.

2 Ibid., p. 91.

3 Kant's antinomy of practical reason is described in terms of the problem of associating the moral attitude directly determined by the law with the effects of the will of the highest good in the world of sense. The antinomy of practical reason is hence solved by finding the right way of formulating the causality linking the good to happiness. Kant, pp. 144ff.

4 "The true function of the Father, which is fundamentally to unite (and not to oppose) a desire to the Law ... The Father the neurotic wishes for is clearly the dead Father ... who would be the perfect master of his desire – which would be just as good, as far as the subject is concerned." Jacques Lacan, "The Subversion of the Subject and the Dialectic of Desire" [1960], in *Écrits*, trans. Bruce Fink (New York: Norton, 2006), p. 698 [824].

5 Kant, *Critique of Practical Reason*, p. 96.

6 See "Kant with Sade" [1963] (discussed in the last chapter of this study), in *Écrits*, pp. 645–68.

7 *The Seminar of Jacques Lacan:* Book XVII, *The Other Side of Psychoanalysis*, ed. Jacques-Alain Miller, trans. Russell Grigg (New York: Norton, 2007), p. 19.

8 Jacques Derrida, "Before the Law," in *Acts of Literature*, ed. Derek Attridge (New York: Routledge, 1992), pp. 191, 192.

9 Ibid., p. 211.

10 As is formulated in other, later sources as well, Freud believed that in articulating the relation of the sense of guilt and bad conscience to the punitive

authority forcing the child to renounce satisfactions, and to the internalized agency called the superego, the origin of moral sense will be disclosed. See Sigmund Freud, "Civilization and Its Discontents" [1930], in *The Standard Edition of the Complete Psychological Works of Sigmund Freud* (London: Hogarth Press and the Institute of Psycho-Analysis), vol. 21, p. 94.

11 Derrida, "Before the Law," p. 198.

12 Ibid., p. 194.

13 Ibid., p. 196.

14 Ibid., p. 208.

15 "The mere existence of a wishful phantasy of killing and devouring him [the father], would have been enough to produce the moral reaction that created totemism and taboo. In this way we should avoid the necessity for deriving the origin of our cultural legacy, of which we justly feel so proud, from a hideous crime ... No damage would thus be done to the causal chain." Sigmund Freud, "Totem and Taboo" [1913], in *Standard Edition*, vol. 13, p. 160.

16 Ibid., p. 159.

17 Derrida, "Before the Law," p. 198.

18 Henry E. Allison, *Kant's Theory of Taste: A Reading of the Critique of Aesthetic Judgment* (Cambridge: Cambridge University Press, 2001).

19 Derrida, "Before the Law," p. 207.

20 Ibid., p. 209.

21 Sigmund Freud, "Delusions and Dreams in Jensen's *Gradiva* [1907], in *Standard Edition*, vol. 9, p. 8.

22 For a detailed discussion of Lacan's distinction between ethics and morality, see section (a) of chapter 5.

1. By Way of Negation

1 Plato, "Republic," book III, para. 398. This forms the basis for Plato's distinction between painting and music, as "simplicity in music was the parent of temperance in the soul" (Ibid., book III, para. 404); this cannot be said of any art born at the moment of imitation.

2 Jacques Lacan, "The Seminar of Jacques Lacan: Book XIV, The Logic of Phantasy" [1966–7], trans. Cormac Gallagher (unpublished), p. 75 (lecture given on 11 January 1967).

3 See De Duve, "Kant after Duchamp," in relation to art as proper name, pp. 3ff.

4 Sigmund Freud, "Negation" [1923], in *The Standard Edition of the Complete Psychological Works of Sigmund Freud* (London: Hogarth Press and the Institute of Psycho-Analysis), vol. 19, pp. 235–9.

5 Jacques Lacan, "The Seminar of Jacques Lacan: Book XXIV," trans. Daniel Collins (unpublished), p. 60.

6 Jean Hyppolite, "A Spoken Commentary on Freud's *Verneinung*," in *The Seminar of Jacques Lacan: Book I, Freud's Papers on Technique*, by Jacques Lacan (Cambridge: Cambridge University Press, 1988), p. 291.

7 I will not enter here in depth into the comparison between the logical notion of negation and the psychoanalytic one, even if this subject does occupy Lacan in his seminar on the logic of phantasy, where he decisively links the logic of phantasy with psychoanalytic idea of negation.

8 Freud, "Negation," p. 235.

9 This will be further elaborated later in this chapter.

10 Lacan also starts off in his analysis of negation from De Morgan logic from the nineteenth century, which formalized in a theretofore-unorthodox manner the implications of negating conjunctions and disjunctions of false propositions. Lacan would use De Morgan's emphasis on the importance of articulating the meaning of *and* and *or* for the truthfulness of the implication, when each set in the implication is empty (negated). Lacan, "Logic of Phantasy," pp. 66–7 (11 January 1967).

11 Freud, "Negation," p. 236.

12 Ibid.

13 Freud, "Civilization and Its Discontents," in *Standard Edition*, vol. 21, chap. 7, p. 124.

14 Freud, "Negation," p. 237.

15 Lacan, "Logic of Phantasy," p. 71 (11 January 1967).

16 Freud, "Negation," pp. 235–6.

17 Freud characterizes the intellectual side of judgment as relating to the choice of action, which puts an end "to the postponement due to thought and which leads over from thinking to acting." Ibid., p. 238.

18 Hyppolite opposes the Freudian negation to the Hegelian "ideal negation." The latter, as much as psychotic negation, constitutes the intellectual with a "destructive appetite," which leaves none of the combatants in the primordial struggle to remark the victory or defeat of any of them (ibid., p. 293). For Freud, however, repression is not total.

19 Lacan, "Logic of Phantasy," p. 73 (11 January 1967).

20 Hyppolite, "Spoken Commentary," p. 291.

21 Lacan, "Logic of Phantasy," p. 37 (7 December 1966).

22 Note that the ego is also emptied of what is satisfying in its "false" image (its ideal ego as materialized in a pleasing object of identification).

23 Lacan, "Logic of Phantasy," p. 67 (11 January 1967).

24 Freud, "'A Child Is Being Beaten': A Contribution to the Study of the Origin of Sexual Perversions" [1919], in *Standard Edition*, vol. 17, pp. 175–204 (my italics).

25 Ibid.

26 Lacan, "Logic of Phantasy," p. 76 (11 January 1967).

27 Lacan, *The Seminar of Jacques Lacan:* Book XI, *The Four Fundamental Concepts of Psychoanalysis* [1963–4], trans. Alan Sheridan (New York: Norton, 1998), p. 220.

28 Lacan "Logic of Phantasy," p. 70 (11 January 1967).

29 Ibid.

30 Freud, "Negation," p. 239.

31 In logic this refers to the implication to be drawn from two sets related through *and* or *or,* respectively. Lacan, "Logic of Phantasy," pp. 57ff. (14 December 1966).

32 Ibid., p. 78.

33 See Martin Heidegger, "What Is Metaphysics?" in *Basic Writings,* ed. David Farrell Krell (New York: HarperCollins Publishers, 1993), pp. 102–3.

34 Jacques Lacan, *The Seminar of Jacques Lacan:* Book VII, *The Ethics of Psychoanalysis,* ed. Jacques-Alain Miller (New York: Norton, 1997), p. 121.

35 Ibid., pp. 115–16.

36 Ibid., p. 121.

37 Ibid., p. 122.

38 Ibid.

39 Ibid., my italic

40 Ibid.

41 Melancholy is where the shadow of a lost object falls on the ego as a result of an emptying gesture. See Sigmund Freud, "Mourning and Melancholia" [1917], in *Standard Edition,* vol. 14, pp. 237–58.

42 Instances of such accusations of art as falsifying truth range from Flaubert's trial after the publication of *Madame Bovary* to the rejection of Courbet from the official salon in Paris of 1851.

43 Alain Badiou, "Art and Philosophy," in *Handbook of Inaesthetics,* trans. Alberto Toscano (Stanford, CA: Stanford University Press, 2005), p. 9.

44 Ibid., p. 15.

2. By Way of Beauty

1 Immanuel Kant, *Critique of Judgment,* trans. Werner S. Pluhar (Indianapolis: Hackett, 1987), "General Comment," p. 127.

2 Martin Kemp, *The Science of Art: Optical Themes in Western Art from Brunelleschi to Seurat* (New Haven, CT: Yale University Press, 1990), p. 42.

3 The law of reason is what determines the will that motivates action; through action an object can become in fact an object of the law, that is, good or

evil. See Kant, *Critique of Practical Reason*, trans. Werner S. Pluhar (Indianapolis: Hackett, 1996), p. 81.

4 Ibid., p. 161n151.

5 Ibid., p. 93.

6 *Exhibitio* is used by Kant to refer to the presentation of an intuition that corresponds to a concept, for instance in *Critique of Judgment*, §8.

7 Arthur Schopenhauer, *The World as Will and Representation*, trans. E.F.J. Payne (New York: Dover, 1969), vol. 1, §36, p. 184.

8 Ibid., §51, p. 244.

9 Ibid., §55, p. 287. Note that Schopenhauer continues to claim that "the concept of freedom is therefore really a negative one, since its content is merely the denial of necessity" (Ibid).

10 Jean-Luc Nancy, "On the Threshold," in *The Muses* (Stanford, CA: Stanford University Press, 1996), pp. 57–68; Jean-Luc Marion, "Crossing the Visible," in *The Crossing of the Visible* (Stanford, CA: Stanford University Press, 2004), pp. 1–23; Jacques Derrida, "pas partout," in *The Truth of Painting*, trans. Geoff Bennington and Ian McLeod (Chicago: University of Chicago Press, 1987), pp. 1–13.

11 Such a strategy is applied to the notion of the invisible by Marion, who illustrates the invisible in perspective painting through examples that span from Raphael's *Marriage of the Virgin* to avant-garde artists.

12 De Kooning was one of the greatest names in the art scene in those years and in the history of abstract expressionism at large.

13 In Mark Stevens and Annalyn Swan's *De Kooning: An American Master* (New York: Knopf, 2004), a range of possible meanings of this act are offered to the reader: the creation of a "ghostly monochromatic work without imagery," a private act of killing of the father going public, and so on (pp. 359–61).

14 Schopenhauer, *World as Will*, §55, pp. 288–9.

15 Jean-Francois Lyotard, *Lessons on the Analytic of the Sublime*, trans. Elizabeth Rottenberg (Stanford, CA: Stanford University Press, 1994), p. 165.

16 Jacques Rancière, *The Politics of Aesthetics*, trans. Gabriel Rockhill (London: Continuum, 2004), p. 24.

17 Kant, *Critique of Judgment*, §42, p. 165. This unequivocal exclusion can be justified, for instance, by Kant's conception of beautiful art as prompting an aesthetic idea by means of a *concept of an object*, whereas a moral judgment depends on *universal concepts*.

18 Jean-Francois Lyotard, "The Interest of the Sublime," in *Of the Sublime: Presence in Question*, ed. Jeffrey S. Librett (Albany, NY: State University of New York Press, 1993), p. 121.

19 This is suggested, for instance, by Kant's distinction between *free beauty* and *accessory beauty*: the former does not presuppose a concept of what the object is meant to be and a perfection of the object in terms of that concept. Art, according to Kant, hence belongs, by and large, to the realm of accessory beauty. *Critique of Judgment*, §16, pp. 76–8.

20 Friedrich Schiller, *On the Aesthetic Education of Man*, trans. Reginald Snell (New Haven, CT: Yale University Press, 1954), p. 27.

21 Kant, *Critique of Judgment*, §42, p. 167.

22 Ibid., §5, p. 53 (italics in original).

23 Ibid., §42, p. 167.

24 Henry E. Allison, *Kant's Theory of Taste: A Reading of the Critique of Aesthetic Judgment* (Cambridge: Cambridge University Press, 2001), pp. 89–90, 228; Paul Guyer, *Kant and the Claims of Taste* (Cambridge: Cambridge University Press, 1997), pp. 162–3.

25 "To distinguish between the agreeable, the good, and the beautiful, we need to differentiate not kinds of pleasure, but rather relationships in which objects stand to the feeling of pleasure." Guyer, *Kant*, p. 153.

26 Kant, *Critique of Judgment*, §49, p. 182.

27 Karsten Harries, *The Broken Frame: Three Lectures* (Washington, DC: Catholic University of America Press, 1989), p. 9.

28 Harries dedicates his essay on "Light without Love" (in *Broken Frame*) to exposing what he sees as the traditional aesthetic approach (the aesthetic object is instantaneous, resists the actual passage of time, is unclouded by meanings and emotions, etc.). Harries shows what kind of purpose this approach had served philosophers but also its apparent short-sightedness.

29 Martin Heidegger, "The Origin of the Work of Art," in *Poetry, Language, Thought,* trans. by Albert Hofstadter (New York: Harper & Row Publishers, 1971), p. 35.

30 Ibid., pp. 35, 79.

31 Ibid., p. 52.

32 Eli Friedlander presents the capacity to judge reflectively as finding what feels like the appropriate and meaningful terms for that given thing, which is another way of reintroducing interest into aesthetic considerations. See "Meaning and Aesthetic Judgment in Kant," *Philosophical Topics* 34 (2006): p. 23.

33 Guyer, *Kant*, p. 164.

34 Allison, *Kant's Theory of Taste*, p. 88.

35 Guyer, *Kant*, p. 169.

36 Kant, *Critique of Judgment*, §41, p. 163.

37 "This [intellectual] judgment is not based on any interest, *yet it gives rise to one*"; the pleasure in this judgment is called the moral feeling. Ibid., §42, p. 167.

38 Ibid., pp. 26ff.
39 Ibid., §41, p. 163.
40 Ibid.
41 Guyer, *Kant*, p. 322.
42 Ex-istence for Lacan refers to the presence of Otherness, strangeness at the place of being, thus in a way continuing Heidegger's notion of ex-sistenz as referring to *Dasein*'s way of relating to its own Being from outside.
43 Kant, *Critique of Judgment*, §49, p. 183.
44 Ibid., §59, p. 228.
45 Allison indicates that hindrances to the performance of moral duty do not necessarily originate from an alien sensuous nature but represent another, competing end that the will freely sets for itself (*Kant's Theory of Taste*, p. 230). Hindrances to morality are hence internal to the moral domain, which implies that given our moral commitment, beauty acts as a way of facilitating the working of the will "from within" reason, rather than as something to be overcome in the sensuous realm for morality to function properly.
46 Kant, *Critique of Judgment*, General Comment, pp. 126–40.
47 Ibid., p. 127.
48 Ibid.
49 Rodolphe Gasché, *The Idea of Form: Rethinking Kant's Aesthetics* (Stanford, CA: Stanford University Press, 2003), p. 160.
50 Ibid., p. 161.
51 Ibid., p. 173.
52 Ibid., p. 176.
53 Kant, *Critique of Judgment*, §42, p. 167.
54 The indeterminate idea of reason that serves to assign order to contingent-looking nature is given various interpretations by Kant's commentators: Guyer identifies the relevant idea with the harmony of cognitive powers, whereas Allison identifies it with the purposiveness of nature.
55 Allison, *Kant's Theory of Taste*, p. 233.
56 Kant, *Critique of Judgment*, §42, pp. 168–9.
57 Aesthetic ideas "necessarily involve a striving toward transcendence, either in the sense of endeavoring to depict something inherently supersensible or of attempting to approximate imaginatively the completeness or totality that is thought in the idea but not attainable in experience." Allison, *Kant's Theory of Taste*, p. 257. The explication here of the notion of aesthetic ideas is based on Allison's discussion in chapter 9 of his study of Kant.
58 Gasché, *Idea of Form*, p. 208
59 Kant, *Critique of Judgment*, §42, p. 169.
60 Ibid., p. 166.
61 Ibid., p. 169.

62 "In the case of beautiful art the aesthetic idea must be prompted by a concept of the object, whereas in the case of beautiful nature, mere reflection on a given intuition, without a concept ... is sufficient for arousing and communicating the idea." Ibid., §51, p. 189.

63 Ibid., §59, p. 229.

64 It is paradoxical because art has to make-believe that it is nature to qualify for an aesthetic judgment, while art loses its aesthetic relevance when the deception is exposed.

65 The necessity that we assign to a judgment of the beautiful, claims Kant, "cannot be derived from determinate concepts" nor "from the universality of experience (from a thorough agreement among judgments about the beauty of a certain object). For not only would experience hardly furnish a sufficient amount of evidence for this, but a concept of the necessity of these judgments cannot be based on empirical judgments." *Critique of Judgment*, §18, pp. 85–6.

66 G.W.F. Hegel, *Aesthetics: Lectures on Fine Arts*, trans. T. M. Knox (Oxford: Clarendon Press, 1975), p. 4–5.

67 Ibid., p. 9.

68 Kant, *Critique of Judgment*, §45, p. 173.

69 Ibid., §42, p. 169.

70 Allison, *Kant's Theory of Taste*, p. 207.

71 Rancière, *Politics of Aesthetics*, p. 21.

72 Kant, *Critique of Judgment*, §45, p. 174.

3. By Way of Truth

1 Jacques Lacan, "The Freudian Thing, or the Meaning of a Return to Freud in Psychoanalysis" [1955], in *Écrits*, trans. Bruce Fink (New York: Norton, 2006), p. 337 [405].

2 Jacques Lacan, *The Seminar of Jacques Lacan: Book XVII, The Other Side of Psychoanalysis* [1969–70], ed. Jacques-Alain Miller, trans. Russell Grigg (New York: Norton, 2007), p. 184.

3 Ibid.

4 Martin Heidegger, "Art and Space," trans. Charles Siebert, *Man and World* 6 (1973): p. 5.

5 This was the theme underlying, for instance, the defence of Gustave Flaubert in his trial after the publication of *Madame Bovary*. See the transcript of Flaubert's trial in *Madame Bovary (Norton Critical Edition)*, ed. Margaret Cohen (New York: Norton, 2004); such a position is often expressed in relation to artworks that blatantly break with politically correct views (like, for instance, Vladimir Nabokov's *Lolita*).

6 Alain Badiou refers to this approach to the relation between art and truth as the classical view.
 "Art and Philosophy," in *Handbook of Inaesthetics*, trans. Alberto Toscano (Stanford, CA: Stanford University Press, 2005), p. 4.

7 Aristotle, *Nichomachean Ethics*, trans. David Ross (Oxford: Oxford University Press, 1998), bk. 2, chap. 4, 1105a.

8 Ibid., bk. 3, chap. 7, 1116a.

9 René Descartes, *Meditations on a First Philosophy*, 3rd ed. (Indianapolis: Hackett, 1993), bk. 1, p. 16.

10 "The problem of justifying duty in secular ethics, then, is the problem of grounding obligation understood in these terms ... Ethics is the often individually costly means to a collective end." Candace Vogler, "Lack of Being, Denial of Good," in "Ignorance of the Law," special issue, *Umbr(a)*, 2003, p. 67.

11 "Pure reason does indeed prove itself in us practically, viz., the autonomy in the principle of morality by which pure reason determines the will to the deed." Immanuel Kant, *Critique of Practical Reason*, trans. Werner S. Pluhar (Indianapolis: Hackett, 1996), p. 60. The existence of god is hence a postulate of pure practical reason.

12 Lacan, *Other Side of Psychoanalysis*, p. 273.

13 Alain Badiou, "Truth: Forcing and the Unnameable," in *Theoretical Writings*, ed. and trans. Ray Brassier and Alberto Toscano (London: Continuum, 2004), p. 122.

14 Kant, *Critique of Practical Reason*, p. 66.

15 Louis Marin, "Representation and Simulacrum," in *On Representation*, trans. Catherine Porter (Stanford, CA: Stanford University Press, 2001), p. 317.

16 Ibid.

17 Jean Baudrillard, "The Trompe-l'Oeil," in *Calligram: Essays in New Art History from France*, ed. Norman Bryson (Cambridge: Cambridge University Press, 1988), p. 55.

18 Ibid., p. 59.

19 Jacques Derrida, *The Truth in Painting*, trans. Geoff Bennington and Ian McLeod (Chicago: University of Chicago Press, 1987), p. 3.

20 Martin Heidegger, *Poetry, Language, Thought*, trans. Albert Hofstadter (New York: Harper & Row, 1975), p. 54; Julian Young, *Heidegger's Philosophy of Art* (Cambridge: Cambridge University Press, 2001), p. 41.

21 Lacan, *Other Side of Psychoanalysis*, p. 104.

22 Ibid., p. 35.

23 Georg Wilhelm Friedrich Hegel, *The Phenomenology of Spirit*, trans. A.V. Miller (Oxford: Oxford University Press, 1977), para. 223, p. 135.

24 Whenever "other" appears in lowercase, it refers to the concrete partner or fellow-human.

25 Ibid., paras. 191–2, pp. 116–17.

26 Ibid., para. 195, pp. 117–18.

27 Lacan, *The Other Side of Psychoanalysis*, p. 37.

28 Ibid., pp. 32–3.

29 Ibid., pp. 42–3.

30 Ibid., p. 51.

31 Ibid., p. 59.

32 Ibid., p. 61.

33 Dany Nobus and Malcolm Quinn, *Knowing Nothing, Staying Stupid: Elements for a Psychoanalytic Epistemology* (London and New York: Routledge, 2005), p. 136.

34 Lacan, *The Other Side of Psychoanalysis*, p. 63.

35 Ibid., p. 57.

36 Bernard-Henri Levy, "The Philosopher's Discourse," trans. Vivian Rehberg, *Lacanian Praxis* 1 (May 2005): p. 36; originally published as "Le Philosophe," *Le Nouvel Âne* 6 (21 March 2005).

37 Martin Heidegger, "On the Essence of Truth," in *Basic Writings*, ed. David Farrell Krell (New York: HarperCollins Publishers, 1993), p. 132.

38 Ibid., p. 130.

39 Ibid., p. 131.

40 Alain Badiou, *Ethics: An Essay on the Understanding of Evil*, trans. Peter Hallward (London: Verso, 2001), p. 43.

41 Ibid., p. 45.

42 Ibid. (italic in the original).

43 Ibid., p. 46.

44 Ibid., p. 52.

45 Badiou, "Truth," p. 129.

46 Ibid.

47 Lacan, *Other Side of Psychoanalysis*, p. 52.

48 Jacques Lacan, *Le Séminaire de Jacques Lacan: Livre IV, Relation d'objet*, ed. Jacques-Alain Miller (Paris: Edition du Seuil, 1994), p. 253 (my translation).

49 Lacan, *Other Side of Psychoanalysis*, p. 13.

50 Ibid., p. 172.

51 Kant, *Critique of Judgment*, §17, pp. 82–3.

52 Ibid., p. 83.

53 Lacan, *Other Side of Psychoanalysis*, p. 43.

54 Lacan, *Le Séminaire de Jacques Lacan: Livre XXIII, Le Sinthome* [1975–6] (Paris: Edition du Seuil), pp. 137–8 (my translation).

55 Lacan, *Other Side of Psychoanalysis*, p. 52.

56 Ibid.

57 Lacan in Seminar XI, discussed by Charles Shepherdson, *Lacan and the Limits of Language* (New York: Fordham, 2008), p. 9.

58 Lacan, *Other Side of Psychoanalysis*, p. 91.

59 Lacan, *The Seminar of Jacques Lacan:* Book XX, *Encore: On Feminine Sexuality, the Limits of Love and Knowledge* [1972–3], ed. Jacques-Alain Miller, trans. Bruce Fink (New York: Norton, 1998), p. 92.

60 Ibid.

61 Dominique Hecq, "The Impossible Power of Psychoanalysis," in *Jacques Lacan and the Other Side of Psychoanalysis: Reflections on Seminar XVII*, ed. Justin Clemens and Russell Grigg (Durham, NC: Duke University Press, 2006), pp. 222–3.

4. By Way of Deception

1 Plato, *Republic*, trans. G.M.A. Grube, rev. C.D.C. Reeve, ed. John M. Cooper (Indianapolis: Hackett, 1997), §382b, p. 58.

2 Jacques Lacan, *The Seminar of Jacques Lacan:* Book XVII, *The Other Side of Psychoanalysis* [1969–70], ed. Jacques-Alain Miller, trans. Russell Grigg (New York: Norton, 2007), p. 79.

3 Louis Marin, "Representation and Simulacrum," in *On Representation*, trans. Catherine Porter (Stanford, CA: Stanford University Press, 2001), p. 314.

4 Ibid., p. 319.

5 Jacques Lacan, *The Seminar of Jacques Lacan:* Book XI, *The Four Fundamental Concepts of Psychoanalysis* [1963–4], trans. Alan Sheridan (New York: Norton, 1998), p. 112.

6 Kant, *Critique of Judgment*, §45, p. 174.

7 Alain Badiou, "Art and Philosophy," in *Handbook of Inaesthetics*, trans Alberto Toscano (Stanford, CA: Stanford University Press, 2005), p. 1.

8 Ernest Gombrich, *The Image and the Eye* (London: Phaidon, 1982), p. 181.

9 Hal Foster, *The Return of the Real* (Cambridge, MA: MIT Press, 1996), p. 141.

10 Lacan, *Four Fundamental Concepts*, p. 104.

11 Foster, *Return of the Real*, p. 141.

12 See Jean-Luc Marion, *The Crossing of the Visible* (Stanford, CA: Stanford University Press, 2004), for a similar argument.

13 W.J.T. Mitchell, *Picture Theory* (Chicago: University of Chicago Press, 1994), p. 325.

14 Ibid., pp. 330–1.

15 Arthur Danto, "Trompe l'Oeil and Transaction: The Art of Boggs," in *Embodied Meanings* (New York: Farrar Straus & Giroux, 1994), pp. 104–11.

16 Jean Baudrillard, "The Trompe l'Oeil," in *Calligram: Essays in New Art History from France*, ed. Norman Bryson (Cambridge: Cambridge University Press, 1988), pp. 53–62.

17 Ibid., p. 59.

18 Ibid., pp. 58–9.

19 Ibid., p. 56.

20 Ibid., p. 54.

21 Ibid., p. 58.

22 Ibid., p. 54.

23 Ibid., p. 59.

24 Ibid.

25 Ibid., p. 56.

26 Ibid.

27 Ibid.

28 Freud, "The Uncanny" [1919], in *The Standard Edition of the Complete Psychological Works of Sigmund Freud* (London: Hogarth Press and the Institute of Psycho-Analysis, 1956–1974), vol. 17, pp. 217–56.

29 Ibid., p. 58.

30 Freud, "Uncanny," p. 226.

31 Immanuel Kant, *Critique of Practical Reason*, trans. Werner S. Pluhar (Indianapolis: Hackett, 2002), p. 44.

32 See Ruth Ronen, *Aesthetics of Anxiety* (Albany, NY: State University of New York Press, 2009), p. 88.

33 The object *a*, which has acquired connotations of the real, denoting an object that can never be attained, which sets desire in motion. See Dylan Evans, *An Introductory Dictionary of Lacanian Psychoanalysis* (New York: Routledge, 1996), p. 125.

34 "I made up my mind to put up with it [with the analysis] till the New Year." Freud, "Fragment of an Analysis of a Case of Hysteria" [1905], in *Standard Edition*, vol. 7, p. 105.

35 In *Écrits*, trans. Bruce Fink (New York: Norton, 2006), pp. 161–75 [197–213].

36 Ibid., p. 171 [209].

37 Kant, *Critique of Practical Reason*, p. 44.

38 Lacan, *Four Fundamental Concepts*, p. 133.

39 Ibid., p. 139.

40 Ibid.

41 Ibid., p. 140.

42 Lacan, *Four Fundamental Concepts*, p. 36.

43 Ibid.

44 Ibid., p. 37.

45 Ibid., p. 35.
46 Lacan, "The Seminar of Jacques Lacan: Book X, Anxiety" [1962–3], trans.
 Cormac Gallagher (unpublished), p. 50 [90] (19 December 1962).
47 Roberto Harari, *Lacan's Seminar on "Anxiety": An Introduction* (New York:
 Other Press, 2001).
48 Freud, "The Economic Problem of Masochism" [1924], in *Standard Edition*,
 vol. 19, pp. 157–72.
49 Lacan, "Anxiety," p. 91.
50 Ibid.
51 Freud, "The Psychogenesis of a Case of Homosexuality in a Woman" [1920],
 in *Standard Edition*, vol. 18, pp. 146–74.

5. By Way of Prohibition

1 Jacques-Alain Miller, "Biologie Lacanienne et événement de corps," *Cause
 Freudienne* 44 (2000): p. 22 (my translation).
2 Alenka Zupančič writes that the existence of an ethical subject assumes a
 prior moment when it becomes impossible to say "I act" or "I think." "Pas-
 sage through this impossible point of one's own non-being, where it seems
 that one can say of oneself only 'I am not', however, is the fundamental
 condition of attaining the status of a free subject." Only then can a leftover
 element serve as the basis for the constitution of an ethical subject. *Ethics of
 the Real* (London: Verso, 2000), p. 32.
3 Immanuel Kant, *Critique of Practical Reason*, trans. Werner S. Pluhar (India-
 napolis: Hackett, 2002), p. 84 [62–3].
4 This distinction can likewise shed a specific light on analytical philosophy's
 rejection of moral theory (since G.E.M. Anscombe's classical project)
 and replacement of it with psychological issues of intention and justifiability.
5 Jacques Lacan, "The Seminar of Jacques Lacan: Book XVI, From an Other
 to an Other" [1968–9], trans. Cormac Gallagher (unpublished), p. 101
 (15 January 1969).
6 Lacan, "The Seminar of Jacques Lacan: Book XV, The Psychoanalytic Act"
 [1967–8], trans. Cormac Gallagher (unpublished), (17 January 1968).
7 See Martha Nussbaum's *The Fragility of Goodness* for the moral dilemma
 materialized by tragedy and taken to two extremes by Plato and Aristotle
 (Cambridge: Cambridge University Press, 2001).
8 Lacan, *The Seminar of Jacques Lacan: Book VII, The Ethics of Psychoanalysis*, ed.
 Jacques-Alain Miller, trans. Dennis Porter (New York: Norton, 1997), p. 22.
9 Zupančič, *Ethics of the Real*, p. 164 (italics in original).
10 Lacan, "From an Other to an Other," p. 101 (15 January 1969).

11 See also "Kant with Sade," where Lacan explains that no law of feeling good can be enunciated (nothing has a constant relation to pleasure), while the good that is the object of the moral law is unconditional, and the imperative enunciating it is categorical. In *Écrits*, trans. Bruce Fink (New York: Norton, 2006), p. 646 [766].

12 Freud, "Civilization and Its Discontents" [1930], in *The Standard Edition of the Complete Psychological Works of Sigmund Freud* (London: Hogarth Press and the Institute of Psycho-Analysis, 1956–1974), vol. 21, p. 80n5.

13 Lacan, *Ethics of Psychoanalysis*, p. 70.

14 Lacan, "Seminar of Jacques Lacan: Book XIV, The Logic of Phantasy" [1966–7], trans. Cormac Gallagher (unpublished), p. 236 (31 May 1967).

15 Richard Boothby, *Death and Desire: Psychoanalytic Theory in Lacan's Return to Freud* (New York: Routledge, 1991), p. 168.

16 Freud, "Civilization and Its Discontents," p. 129.

17 Lacan, "Logic of Phantasy," p. 238.

18 For an explanation of the place of freedom in Kant, see Zupančič, *Ethics of the Real*, pp. 22–4.

19 Lacan, "Logic of Phantasy," p. 236 (31 May 1967).

20 Ibid., p. 237.

21 In Seminar XXII Lacan proposes to differentiate "at the limit" from "by the limit": the former assumes that the real is encountered at fatal moments "at the limit" – like the moment of a fight to the death – while Lacan opts for "by the limit" to indicate that the subjective consistency, even if real, must be supported by the symbolic. "The Seminar of Jacques Lacan: Book XXII, Crucial Problems" [1974–5], trans. Cormac Gallagher (unpublished), p. 97 (15 April 1975).

22 Lacan, "Logic of Phantasy," p. 239.

23 Nancy, *Hegel: The Restlessness of the Negative*, p. 68.

24 Lacan, *Ethics of Psychoanalysis*, p. 69.

25 Ibid., p. 83.

26 Kant, *Critique of Practical Reason*, p. 45.

27 Lacan, *Ethics of Psychoanalysis*, pp. 76–7.

28 Lacan, "Kant with Sade," p. 647 [767].

29 Quoted in ibid., p. 648 [760].

30 Ibid., p. 650 [770].

31 Zupančič, *Ethics of the Real*, p. 163.

32 Lacan, *Ethics of Psychoanalysis*, p. 83.

33 Jean-François Lyotard, *The Postmodern Condition: A Report on Knowledge*, trans. Geoff Bennington and Brian Massumi (Minneapolis: University of Minnesota Press, 1984), p. 78.

34 Lacan, *Ethics of Psychoanalysis*, p. 83.

35 Lacan, "The Seminar of Jacques Lacan: Book XVIII, On a Discourse That Might Not Be a Semblance," trans. Cormac Gallagher (unpublished), [pp. 66–7] (17 February 1971).

36 See Chapter 2, note 42.

37 The difference between being and having the phallus as marking two distinct sexual positions (rather than two genders or two biological types) is discussed by Lacan in *The Seminar of Jacques Lacan: Book XX, Encore: On Feminine Sexuality, the Limits of Love and Knowledge* [1972–3], ed. Jacques-Alain Miller, trans. Bruce Fink (New York: Norton, 1998), pp. 78–89.

38 Lacan, "On a Discourse." [p. 68] (17 February 1971).

39 Ibid., [p. 67.]

40 *Mentir* = to lie.

41 Lacan, "On a Discourse," p. 21.

42 Judaism indeed is unique among monotheistic religions in assuming a god positioned outside nature, that is, outside the world of physics, humans, and so on.

43 Maimonides interprets in this spirit the phrase "in the image of god," which appears in Genesis to account for the way Adam and Eve were created, and he writes that *image* here (*Zelem* in Hebrew) does not refer to form or outline but only to the intellectual apprehension of a species. See *The Guide for the Perplexed*, trans. Shlomo Pines (Chicago: University of Chicago Press, 1963), chap. 1.

44 Exodus 20:18.

45 See W.J.T. Mitchell, *Iconology: Image, Text, Ideology* (Chicago: University of Chicago Press, 1986).

46 See Rancière, *The Politics of Aesthetics*, pp. 20–30.

47 Lyotard, for example, suggests linking the Second Commandment with the making of sublime painting. *Postmodern Condition*, p. 78.

48 Leo Steinberg, "Who's Who in Michelangelo's *Creation of Adam*: A Chronology of the Picture's Reluctant Self-revelation," *Art Bulletin* 74, no. 4 (1992): pp. 552–66.

49 Jane Schuyler as quoted in Maria Rzepinska, "The Divine Wisdom of Michelangelo in *The Creation of Adam*," *Artibus et Historiae* 15, no. 29 (1994): pp. 181–7.

50 Save Marcel Duchamp's ready-mades, which, in their initiating moment, succeed in sustaining the power of desire in the creative act despite the fact that they aim to "make a whatever." See Thierry de Duve, *Kant after Duchamp* (Cambridge, MA: MIT Press, 1996), p. 358.

51 "The moral law is given as a fact, as it were, of pure reason of which we are conscious a priori and which is apodeictically certain, even supposing that in experience no example could be hunted up where it is complied with exactly." Kant, *Critique of Practical Reason*, p. 66.

52 Ibid.

53 De Duve, *Kant after Duchamp*, p. 358.

54 Jacques Lacan, *The Seminar of Jacques Lacan: Book XI, The Four Fundamental Concepts of Psychoanalysis*, ed. Jacques-Alain Miller, trans. Alan Sheridan (New York: Norton, 1998), pp. 275–6.

55 Kant, *Critique of Practical Reason*, p. 45 (italics in original).

56 Lacan, *Four Fundamental Concepts*, p. 112.

57 Lacan, *Ethics of Psychoanalysis*, p. 187.

58 Lacan, *Four Fundamental Concepts*, p. 166.

59 Kant, *Critique of Practical Reason*, p. 25.

60 Ibid.

61 Ibid.

62 Ibid., p. 81.

63 Ibid., p. 78.

64 Ibid., p. 87.

65 Nancy, *Hegel*, p. 67.

66 Kant, *Critique of Practical Reason*, p. 78.

67 Ibid., p. 79.

68 Marion, *De surcroit: Etudes sur les phénoménes saturés* (Paris : Presses Universitaires de France, 2001), pp. 70–1.

69 Ibid., p. 83.

70 Lacan, *Ethics of Psychoanalysis*, p. 197.

71 Lacan, *Four Fundamental Concepts*, pp. 138–9.

72 "There is something so special in the boundless esteem for the pure moral law stripped of all advantage – as this law is presented to us, for compliance, by practical reason, whose voice makes even the boldest offender tremble and compels him to hide from his sight." Kant, *Critique of Practical Reason*, p. 104.

73 Ibid., p. 51.

74 Lacan, "Kant with Sade," p. 650 [770].

75 According to Slavoj Zizek, it is exactly at this point that one can notice the link and difference between Kant and Sade, since Sade unveils the split subject that Kant disguises with the voice of reason that is allegedly immanent to the subject. See Zizek, "Kant with (or against) Sade" [1999], in *The Zizek Reader*, ed. Elizabeth Wright and Edmond Wright (Oxford: Blackwell, 1999), pp. 290–1.

76 Lacan, "Kant with Sade," p. 647 [768].

77 Mladen Dolar, "The Object Voice," in *Gaze and Voice as Love Objects*, ed. Slavoj Zizek and Renata Salecl (Durham, NC: Duke University Press, 1996), p. 24.

78 Dolar, after Theodor Reik and Lacan, brings the case of the shofar in Jewish rituals, the shofar as the emblem of the voice without content that sticks to the law. Ibid., p. 26.

79 Jacques Lacan, "Introduction to the Names-of-the-Father Seminar" [1963], in *Television*, trans. Denis Hollier, Rosalind Krauss, and Annette Michelson (New York: Norton, 1990), p. 87.

80 Lacan, *Ethics of Psychoanalysis*, p. 81.

81 Lacan, "Names-of-the-Father Seminar," p. 94.

82 Genesis 22:12.

83 Sigmund Freud, "Totem and Taboo" [1913], in *Standard Edition*, vol. 13, pp. 1–162.

84 Kant, *Critique of Judgment*, "General Comment," p. 135.

Conclusion

1 Jean-Luc Nancy, *Hegel: The Restlessness of the Negative* (Minneapolis: University of Minnesota, 2002), pp. 70–1.

Bibliography

Allison, Henry E. *Kant's Theory of Taste: A Reading of the Critique of Aesthetic Judgment.* Cambridge: Cambridge University Press, 2001.

Aristotle. *Nichomachean Ethics.* Translated by David Ross. Oxford: Oxford University Press, 1998.

Badiou, Alain. "Art and Philosophy." In *Handbook of Inaesthetics.* Translated by Alberto Toscano, pp. 1–15. Stanford, CA: Stanford University Press, 2005.

Badiou, Alain. *Ethics: An Essay on the Understanding of Evil.* Translated by Peter Hallward. London: Verso, 2001.

Badiou, Alain. "Truth: Forcing and the Unnameable." In *Theoretical Writings.* Edited and translated by Ray Brassier and Alberto Toscano, pp. 121–136. London: Continuum, 2004.

Baudrillard, Jean. "The Trompe-l'Oeil." In *Calligram: Essays in New Art History from France*, edited by Norman Bryson, pp. 53–62. Cambridge: Cambridge University Press, 1988.

Boothby, Richard. *Death and Desire: Psychoanalytic Theory in Lacan's Return to Freud.* New York: Routledge, 1991.

Danto, Arthur. "Trompe l'Oeil and Transaction: The Art of Boggs." In *Embodied Meanings*, pp. 25–31. New York: Farrar Straus & Giroux, 1994.

Derrida, Jacques. "Before the Law." In *Acts of Literature.* Edited by Derek Attridge, pp. 181–220. New York: Routledge, 1992.

Derrida, Jacques. *The Truth in Painting.* Translated by Geoff Bennington and Ian McLeod. Chicago: University of Chicago Press, 1987.

Descartes, Réné. *Meditations on a First Philosophy.* 3rd ed. Indianapolis, IN: Hackett, 1993.

Dolar, Mladen. "The Object Voice." In *Gaze and Voice as Love Objects*, edited by Slavoj Zizek and Renata Salecl, pp. 7–31. Durham, NC: Duke University Press, 1996.

Duve, Thierry de. *Kant after Duchamp.* Cambridge, MA: MIT Press, 1996.

Evans, Dylan. *An Introductory Dictionary of Lacanian Psychoanalysis.* New York: Routledge, 1996.

Foster, Hal. *The Return of the Real.* Cambridge, MA: MIT Press, 1996.

Freud, Sigmund. "A Child Is Being Beaten: A Contribution to the Study of the Origin of Sexual Perversions." 1919. In *Standard Edition,* vol. 17, pp. 175–204.

Freud, Sigmund. "Civilization and Its Discontents." 1930. In *Standard Edition,* vol. 21, pp. 57–146.

Freud, Sigmund. "The Economic Problem of Masochism." 1924. In *Standard Edition,* vol. 19, pp. 157–72.

Freud, Sigmund. "Fragment of an Analysis of a Case of Hysteria." 1905. In *Standard Edition,* vol. 7, pp. 1–122.

Freud, Sigmund. "Mourning and Melancholia." 1917. In *Standard Edition,* vol. 14, pp. 237–58.

Freud, Sigmund. "Negation." 1923. In *Standard Edition,* vol. 19, pp. 235–9.

Freud, Sigmund. "The Psychogenesis of a Case of Homosexuality in a Woman." 1920. In *Standard Edition,* vol. 18, pp. 146–74.

Freud, Sigmund. *The Standard Edition of the Complete Psychological Works of Sigmund Freud.* Translated under the general editorship of James Strachey, in collaboration with Anna Freud, assisted by Alix Strachey and Alan Tyson. London: Hogarth Press and the Institute of Psycho-Analysis, 1956–1974.

Freud, Sigmund. "Totem and Taboo." 1913. In *Standard Edition,* vol. 13, pp. 1–162.

Freud, Sigmund. "The Uncanny." 1919. In *Standard Edition,* vol. 17, pp. 217–56.

Friedlander, Eli. "Meaning and Aesthetic Judgment in Kant." *Philosophical Topics* 34 (2006): pp. 21–34.

Gasché, Rodolphe. *The Idea of Form: Rethinking Kant's Aesthetics.* Stanford, CA: Stanford University Press, 2003.

Gombrich, Ernest. *The Image and the Eye.* London: Phaidon, 1982.

Guyer, Paul. *Kant and the Claims of Taste.* Cambridge: Cambridge University Press, 1997.

Harari, Roberto. *Lacan's Seminar on "Anxiety": An Introduction.* New York: Other Press, 2001.

Harries, Karsten. *The Broken Frame.* Washington, DC: Catholic University of America Press, 1989.

Hecq, Dominique." The Impossible Power of Psychoanalysis." In *Jacques Lacan and the Other Side of Psychoanalysis: Reflections on Seminar XVII,* edited by Justin Clemens and Russell Grigg, pp. 216–28. Durham, NC: Duke University Press, 2006.

Hegel, Georg Wilhelm Friedrich. *Aesthetics: Lectures on Fine Arts.* Translated by T.M. Knox. Oxford: Clarendon, 1975.

Hegel, G.W.F. *The Phenomenology of Spirit.* Translated by A.V. Miller. Oxford: Oxford University Press, 1977.

Heidegger, Martin. "Art and Space." Translated by Charles Siebert. *Man and World* 6 (1973): pp. 3–8.

Heidegger, Martin. "On the Essence of Truth." In *Basic Writings.* Edited by David Farrell Krell, pp. 111–39. New York: HarperCollins Publishers, 1993.

Heidegger, Martin. "The Origin of the Work of Art." In *Poetry, Language, Thought.* Translated by Albert Hofstadter, pp. 15–86. New York: Harper & Row, 1975.

Heidegger, Martin. "What Is Metaphysics?" In *Basic Writings.* Edited by David Farrell Krell, pp. 89–110. New York: HarperCollins Publishers, 1993.

Hyppolite, Jean. "A Spoken Commentary on Freud's Verneinung." In *The Seminar of Jacques Lacan: Book I, Freud's Papers on Technique*, by Jacques Lacan, 289–98. Cambridge: Cambridge University Press, 1988.

Kant, Immanuel. *Critique of Judgment.* Translated by Werner S. Pluhar. Indianapolis: Hackett, 1987.

Kant, Immanuel. *Critique of Practical Reason.* Translated by Werner S. Pluhar. Indianapolis: Hackett, 2002.

Kemp, Martin. *The Science of Art: Optical Themes in Western Art from Brunelleschi to Seurat.* New Haven, CT: Yale University Press, 1990.

Lacan, Jacques. "Aggressiveness in Psychoanalysis." 1948. In *Écrits*, pp. 82–101.

Lacan, Jacques. *Écrits.* Translated by Bruce Fink. New York: Norton, 2006.

Lacan, Jacques. "The Freudian Thing, or the Meaning of a Return to Freud in Psychoanalysis." 1955. In *Écrits*, pp. 334–63.

Lacan, Jacques. "Introduction to the Names-of-the-Father Seminar." 1963. In *Television.* Translated by Denis Hollier, Rosalind Krauss, and Annette Michelson, pp. 81–95. New York: Norton, 1990.

Lacan, Jacques. "Kant with Sade." 1963. In *Écrits*, pp. 645–68.

Lacan, Jacques. "Logical Time and the Assertion of Anticipated Certainty." 1945. In *Écrits*, pp. 162–75.

Lacan, Jacques. *Le Séminaire de Jacques Lacan:* Livre IV, *Relation d'objet.* 1956–7. Edited by Jacques-Alain Miller. Paris: Edition du Seuil, 1994.

Lacan, Jacques. *Le Séminaire de Jacques Lacan:* Livre XXIII, *Le Sinthome.* 1975–6. Edited by Jacques-Alain Miller. Paris: Edition du Seuil, 2005.

Lacan, Jacques. *The Seminar of Jacques Lacan:* Book VII, *The Ethics of Psychoanalysis.* 1959–60. Edited by Jacques-Alain Miller, translated by Dennis Porter. New York: Norton, 1997.

Lacan, Jacques. "The Seminar of Jacques Lacan: Book X, Anxiety." 1962–3. Translated by Cormac Gallagher. Unpublished.

Lacan, Jacques. *The Seminar of Jacques Lacan:* Book XI, *The Four Fundamental Concepts of Psychoanalysis.* 1963–4. Translated by Alan Sheridan. New York: Norton, 1998.

Lacan, Jacques. "The Seminar of Jacques Lacan: Book XIV, The Logic of Phantasy." 1966–7. Translated by Cormac Gallagher. Unpublished.

Lacan, Jacques. "The Seminar of Jacques Lacan: Book XV, The Psychoanalytic Act." 1967–8. Translated by Cormac Gallagher. Unpublished.

Lacan, Jacques. "The Seminar of Jacques Lacan: Book XVI, From an Other to an Other." 1968–9. Translated by Cormac Gallagher. Unpublished.

Lacan, Jacques. *The Seminar of Jacques Lacan:* Book XVII, *The Other Side of Psychoanalysis.* 1969–70. Edited by Jacques-Alain Miller, translated by Russell Grigg. New York: Norton, 2007.

Lacan, Jacques. "The Seminar of Jacques Lacan: Book XVIII, On a Discourse That Might Not Be a Semblance." 1971. Translated by Cormac Gallagher. Unpublished.

Lacan, Jacques. *The Seminar of Jacques Lacan:* Book XX, *Encore: On Feminine Sexuality, the Limits of Love and Knowledge.* 1972–3. Edited by Jacques-Alain Miller, translated by Bruce Fink. New York: Norton, 1998.

Lacan, Jacques. "The Seminar of Jacques Lacan: Book XXII, Crucial Problems." 1974–5. Translated by Cormac Gallagher. Unpublished.

Lacan, Jacques. "The Seminar of Jacques Lacan: Book XXIV, L'insu que sait de l'une bévue, s'aile à mourre." 1976–7. Translated by Daniel Collins. Unpublished.

Lacan, Jacques. "The Subversion of the Subject and the Dialectic of Desire." 1960. In *Écrits,* pp. 671–701.

Levy, Bernard-Henri. "The Philosopher's Discourse." Translated by Vivian Rehberg. *Lacanian Praxis* 1 (May 2005): pp. 34–7. Originally published as "Le Philosophe" in *Le Nouvel Âne,* no. 6 (21 March 2005).

Lyotard, Jean-Francois. "The Interest of the Sublime " In *Of the Sublime: Presence in Question,* edited by J.S. Librett, pp. 109–32. Albany, NY: State University of New York Press, 1993.

Lyotard, Jean-Francois. *Lessons on the Analytic of the Sublime.* Translated by Elizabeth Rottenberg. Stanford, CA: Stanford University Press, 1994.

Lyotard, Jean-Francois. *The Postmodern Condition: A Report on Knowledge.* Translated by Geoff Bennington and Brian Massumi. Minneapolis: University of Minnesota Press, 1984.

Maimonides. *The Guide for the Perplexed.* Translated by Shlomo Pines. Chicago: University of Chicago Press, 1963.

Marin, Louis. "Representation and Simulacrum." In *On Representation*. Translated by Catherine Porter, pp. 309–19. Stanford, CA: Stanford University Press, 2001.

Marion, Jean-Luc. *The Crossing of the Visible*. Stanford, CA: Stanford University Press, 2004.

Marion, Jean-Luc. *De surcroît: Etudes sur les phénoménes saturés*. Paris: Presses Universitaires de France, 2001.

Miller, Jacques-Alain. "Biologie Lacanienne et événement de corps." *Cause freudienne* 44 (2000): pp. 7–59.

Mitchell, W.J.T. *Iconology: Image, Text, Ideology*. Chicago: University of Chicago Press, 1986.

Mitchell, W.J.T. *Picture Theory*. Chicago: University of Chicago Press, 1994.

Nancy, Jean-Luc. *Hegel: The Restlessness of the Negative*. Minneapolis: University of Minnesota Press, 2002.

Nancy, Jean-Luc. *The Muses*. Stanford, CA: Stanford University Press, 1996.

Nobus, Dany, and Malcolm Quinn. *Knowing Nothing, Staying Stupid: Elements for a Psychoanalytic Epistemology*. London and New York: Routledge, 2005.

Nussbaum, Martha. *The Fragility of Goodness*. Cambridge: Cambridge University Press, 2001.

Plato. *Republic*. Translated by G.M.A. Grube, revised by C.D.C. Reeve, edited by John M. Cooper. Indianapolis: Hackett, 1997.

Rancière, Jacques. *The Politics of Aesthetics*. Translated by Gabriel Rockhill. London: Continuum, 2004.

Ronen, Ruth. *Aesthetics of Anxiety*. Albany, NY: State University of New York Press, 2009.

Rzepinska, Maria. "The Divine Wisdom of Michelangelo in *The Creation of Adam*." *Artibus et Historiae* 15, no. 29 (1994): pp. 181–7.

Schiller, Friedrich. *On the Aesthetic Education of Man*. Translated by Reginald Snell. New Haven, CT: Yale University Press, 1954.

Schopenhauer, Arthur. *The World as Will and Representation*. Translated by E.F.J. Payne. New York: Dover, 1969.

Shepherdson, Charles. *Lacan and the Limits of Language*. Bronx, NY: Fordham University Press, 2008.

Steinberg, Leo. "Who's Who in Michelangelo's *Creation of Adam*: A Chronology of the Picture's Reluctant Self-revelation." *Art Bulletin* 74, no. 4 (1992): pp. 552–66.

Stevens, Mark, and Annalyn Swan. *De Kooning: An American Master*. New York: Knopf, 2004.

Van Gerwen, Rob (ed.), *Richard Wollheim on the Art of Painting: Art as Representation and Expression*. Cambridge: Cambridge University Press, 2001.

Vogler, Candace. "Lack of Being, Denial of Good." In "Ignorance of the Law."
 Special issue, *Umbr(a)*, 2003, pp. 63–80.
Young, Julian. *Heidegger's Philosophy of Art*. Cambridge: Cambridge University
 Press, 2001.
Zizek, Slavoj. "Kant with (or against) Sade." In *The Zizek Reader*, edited by Eliza-
 beth Wright and Edmond Wright, pp. 283–301. Oxford: Blackwell, 1999.
Zupančič, Alenka. *Ethics of the Real*. London: Verso, 2000.

Index

act, 42, 77, 142; of creation, 34–6; passage to act, 121
aesthetic: ethics and aesthetics (*see* ethics); faculty, 12, 52; Heideggerian aesthetics (*see* Heidegger, M.); idea, 46, 57–9, 65, 110, 165n17, 167n57, 168n62; imperative, 15, 71, 94, 124, 139–40, 142–3, 147, 149; interest (*see* interest); judgment, 16, 39, 44–8, 50–61, 160, 166n32, 168n64; Kantinian aesthetics, 7, 15, 20, 41, 45–8, 50–61, 68, 71, 85, 110, 165n17; law, 59–60, 71, 94, 132, 137, 156, 159; morality and aesthetics, 12, 16, 41, 42, 44–8, 50–61, 68; nature, 73; regime (*see* regime); subject, 45, 52, 65
affect, 8, 26, 62, 93, 98, 104, 111–13, 120, 127, 143, 147
alétheia, 80–1
Allison, H. E., 12, 50, 57, 167n45, 167n54, 167n57
analyst, 74, 77–8, 81, 85–91, 113, 118; discourse of the (*see* discourse)
antinomy, 5, 161n3
anxiety, 111–13, 115, 120–1, 147, 172n32, 173nn46–7

aphanisis, 148
Aristotle, 31, 68–9, 123–8, 173n7
ars poetica, 73

Badiou A., 20, 37, 71, 81–3, 97, 169n6
Baudrillard, J., 72, 102, 105–10, 119
beauty, 12, 15–16, 20, 39, 41, 43–65, 68, 85, 93, 96, 110, 160, 166n19, 167n45, 168n65
Bedeutung, 24
Boothby, R., 174n15
Botticelli, 101

Caravaggio, 154–5
cause of desire, 28, 88–90, 112, 129, 134–5, 141
cogito, 24–6, 29–35, 76, 98, 109, 111, 117
Coleridge, S. T., 61

Danto, A., 102, 104
das Ding. See Thing, the
death, 20, 53, 90, 109–10, 114, 126, 128–31, 174n21
deception, 16, 56, 58–9, 61–5, 72–3, 93–122, 168n64
Demand, T., 98, 101, 119